Step Into the Lives
of Five Famous Painters

ART+TRAVEL

EUROPE

MUSEYON
GUIDES

A CURATED GUIDE TO YOUR OBSESSIONS

www.museyon.com

©Museyon Inc. 2010

Publisher: Akira Chiba
Editors: Heather Corcoran, Stef Schwalb
Editorial Consultant: Anne Ishii
Art Director: Deena Campbell
Sales and Marketing Manager: Laura Robinson
Contributor: Catherine Ventura
Copy Editors: Joyce Artinian, Helen Schumacher

Cover Photo: Akira Chiba
Cover Illustration: Tiny Inventions

Published in the United States by:
Museyon, Inc.
20 E. 46th St., Ste. 1400
New York, NY 10017

Museyon is a registered trademark.
Visit us online at www.museyon.com

ISBN 978-0-9822320-5-7

195902

Printed in China

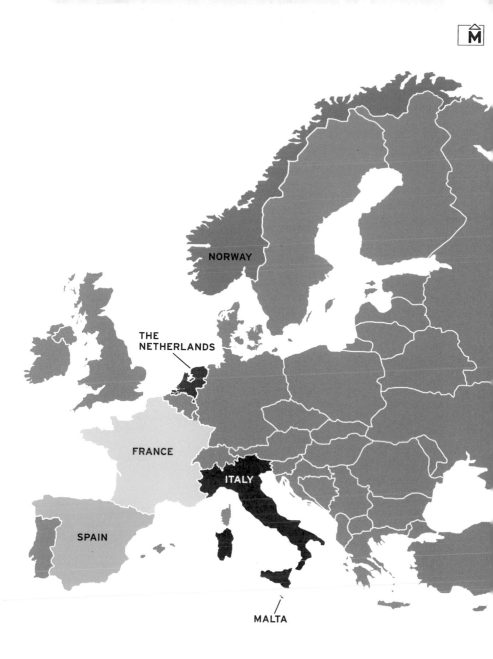

NORWAY

THE
NETHERLANDS

FRANCE

ITALY

SPAIN

MALTA

MAP : **EUROPE**

TABLE OF CONTENTS

VAN GOGH AND ARLES 06
FRANCE BY KRISTIN HOHENADEL

VERMEER AND DELFT 48
THE NETHERLANDS BY SANDRA SMALLENBURG

GOYA AND MADRID 86
SPAIN BY GEORGE STOLZ

CARAVAGGIO AND ROME 126
ITALY BY BARBIE LATZA NADEAU

MUNCH AND OSLO 160
NORWAY BY LEA FEINSTEIN

INDEX + CREDITS 200
CONTRIBUTORS + ACKNOWLEDGEMENTS 206

ICON KEY	⌂ address	💻 website	○ open
	☎ telephone	$ cost	● closed

VAN GOGH and Arles

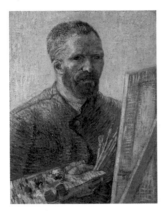

In a career that lasted only 10 years, Dutch-born Vincent Van Gogh created some of the best-loved paintings in modern art. Many of his most dazzling canvases were completed in the year he spent in Arles, a sunny village in the south of France. Exhausted by his hard-drinking, hard-living days in Paris, he was hoping to create an idyllic artists' community in Arles. The first, and only, artist to join him there was Paul Gauguin and the plan ended badly for both their friendship and Van Gogh's left ear. Van Gogh produced an amazing amount of inspired work in Arles, including what may be the only painting he was able to sell in his brief career. Yet his struggle with mental illness proved too much for him and he took his own life at 37.

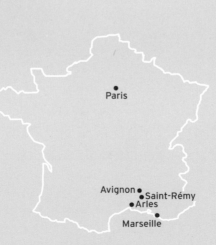

Paris

Avignon
Saint-Rémy
Arles

Marseille

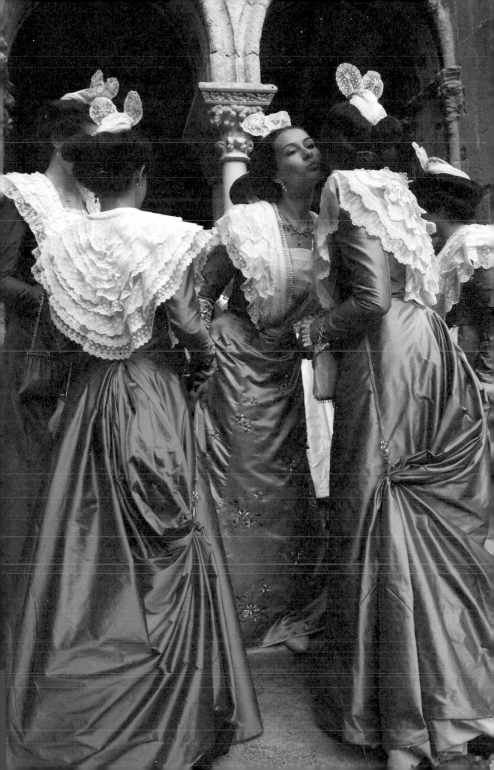

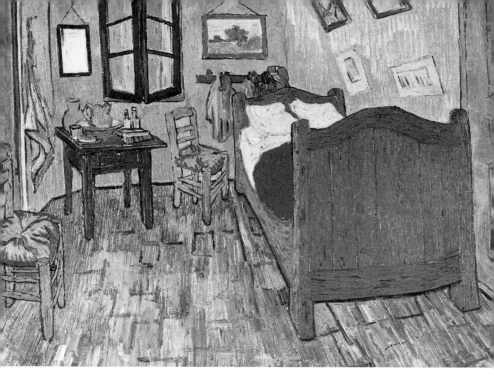

BY KRISTIN HOHENADEL

The light changes palpably on a high-speed train heading south from Paris to Provence. The landscape brightens, fields of sunflowers rush by, and a sense of déjà vu sets in as a 3-D rendering of Vincent Van Gogh's vision of southern France materializes in all its vivid poetry.

In February of 1888, the Dutch artist boarded a train to make this same journey, fleeing gray Paris to seek out the shock of Provençal color and light. But before he painted the now-iconic images of sunflowers and wheat fields and nights lit with stars that flame like miniature suns, the 35-year-old Dutchman found himself snowed in for three weeks of uncharacteristically wintry Provençal weather. Legend has it that Arles was just a stop on a journey to Marseille to meet the painter Adolphe Monticelli, whose work he greatly admired. Van Gogh ended up staying for 15 months in Arles, a pretty, scrappy town in Camargue, with its Roman ruins and bullfighters, soldiers, and women in Arlesian costume.

Bedroom at Arles (1888) Van Gogh Museum, Amsterdam
[next page top] *Van Gogh Painting Sunflowers* (1888) by Paul Gauguin
[previous spread] *Self-Portrait* (1888), Van Gogh Museum; **Arlésiennes** by Christophe Loviny

Marooned for those first few weeks in his room at the restaurant/hotel Carrel, he painted the view from its window and the woman at the front desk. The wintry landscapes reminded him of the Japanese prints he so admired. In the spring, the artist moved to a yellow house on the Place Lamartine; he dreamed of turning it into an artists' compound and embarked on a period of frenzied productivity—he made some 300 paintings and drawings here—and unprecedented madness.

At that point in his life, nobody could have predicted that the then-obscure Van Gogh was at work on the handful of paintings, now scattered around the world, that would earn him posthumous status as one of the world's most celebrated, influential, and high-grossing artists. Especially not the people of Arles, who, when they noticed him at all, saw what looked like an unwashed, half-starved, perpetually drunk, redheaded, raving-mad foreigner. They never imagined they had a genius in their midst.

The story of Van Gogh has always been irresistible from a human perspective, because the man died penniless (having sold exactly one painting), taking his own life in a fit of despair in July 1890, at the age of 37. Born in Holland in 1853, he

SUNFLOWERS

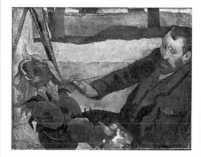

In August 1888, Van Gogh embarked on this series of sunflowers as decoration for the guest room for Paul Gauguin in the Yellow House. Each painting became increasingly brighter, culminating with the fourth canvas, currently at the National Gallery in London. Here a bright yellow background replaces the blue of the previous versions. Three repetitions of the third and fourth versions were painted the following winter.

The Arles *Sunflowers* are so closely tied to Van Gogh that they have become among the most valuable canvases ever painted. A repetition of the fourth version (yellow background) sent shockwaves through the art market in 1987, when it sold for nearly $40 million at auction—more than quadruple the previous record. It didn't hold long though, another Van Gogh was sold shortly thereafter for over $50 million.

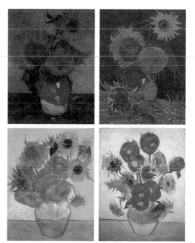

> [clockwise from top left] *Sunflowers* **First Version, Second Version,** destroyed by fire in WWII, **Fourth Version,** and **Third Version**

was the son of a pastor and was drawn from an early age to religion and art. He tried and failed to become a man of God like his father and an art dealer like his uncle, dabbling as a bookseller and English teacher along the way. Eccentric, sensitive, off-puttingly intense, and unlucky in love, he seemed to be constantly rejected by the world. At the age of 27, largely inspired by the socially conscious work of Jean-François Millet, he decided to become a painter. In 1886 he went to Paris, where his younger brother, Theo, an art dealer, introduced him to the Impressionists, encouraged him to paint, and funded his trip to Arles.

In Arles, the late-blooming, self-taught artist, who had now absorbed the lessons of the Impressionists and the pointillism of Seurat, experimented with his own Post-Impressionist style. His developing Expressionist technique rendered ordinary things—a vase of sunflowers, his own bedroom in Arles—in intense colors and muscular brushstrokes that distorted the ordinary, transforming it with a heightened emotion that both reflected the sentiment of the artist and stirred deep feeling in the spectator. His earlier

Sunflower field in **Provence**

TIMELINE

YOUTH
1853-1880

March 30, 1853
Vincent Van Gogh is born in Zundert, The Netherlands

July 1869
Begins an apprenticeship with global art dealers Goupil & Cie

August 1872
Works at The Hague branch and begins correspondence with his brother Theo

June 1873
Moves to the London Goupil & Cie branch

1874
Transfers to Paris for three months and then heads back to England

May 1875
Travels to Paris again and is inspired by art he sees there

March 1876
Dismissed from Goupil & Cie, decides to become a clergyman and returns to England to teach

1877
Moves to Amsterdam and attempts to enroll in theology school

December 1878
Gives up his studies and then heads to Borinage, a coal-mining district near

Brussels, to work as a preacher

YOUNG ARTIST
1880-1885

1880
Van Gogh decides to become an artist and moves to Brussels

1881
Takes painting lessons from his cousin Anton Mauve, a member of the Hague School

March 26, 1885
Van Gogh's father dies; he completes *The Potato Eaters*

January 1886
Enrolls in Royal Academy of Fine Arts Antwerp for training, but grows impatient and withdraws two months later

PARIS 1886-1888

February 27, 1886
Van Gogh arrives in Paris

1886
Theo introduces Van Gogh to the works of Claude Monet and the Impressionists

Van Gogh studies with Fernand Cormon

Meets and befriends Paul Gauguin, Henri de Toulouse-Lautrec, Émile Bernard, Camille Pissarro and John Russell

Perfects his skills in self-portraits and experiments in color

1887
Organizes a group show of his and his friends' paintings at a Paris restaurant

ARLES 1888-1889

February 19, 1888
Van Gogh boards a train for Provence and gets off at Arles

1888
Rents the Yellow House, hopes to establish artist colony, and invites Gauguin to join him (he paints *Sunflowers* in anticipation of his arrival)

October 1888
Gauguin arrives and remains for nine weeks

December 1888
Tensions between Van Gogh and Gauguin hit a breaking point

Van Gogh cuts off his left earlobe, is admitted to the hospital, and remains there until January 1889

SAINT-RÉMY
1889-1890

May 1889
Van Gogh voluntarily commits himself into a psychiatric hospital and converts his cell into a studio

1890
Creates masterpieces *Irises, Cypresses,* and *Starry Night* and sends them to Theo in Paris

AUVERS-SUR-OISE
1890

July 27, 1890
Van Gogh walks into a wheat field and shoots himself. He staggers back to his room, where two days later, on July 29, he dies with Theo at his side

> ^ **Place Lamartine** and *The Yellow House* (1888)
> › *The Church at Auvers* (1890) Musée d'Orsay, Paris

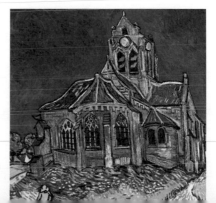

work had been somber and grim (like *The Potato Eaters* (1885), which was based on his time spent evangelizing among poor Belgian miners, and which many consider his first great work of art). But in Arles he finally found the light, what he described in a letter to Theo as "the high yellow note." (Some historians have suggested that his obsession with yellow may have come not only from the light of the south but from chemicals firing in his brain high on too much absinthe, which caused him to hallucinate and is thought to produce a sort of yellow vision when taken to excess.)

Van Gogh never achieved his vision of establishing an artists' commune at the Yellow House, a wish he articulated to Theo in a letter: "If I could find another painter inclined to work in the South, and who, like myself, would be sufficiently absorbed in his work to be able to resign himself to living like a monk who goes to the brothel once a fortnight—who for the rest is tied up in his work, and not very willing to waste his time—it might be a good job. Being all alone, I am suffering a little under this isolation."

He painted those ubiquitous sunflowers—reproductions of which now hang on the walls of bedrooms the world over—to decorate his guest room for Gauguin, who joined him in Arles in October of 1888. Famously, things did not go well. The psychotic episode that resulted in Van Gogh attacking Gauguin and lopping off his own earlobe—which he presented to a prostitute named Rachel—is one of the art world's most memorable anecdotes. That story was recently challenged by a pair of German art historians who claimed that it was Gauguin who sliced off Van Gogh's earlobe with a sword. This claim has been refuted by descendants of the doctors who treated Van Gogh at the time, who insist that the scientific and historical evidence prove that the injury could only have been the self-inflicted result of a moment of violent rage.

"I think the Germans have a book to sell," says Pierrette Nouet, a city guide who has been giving Van Gogh tours for a decade. "And we've said so much about Van Gogh that every so often you have to find something new to say about him. In one sense it's good because it shows that he's an artist who, 100 years

MOVIES

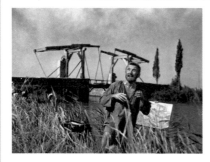

ON LOCATION
Lust for Life (1956)
Director: Vincente Minnelli
Based on the best-selling novel by Irving Stone, Vincente Minnelli's biographical account of Van Gogh's life stars Kirk Douglas as the tortured artist and Anthony Quinn as the fiery Paul Gauguin (a performance for which he won an Oscar). Filmed in the real-life locations where the artist lived and worked—a point emphasized even in the film's 1956 trailer—Lust for Life follows Van Gogh from the coal mines of Belgium to the French countryside, capturing the scenes depicted in his work along the way. From a table of potato-eating peasants to women washing clothes by the Pont de Langlois bridge in Arles, Minnelli's cinematic recreations of the paintings are painstakingly true to the originals. The director even went so far as to spray-paint a Provençal field yellow to better match Van Gogh's vision.

Vincent: The Life and Death of Vincent Van Gogh (1987)
Director: Paul Cox
A passionate documentary about the artist, narrated by actor John Hurt, it relays the story of Van Gogh's turbulent life through his letters and work.

Vincent and Theo (1990)
Director: Robert Altman
This biographical film, originally developed as a miniseries for European television, explores the relationship between the artist and his brother through their trials, tribulations, and emotional struggles.

Vincent, The Full Story: A Documentary (2004)
Director: Waldemar Januszczak
This documentary delves into the artist's life and achievements. It is divided into three parts: "From Vincent's Birth to His Masterpiece," "From the Early Paintings to Arles," and "From Arles to Suicide."

The Eyes of Van Gogh (2005)
Director: Alexander Barnett
This film explores the story of the 12 months the tormented artist spent in the insane asylum at Saint-Rémy through visceral images of hallucinations, memories, and dreams.

Van Gogh (1991)
Director: Maurice Pialat
The final months of the artist's turbulent life are chronicled in this compelling account starring French actor Jacques Dutronc in a passionate and emotionally charged performance.

Dreams (1990)
Director: Akira Kurosawa
This film, based on eight of the director's dreams, takes a journey through magical realism from the lyrical to the apocalyptic. "Crows" features director Martin Scorsese as Vincent Van Gogh and tells the story of an art student who finds himself inside the artist's work and converses with him in a field. The student then loses sight of Van Gogh and travels through other works in the hopes of finding him.

Starry Night (1999)
Director: Paul Davids
This comedy offers an innovative premise: A woman makes a magic potion that can bring people back from the dead, and Vincent Van Gogh is the first person on the list. Once alive, he is disoriented and shocked to find his work so valuable and well known. He starts stealing whatever he can from galleries and collectors and has a difficult time getting people to believe who he is.

later, can still stir up debate." Nouet is careful to point out that Van Gogh did sell one painting for "100 francs, which wasn't nothing at the time." She cites a good review that was published before his death, challenging the notion that he died in total obscurity. "He wasn't a martyr," she says. "Maybe the Arlesians didn't like him because he acted crazy, drank 70 percent absinthe, screamed all night. But he wasn't unloved—that's a legend. He was unknown," she adds. "Once he became famous, everybody suddenly had a grandfather who knew him. But it wasn't true." (As it happens, the world's oldest woman, Jeanne Calment, who died in 1997 at the age of 122, was an Arlesian. She claimed she remembered seeing Van Gogh in her uncle's shop buying paint supplies, recalling him as "dirty, badly dressed, and disagreeable.") Nouet, 58, says that they didn't learn about Van Gogh when she was in school. As a teenager, she had a one-eared dog named after the artist, and she says that people were always asking her to explain the funny name.

It's because of tourists from around the world that the city finally decided to offer walking tours tracing Van Gogh's steps, she says. "When tourists arrive, they ask two things: 'Where is his house?' and 'Where is the Van Gogh Museum?'" says Nouet. "The house was bombed in '44. And they're always disappointed when you say that the Van Gogh Museum is actually in Amsterdam." Visitors are even more shocked to learn that the city does not possess a single canvas painted by Van Gogh. Not even *L'Arlésienne* (1888), which, to the chagrin of the locals, is housed at the Musée d'Orsay in Paris.

The Vincent Van Gogh Foundation is a small private museum in Arles that was established by Yolande Clergue in 1983 to help fill that void. It is full of commissioned paintings, photographs, and other creative work inspired by Van Gogh. Works by David Hockney, Francis Bacon, Fernando Botero, and many other contemporary artists attest to the artist's legacy and lasting influence on contemporary art. Tourists are sometimes outraged to realize that the foundation doesn't have any works by its namesake artist, says communications director Souraya Abifarès one afternoon after leading a group of preschool-age children on a tour.

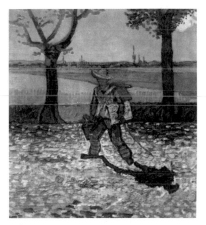

^ **Painter on the Road to Tarascon** (1888), formerly at the Kaiser-Friedrich Museum, Magdeburg, destroyed by fire in World War II

"There are kids who have some initiation about art, and they know the *Sunflowers* and *Starry Night* (1889), but not a lot, frankly," says Abifarès. "We work with schoolchildren because it's not just a museum for adults and to make money—it also has a pedagogical mission to educate children about who Van Gogh was and to encourage young people to become interested in art. Nobody believed in Van Gogh, but we want to believe in young people, to encourage them in ways that Van Gogh was never encouraged." In the museum is a copy of the petition signed by a few dozen of Van Gogh's neighbors, who begged the mayor to send the crazy man back to his own family. "The descendants of those people now cringe to think, 'We had a genius among us, and what did our grandparents do?'" says Abifarès. "If Arles is known around the world, it's because of Van Gogh."

Nobody is sure why he got off the train in Arles, a town that was not associated with art. When he lived there, the last famous artist had been Jacques Réattu, a painter who died 20 years before Van Gogh was born and whose name is attached to the Musée Réattu, a contemporary art space perched on the banks of the Rhône. It was the first museum in France to house a permanent photography collection, and it now holds 57 drawings donated by Picasso.

Modern-day Arles has become an international photography capital, with an annual international photography show, Les Rencontres d'Arles. It is also known for its small but influential publishing house, Actes Sud, which focuses on international writers; the Frank Gehry–designed renovation of the former SNCF train repair shops, which will become a major arts complex and second downtown; and the recently bankrupt but widely admired fashion designer Christian Lacroix, who is today's most famous Arlesian. "It's a beautiful city that has stayed authentic," Nouet says. "It's not a museum. When kids skateboard against the walls of the Antique Theater and people transform the outside of the amphitheater into a parking lot, that's not good. On the other hand, it's not a sanctuary that opens at 8:00 a.m. and closes up at night."

And while you can't help but notice the city's Roman ruins (a UNESCO World Heritage site), searching for a trace of Van Gogh is a more challenging proposition. "I call this a virtual tour," Nouet says, pointing out that the Roman ruins and archaeology didn't interest Van Gogh. "The problem is that the town was bombarded in '44, and the places where he lived, slept, and ate are mostly destroyed," she explains. Nevertheless, art lovers from around the world continue to make the pilgrimage to this city of 53,000 inhabitants, bent on chasing his ghost.

> **Pont de Langlois**, nicknamed the Van Gogh Bridge

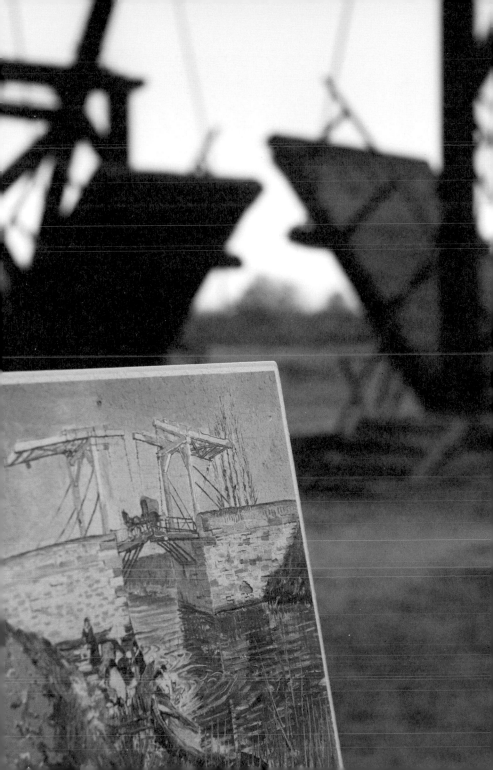

AIRPORTS: ✈
Marseille Provence Airport
☎ 33 4 42 14 14 14
🖥 www.marseille.aeroport.fr

Paris to Arles
If you are heading to Arles from Paris, the trip is pretty simple. To journey by train, take the TGV from Paris-Gare de Lyon to Avignon-TGV station (2 hours, 40 minutes) and then a shuttle bus to Arles. If you take the TGV direct from Paris-Gare de Lyon to Arles, it takes 4 hours.

TRAIN: 🚆
TGV France
☎ 33 (0) 8 92 35 35 35
🖥 www.tgv.com

SNCF d'Arles
☎ 33 (0) 8 36 35 35 35
🖥 www.sncf.fr

BUS: 🚌
Arles Bus Station
☎ 33 (0) 4 90 49 38 01

TAXI: 🚕
Arles Taxi Radio
☎ 33 (0) 4 90 96 90 03

TOURISM OFFICE: 🌐
Office de Tourisme
🏠 Boulevard des Lices
☎ 33 (0) 4 90 18 41 20
🖥 www.arlestourisme.com
○ Mon-Sat 9AM-4:45PM;
Sun 10AM-1PM

FOR YOUR INFORMATION...

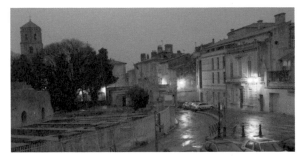

Arles, a UNESCO World Heritage Site, was a 6th-century BC Greek colony that later became a thriving city and stronghold in Roman Gaul. It is home to monuments, museums, festivals, bullfights, and joie de vivre. Situated on the banks of the Rhône River and gateway to the untamed Camargue marshlands (home of the wild Camargue horses and the French cowboys who ride them), Arles combines the natural beauty that attracted such artists as Van Gogh and Gauguin with a rich heritage of important Roman, Christian, and 17th-century architectural sites and monuments. Proud of its heritage and traditions, Arles hosts dozens of historic and cultural festivals during the spring and summer months, as well as some of the most important and colorful bullfighting contests in France.

Weather 🌐

There are two types of wind that blow in Arles: a wind from the south and a wind from the north, which is called the Mistral and dispels the clouds. The winds are unpredictable and can blow anytime in the year. The weather in Arles is mild. Summers are hot (July and August) and winters (January and February) are not very cold. Thus the best period to visit might be late spring (April and May), when it's moderate.

⌃ [top] **Arles** at dawn [bottom] **Fontaine A. Pichot**

BEFORE YOU GO, GET IN THE KNOW: SUGGESTED WEBSITES AND BOOKS

WEBSITES

Arles Office of Tourism
💻 www.tourisme.ville-arles.fr

The official website for the tourism office in Arles provides general information, such as maps, weather, and access, as well as dining and accommodation suggestions. There's also a virtual tour, calendar of events, and recommended activities and sights to see.

Van Gogh Museum
💻 www.vangoghmuseum.nl
The Van Gogh Museum houses the largest collection of Van Gogh's art in the world, and its website features a wealth of information about the artist. It also has sections for education, research, and children.

Vincent Van Gogh Gallery
💻 www.vggallery.com
Endorsed by the Van Gogh Museum in Amsterdam, this website is a comprehensive resource for the artist's body of work and letters. It also offers biographical information, exhibition and auction information, as well as cultural events.

Vincent Van Gogh Foundation
💻 www.fondationvangogh-arles.org
Currently only in French, this website features information about the small private museum in Arles that was established in 1983 to honor the artist's life and influence.

BOOKS

The Complete Van Gogh
by Jan Hulsker (Crescent, 1985)
Art historian Jan Hulsker, awarded the Royal Netherlands Academy of Sciences' distinguished silver medal for his contribution to Dutch art and literature, has written several books on Van Gogh. This one is considered to be the authoritative catalogue of the artist's works.

Van Gogh: His Life and His Art
by David Sweetman (Touchstone, 1990)
A biographical account of the artist's life and work based primarily on the correspondence of Van Gogh, his brother Theo, and his friends. It also incorporates research from scholars and social history.

The Yellow House: Van Gogh, Gauguin, and Nine Turbulent Weeks in Arles
by Martin Gayford (Little, Brown and Company, 2006)

This dramatic biographical account, from the renowned art critic Martin Gayford, delves into the brief period Van Gogh and Gauguin shared a home together in Arles, what masterpieces were created during this time, and what happened to each of them as a result of the experience.

Van Gogh in Arles
by Ronald Pickvance (The Metropolitan Museum, 1984)
This book, which also has a companion edition (*Van Gogh in Saint-Rémy and Auvers*), features excellent images of the artist's paintings and drawings, as well as insightful commentary from its author, a renowned Van Gogh scholar.

Vincent Van Gogh: Life and Work
by Dieter Beaujean (Könemann, 1999)
An examination of the artist's legacy through masterpieces such as *Sunflowers, The Bridge at Langlois, The Postman Roulin, Vincent's Chair, Café Terrace on the Place du Forum Night*, plus 11 other paintings.

CALENDAR...YEARLY EVENTS

FERRIAS CORRIDAS / BULLFIGHTS
🏛 Arles Amphitheater
☎ 33 (0) 8 91 70 03 70
🖥 www.arenes-arles.com

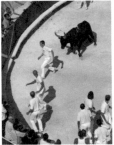

FÊTE DES GARDIANS / CAMARGUE COWBOYS FESTIVAL
🏛 Various locations throughout city
☎ 33 (0) 4 90 18 41 20

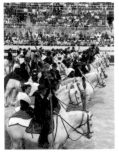

LES RENCONTRES D'ARLES / INTERNATIONAL PHOTOGRAPHY FESTIVAL
🏛 Various locations throughout city
☎ 33 (0) 4 90 96 76 06
🖥 www.rencontres-arles.com

Ferrias Corridas / Bullfights (April and September)

Traditional bullfights in the Roman arena of Arles—known as Feria Corridas—are held around Easter time and then again at the end of September. Between those dates you can also see Camargue-style fighting, teams of bullfighters who try to remove a tassel from a bull's horn (without killing the bull).

Fête des Gardians / Camargue Cowboys Festival (May)

The Camargue, which borders on Arles, is the marshy delta area of the Rhône River. It is also the Wild West of France, home to black bulls, wild white horses, and the French "cowboys," known as Gardians, who ride the horses and herd the bulls. During the Festival of Gardians, which dates back to 1529 and is held in Arles each May, dozens of Camargue cowboys ride their horses through the streets of Arles and take part in a parade, races, games, and the traditional Provençal bullfights where several acrobatic cowboys try to snatch a flower from between the bull's horns.

Les Rencontres d'Arles / International Photography Festival (July)

The International Photography Festival is held every July, filling the historic structures of Arles with retrospectives and work by some of the most prominent names in photography as well as by promising contemporary newcomers.

Les Suds à Arles: Festival de Musique du Monde / Arles South: International Music Festival (July)

A ritual since 1996, the international music festival known as "Les Suds" brings together performers from all over the world for concerts as well as courses in dance, music, and voice.

Fête du Costume / Costume Festival (July)

The beauty of traditional 19th-century Arlesian costumes—immortalized in many of Van Gogh's works—is celebrated in the annual Costume Festival, which takes place in the

Roman Amphitheater on the first Sunday in July. Women of all ages participate, wearing their best long full skirts, lacy capelets, and be-ribboned bonnets. On the last Friday evening in June, hundreds of men, women, and children also don traditional costumes for the "Pegoulado," a long torch-lit parade down the Boulevard des Lices.

Les Prémisces du Riz / The Rice Festival

(September)

For three days each September, the cobbled streets of Arles are transformed into a colorful Spanish-style fiesta as bulls run and steam rises from giant vats of paella for the annual Rice Harvest Festival. Some of the best Spanish toreadors come to Arles for Spanish-style bullfighting in the picturesque Roman arena, which usually hosts traditional Provençal-style fights. As the bulls are killed, their fresh meat is distributed to the best local restaurants, which use it to create specialty dishes each night. Other highlights include parades with the famous horses and cowboys of the Camargue, the crowning of a "Rice Ambassadress," and folk dancing with women wearing the traditional Arlesian costumes and lace headdresses that were painted by Van Gogh.

LES SUDS À ARLES: FESTIVAL DE MUSIQUE DU MONDE/ ARLES SOUTH: INTERNATIONAL MUSIC FESTIVAL

⌂ 66 rue du 4 Septembre
☎ 33 (0) 4 90 96 06 27
🖥 www.suds-arles.com

FÊTE DU COSTUME / COSTUME FESTIVAL

⌂ Roman Amphitheater
🖥 www.festivarles.com

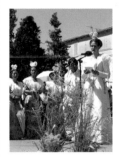

LES PRÉMISCES DU RIZ/ THE RICE FESTIVAL

⌂ Various locations throughout city

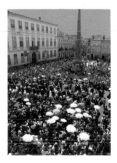

LA REINE D'ARLES / THE QUEEN OF ARLES

Since 1930, every three years in May, during the Fête des Gardians, a jury of seven people elects a symbolic First Lady of the city of Arles. Chosen from among the young women who come from old Arlesian families, "La Reine d'Arles," or Queen of Arles, must have been born in Arles, speak Provençal dialect, and be familiar with the traditional customs and folklore of Provence. The young Queen and her maids of honor, wearing the elegant traditional costumes of Arlesian women made famous in the paintings of Van Gogh and Gauguin, lead the opening ceremonies for most of the traditional summer events and festivals in Arles. 🖥 www.reinedarles.com

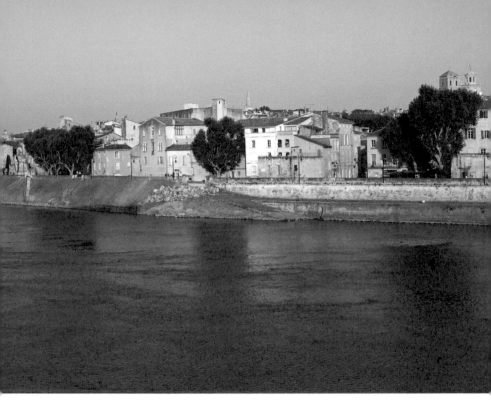

BY KRISTIN HOHENADEL

While none of Vincent Van Gogh's original works remain in Arles, the city has consecrated him as its poster boy by installing a series of plaques with reproductions of his most famous works in the spots where he most likely set his easel. The following is a scenic tour of the most worthwhile sites in the city center, easily walkable in an hour or two on foot. The office of tourism in Arles offers free guided group tours twice a week and, for a fee, private two-hour tours by appointment.

WALKING TOUR

If you arrive in Arles by train, your walking tour of Van Gogh's stomping grounds begins a few minutes' walk from the train station, at the epicenter of Van Gogh's former neighborhood, outside the 15th-century gates that lead into town.

˄ **Arles on the Rhône River**

Today the **Place Lamartine** is an unremarkable traffic roundabout with parking lots and a Monoprix supermarket. But this is the site of the mythical Yellow House, immortalized in the painting of the same name (now at the Van Gogh Museum in the Netherlands), which was destroyed by wartime bombs in 1944. "What a powerful sight, those yellow houses in the sun and then the unforgettable clarity of the blue [sky]," the artist wrote to Theo. The house also contained his famous bedroom.

Nearby was the site of the **Café de la Gare**, owned by Joseph-Michel Ginoux and his wife Marie (pictured in *L'Arlésienne* (1888)), whose interior is the subject of *The Night Café* (1888). The painting is now at the Yale University Art Gallery, in New Haven, Connecticut. Van Gogh was known to sign only paintings he was proud of; he signed this one "Vincent le café de nuit."

A short walk from the Place Lamartine, on the expansive **banks of the Rhône River**, you can find the spot where Van Gogh perched to paint *Starry Night over the Rhône* (1888), now at the Musée d'Orsay in Paris. A walk along the river is a welcome antidote to the charming, if cramped, confines of the city. Unfortunately, if you go at night, the stars are often imperceptible because of pollution.

Also a short walk away, outside the **Arles Amphitheater**, is a reproduction of *Les Arènes* (1888), now at the State Hermitage Museum, in St. Petersburg, Russia. Van Gogh painted this work from memory a few months after bullfighting season was over. The spectators are the heroes and heroines of the painting, the bulls and bullfighter merely brushstrokes in the background. Today the amphitheater is used for bullfights twice a year and for la course camarguaise, a nonviolent competition between man and beast in which young bullfighters in training snatch pom-poms from a bull's head, then run away and jump like acrobats onto the stadium's barriers.

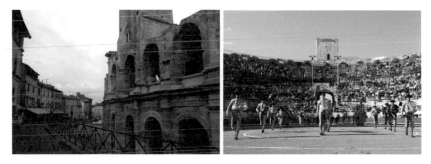

˄ **Arles Amphitheater** and **Paseo**

Opposite the amphitheater is the **Vincent Van Gogh Foundation**, a small private museum that honors Van Gogh's influence and features tribute works by contemporary artists including David Hockney and Francis Bacon.

Making your way to the public garden, **Jardin d'Été**, on Boulevard des Lices opposite the tourism office, you will find a hollow life-size bronze bust of Van Gogh, a commission realized by William Earl Singer in 1966. Careful observers will note that the statue shows Van Gogh without a left earlobe, contradicting his self-portraits that show his right earlobe missing. Police reports from the incident in which Van Gogh supposedly cut off his lobe with a razor confirm that it was the left; art historians believe the discrepancy can be traced to Van Gogh's use of mirrors to paint his self-portraits.

Elsewhere in the garden, you will find a reproduction of *L'entrée du Jardin Public à Arles* (1888), which is now part of the Phillips Collection in Washington, D.C. If you look carefully, you will see that the painting does not correspond to the immediate surroundings. Historians aren't sure whether the work depicts this garden or another closer to the Place Lamartine that no longer exists. But with its tall trees, blue sky, and strolling Arlesians, the spot captures the spirit of the painting on a sunny midsummer afternoon.

The hospital where Van Gogh was sent to recover after slicing off his earlobe is now a médiathèque. It has been renamed **Espace Van Gogh**, and its

Detail of **Église St-Trophime**

courtyard arches have been painted yellow to more closely mimic the canvas that Van Gogh painted from memory of his view from the window. It's a pretty spot with a fountain and seasonal flowers, and there are plenty of inexpensive postcards on sale nearby.

End your tour at the **Place du Forum**, where the most recognizable Van Gogh sites still exists: the **Café La Nuit (Café Van Gogh)**, the setting of *Café Terrace on the Place du Forum* (*Café Terrace at Night*) (1888), one of his most famous paintings, reproductions of which hang in coffee shops from Naples to Beijing. Locals advise that you settle onto the terrace of the **Grand Hotel Nord-Pinus** a few steps away, once the haunt of Hemingway, Picasso, and celebrity bullfighters, and now the hippest bobo hangout in town.

Further off the beaten path are the **Pont de Trinquetaille** (L'escalier du pont de Trinquetaille), **Le vieux moulin (Old Mill)** on rue Mireille, the cemetery of **Les Alyscamps** (also painted by Gauguin during his time in Arles), and the **Pont de Langlois** (also known as the Van Gogh Bridge), which was displaced to the south of the city after postwar reconstruction.

Espace Van Gogh

WHERE TO SEE...THE WALKING TOUR

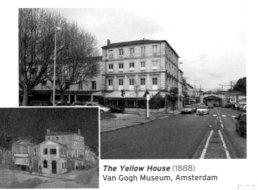

The Yellow House (1888)
Van Gogh Museum, Amsterdam

1 **Place Lamartine**
The Yellow House, the home that Van Gogh lived in during most of his time in Arles, once stood on the Place Lamartine.

3 **Les Arénes d'Arles /
Arles Amphitheater**
⌂ Rond-Point des Arènes
☎ 33 (0) 8 91 70 03 70
○ Summer 9AM-6PM
Winter 10AM-4:30PM
$ 6 Euros
Dating back to Roman times, the Amphitheater is where many cultural events occur over the course of the year, including the famous bull fights.

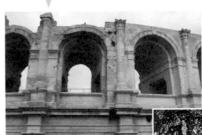

Les Arénes (1888)
The State Hermitage Museum,
St. Petersburg

5 **Fondation Van Gogh /
Van Gogh Foundation**
⌂ 24 bis, Rond-Point des Arènes
☎ 33 (0) 4 90 49 94 04
🖥 www.fondationvangogh-arles.org
○ Apr-Jun 10AM-6PM
Jul-Sep 10AM-7PM
Oct-Mar 11AM-5PM
$ 6 Euros
This small, private museum honors Van Gogh with work by contemporary artists.

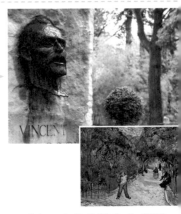

Entrance to the Public Garden (1888)
The Phillips Collection, Washington D.C.

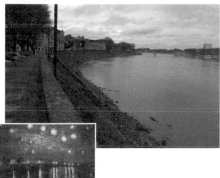

2 **Banks of the Rhône River**
The place where Van Gogh stood to paint the famous *Starry Night Over the Rhône* is a lovely place to walk along to get away from the hustle and bustle of Arles central.

Starry Night over the Rhône (1888)
Musée d'Orsay, Paris

4 **Espace Van Gogh /**
Van Gogh Space
⌂ Place du Docteur Félix Rey
☎ 33 (0) 4 90 49 39 39
○ Tue-Wed, Fri-Sat 8AM-6PM
The gardens at the hospital where Van Gogh recovered after chopping off his own ear were an inspiration for many works.

Le Jardin de la Maison de Santé a Arles (1889)
Private Collection

6 **Jardin d'Été**
Boulevard des Lices
This public garden featuress a bronze bust of Van Gogh, sans his ear.

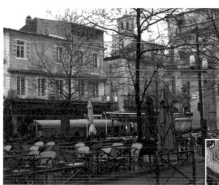

7 **Place du Forum**
11 Place du Forum
The Place du Forum is where you'll find the so-called Café Van Gogh, made famous by the painting *Café Terrace at Night*.

Café Terrace on the Place du Forum (Café Terrace at Night) (1888)
Kröller-Müller Museum, Otterlo

27

**LES ALYSCAMPS /
ALYSCAMP CEMETERY**
⌂ Rue Pierre-Renaudel
☎ 33 (0) 4 90 49 36 87
🖳 www.tourisme.ville-arles.fr
○ Jun-Sep 8:30AM-7PM
Oct & Mar 9AM-12:30PM,
2PM-6PM; Nov-Feb
9AM-12PM, 2PM-4:30PM;
Apr 9AM-12:30PM, 2PM-
6:30PM; May 9AM-12:30PM,
2PM-7PM
$ 3.50 Euros

1 Les Alyscamps / Alyscamp Cemetery

Les Alyscamps (from the Latin for "Elysian Fields"), located a short distance from the walls of the old town of Arles, was one of the most famous Roman necropolises of the ancient world. Coffins were shipped from all over the empire to be buried there, in simple sarcophagi or elaborate monuments. Now an outdoor museum, Les Alyscamps was also the spot chosen by Vincent Van Gogh and Paul Gauguin for their first open-air painting expedition after Gauguin joined Van Gogh in Arles.

2 Pont Van Gogh / Van Gogh Bridge

The Van Gogh Bridge (Pont de Langlois) is a reconstruction of the wooden drawbridge that Van Gogh sketched and painted many times in the months after he arrived in Arles in 1888. The best known being his painting *Bridge at Arles*. The original wooden bridge—which crossed the Canal d'Arles just south of town, and was frequented by washerwomen—had been built by a Dutch engineer, so it may have reminded Van Gogh of his native Holland. In 1930 the wooden bridge was replaced by a concrete

> ⌃ **Les Alyscamps**
> ⌃ The Alyscamp Cemetery was one of the first works that Van Gogh painted (top)
> following the arrival there of his friend and mentor Paul Gauguin (bottom).

version that was destroyed during the war in 1944. A replica of the original wooden drawbridge was constructed in 1962, a few kilometers away from the original site, and was made a French national monument in 1988.

3 Église St-Trophime / Church of St. Trophime

The Church of St. Trophime (Trophimus) is a Roman Catholic church and former cathedral. A masterpiece of Romanesque architecture, it was built between the 12th and 15th centuries on the site of an earlier basilica.

4 Théâtre Antique

The Théâtre Antique is a Roman theater commissioned by Emperor Augustus in the 1st century AD. While the foundations can be seen, only two full Corinthian columns remain standing. In 1651, workmen digging a well on the site discovered a statue known as the "Venus of Arles," a Roman copy of a Hellenistic masterpiece. The marble sculpture, which is over 6 feet high, was in several pieces when it was uncovered, but King Louis XIV had it restored, and it is currently on display in the Louvre.

PICASSO IN ARLES

Though Pablo Picasso spent a good part of his life in political exile in France, he was a Spaniard through and through and loved the corrida. The last 12 years of his life were spent in the village of Mougins, and from there he would often travel with his coterie of friends to see the bullfights in the Roman arena in nearby Arles. Bullfights were an ongoing subject in his work, and many of his later paintings and drawings were inspired by the spectacles he saw in Arles. Picasso was also deeply connected to Arles through his love of Van Gogh's work. Van Gogh's influence can be seen in many of Picasso's own paintings and drawings, but nowhere more clearly than in his witty *Portrait of Lee Miller as an Arlésienne* (1937)—an homage to Van Gogh's *L'Arlesienne* series—which is hanging in the Réattu Museum in Arles. Picasso very generously donated 57 drawings to the Réattu Museum when it organized a Picasso exhibition in 1971, two years before his death, and his *Portrait of Maria* (his mother), painted in 1932 and donated by his last wife, Jacqueline, is also part of the Réattu's permanent collection.

PONT VAN GOGH / VAN GOGH BRIDGE
⌂ Route du Pont de Langlois
Directions: From the center of Arles, drive south on D35 toward Port Saint-Louis du Rhône. After approximately 2 miles, look for small signs for the Pont Van Gogh.

THE ÉGLISE ST-TROPHIME / CHURCH OF ST. TROPHIME
⌂ Place de la République
☎ 33 (0) 4 90 49 36 74
○ Daily 8:30-6PM; Cloister Mar-Apr 9AM-6PM; May-Sep 9AM-7PM; Oct 9AM-6PM; Nov-Feb 10AM-5PM
$ 3.50 Euros (Cloister)

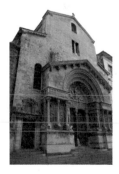

THÉÂTRE ANTIQUE
⌂ Rue du Cloître
☎ 33 (0) 4 90 93 05 23
○ Mar-Apr 9AM-6PM; May-Sep 9AM-7PM; Oct 9AM-6PM; Nov-Feb 10AM-4:30PM
$ 3 Euros

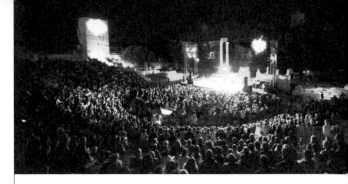

MUSÉE DÉPARTEMENTAL DE L'ARLES ANTIQUES / ARLES MUSEUM OF ANTIQUITY
🏠 Presqu'ile du Cirque Romain
☎ 33 (0) 4 90 18 88 88
🖥 www.arles-antique.cg13.fr
◯ Apr-Oct 9AM-7PM Nov-Mar 10AM-5PM;
● May 1, Nov 1, Dec 25, Jan 1
$ 5.50 Euros

Plaine de la Camargue
near by **Arles**

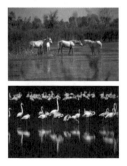

5 Musée Départemental de l'Arles Antiques / Arles Museum of Antiquity

(aka The Musée de l'Arles Antique or Musée de l'Arles et de la Provence Antiques) The Arles Museum of Antiquity, which sits beside the ruins of the Roman Circus, opened in 1995 and contains a collection of over 600 artifacts that date from prehistory to the 6th century AD, including what's thought to be the oldest known bust of Julius Caesar, which was found in 2008 on the banks of the Rhône in Arles.

UNESCO

Arles, dubbed "Little Rome in Gaul," has a collection of Roman monuments second only to those of Rome itself and since 1981 has been listed as a UNESCO World Heritage Site (sites UNESCO helps preserve because of their "outstanding value to humanity"). Arles, which had been colonized by Greeks in the 6th century BC, wisely allied itself with Julius Caesar who rewarded Arles by making it a Roman colony and lavishing it with public works. Arles' impressive Roman monuments include the arena (which was built for gladiator fights and where bullfights are still held today), the Roman Theatre, the Baths of Constantine, the Alyscamps necropolis, and subterranean galleries known as the Cryptoporticus. Arles was partially destroyed by invasions during the early Middle Ages, but it was rebuilt to its former glory during the 12th century, incorporating the Roman with the Romanesque and becoming an important religious center. The church of Saint-Trophime, which dates from that period, is one of Provence's most impressive examples of Romanesque architecture and the Roman sites and museums are an extraordinary glimpse into life in a Roman provincial capital.

6 Musée Réattu / Réattu Museum

The Musée Réattu houses a collection of works by local painter Jacques Réattu as well as a collection of etchings and drawings by Picasso, work by 17th- to 19th-century artists, and work by contemporary artists such as Raoul Dufy.

(*NOTE: All monuments and museums are closed on January 1,

May 1, November 1 and December 25. In addition, all ticket offices close 30 minutes before the hours of operation cease.)

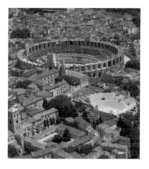

MUSÉE RÉATTU/ RÉATTU MUSEUM
⌂ 10 rue du Grand Prieuré
☎ 33 (0) 4 90 49 37 58
🖵 www.museereattu. arles.fr
○ Opens Tues-Sun 10AM call for closing times Jul-Sep Fri 3PM-10:30PM
● Mondays
$ 7 Euros

L'ARLÉSIENNE

When Paul Gauguin came to join Van Gogh in Arles in 1888, he proposed they do a series of portraits of Madame Marie Ginoux, the proprietor of the Café de la Gare, where Van Gogh had rented a room before moving to the Yellow House. Gauguin used his charms to persuade Mme. Ginoux to pose, and in the very first sitting—while Gauguin only completed a charcoal drawing—Van Gogh produced a finished painting, famously "slashing" the oil paints onto a rough piece of burlap Gauguin had purchased just after he got to Arles. Van Gogh went on to make a more elaborate copy on canvas of that first portrait, and then four more versions while he was in

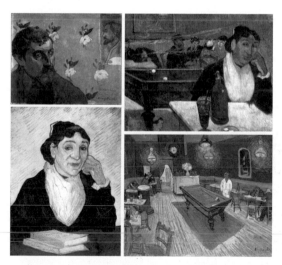

the asylum at Saint-Rémy. The paintings are all called L'Arlésienne (which means "the woman from Arles"), as well as L'Arlésienne (Madame Ginoux) and Portrait of Madame Ginoux, and they all picture the 40-year-old Mme. Ginoux seated at a café table, wearing the traditional clothes and cap from the region. Van Gogh considered those six paintings to be homages to his friend Gauguin, writing to him: "I tried to be respectfully faithful to your drawing." But Van Gogh's paintings are considered masterpieces on their own merit, and one from the Saint-Rémy series sold in 2006 for over $40.3 million, the fourth highest price on record for a painting by Van Gogh.

[top] *Self-Portrait with Portrait of Bernard* (1888), *Night Café at Arles, (Mme Ginoux)* (1888) by Gauguin. [bottom] *L'Arlésienne: (Madame Ginoux)* (1890), *The Night Café* (1888) by Van Gogh

LA CHASSAGNETTE
🏠 Rue de l'Ecole du Sambuc
💻 lachassagnette.blogspirit.com
☎ 33 (0) 4 90 97 26 96
○ Thu-Mon 12PM-2PM, 8PM-10PM
● Tuesdays & Wednesdays, Dec 20-Feb 15
$ 34-60 Euros

LE CILANTRO
🏠 31 rue Porte de Laure
💻 www.restaurantcilantro.com
☎ 33 (0) 4 90 18 25 05
○ Tue-Sat 12PM- 3PM, 7:30PM-10PM
● Sep-Jun Sun-Mon Jul-Aug Sundays
$ 29-99 Euros

LE GALOUBET
🏠 18 rue du Docteur Fanton
☎ 33 (0) 4 90 93 18 11
○ Tue-Sat 12PM-3PM Daily 7PM-11PM
● Sun & Mon lunch
$ 20-30 Euros

LE CRIQUET
🏠 21 rue Porte de Laure
☎ 33 (0) 4 90 96 80 51
○ Thu-Tue 12PM-2PM, 7PM-10PM
$ 15-30 Euros

WHERE TO...EAT AND SLEEP

EAT
A La Chassagnette
This restaurant, open weekly from Thursdays to Mondays, is known for its innovative French cuisine. Dishes are prepared with fresh ingredients that come from the chef's organic vegetable garden located onsite.

B Le Cilantro
Chef Jérôme Laurent, who once worked for Alain Ducasse, is at the helm of this gourmet restaurant located in the heart of Arles. The menu boasts world cuisine with a strong Mediterranean influence and a large selection of wines.

C Le Galoubet
Located a few minutes from the arenas, this bistro is a place Van Gogh knew well (it's reported he dined here several times back in his day). They are known for their impeccable foie gras.

D Le Criquet
This casual Provence restaurant is a favorite with many locals in Arles. The friendly, family-run enterprise offers traditional dishes with an emphasis on fish. Two popular items on the menu include "Bourride des Calanque" and the "Panache des Coquillage."

"Bourride des Calanque" at **Le Criquet**

SLEEP

E Hotel Jules Cesar

Originally a 17th-century Carmelite convent, this luxurious hotel is presently stylized after a Roman palace and successfully blends the old world and the new. It's located in one of the livelier areas of Arles and offers guests old-fashioned hospitality as well as an excellent restaurant onsite.

F L'Hôtel Particulier

Located in the "La Roquette" area of town, this 18th-century mansion is elegant and unique. The interiors are furnished with an unusual array of objects including Spanish chairs and chandeliers, old mirrors, and crimson velvet; it also boasts modern amenities such as a swimming pool (located in a beautiful garden area) and marble steam room. The roof terrace offers excellent views of the garden and surrounding area.

G Grand Hotel Nord-Pinus

This unique, romantic hotel is known for its amenities and—even more so—for all the famous people who have stayed here. In the '50s and '60s, Picasso, Hemingway, Cocteau, Fritz Lang, and John Huston were regular patrons, in addition to many renowned 20th-century bullfighters. Today, its salon and bar remain popular hangouts for guests and other visitors to Arles.

H Le Calendal

This charming, stylish hotel is housed in a 17th-century building that features a beautiful courtyard café and is located between the Antique Theater and amphitheater in Arles' historical center. Its peaceful atmosphere is a big hit with guests who also appreciate the onsite spa and attentive staff.

HOTEL JULES CESAR
⌂ 9 Boulevard des Lices
🖥 www.hotel-julescesar.fr
☎ 33 (0) 4 90 52 52 52
$ 160 Euros-

L'HÔTEL PARTICULIER
⌂ 4 rue de la Monnaie
🖥 www.hotel-particulier.com
☎ 33 (0) 4 90 52 51 40
$ 209 Euros-

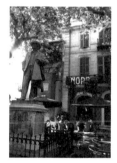

GRAND HOTEL NORD-PINUS
⌂ Place du Forum
🖥 www.nord-pinus.com
☎ 33 (0) 4 90 93 44 44
$ 160 Euros-

LE CALENDAL
⌂ 5 rue Porte de Laure
🖥 www.lecalendal.com
☎ 33 (0) 4 90 96 11 89
$ 109 Euros-

MAP OF VENUES AND CITY LANDMARKS

1 Place Lamartine
2 Banks of the Rhône River
3 Arles Amphitheater / Les Arénes d'Arles
4 Van Gogh Space / Espace Van Gogh
5 Van Gogh Foundation / Fondation Van Gogh
6 Jardin d'Été
7 Place du Forum

1 Les Alyscamps / Alyscamp Cemetery
2 Pont Van Gogh / Van Gogh Bridge
3 The Église St-Trophime /Church of St. Trophime
4 Théâtre Antique
5 Musée Départemental de l'Arles Antiques /Arles Museum of Antiquity
6 Musee Réattu / Réattu Museum

A La Chassagnette
B Le Cilantro
C Le Galoubet
D Le Criquet
E Hotel Jules Cesar
F L'Hôtel Particulier
G Grand Hotel Nord-Pinus
H Le Calendal

KEY

ⓘ Information
 Walking Tour
 Scene Stealers
 Others
 Eat and Sleep

Rue Gaston Tessier

Pont de Trinquetaille

5

F

Rue Gambetta

4

A

2

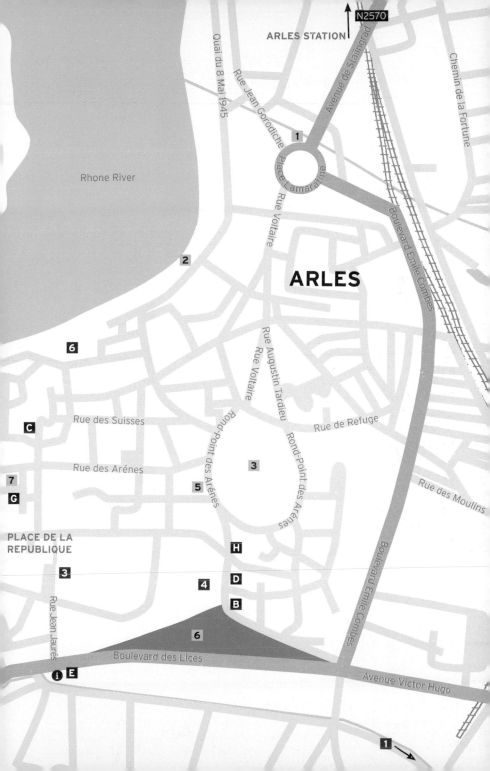

ACCESS

If you are heading to Saint-Rémy from Arles, the trip is an easy one via bus. It takes just 50 minutes, and the buses leave five to six times a day. By car, it just takes one-half hour.

EXTENDED TRAVEL

SAINT-RÉMY

If you want to continue your exploration of Van Gogh's Provençal period, then take a trip to nearby Saint-Rémy-de-Provence. Van Gogh spent a self-imposed year at the Saint Paul de Mausole Asylum here, drifting between madness and periods of lucid productivity that resulted in some 150 works, including such famous paintings as *Starry Night, Wheat Field with Cypresses,* now at the London National Gallery, and *Irises,* currently on view at the Getty Center in Los Angeles. Alongside the asylum you can still see the olive groves where Van Gogh set up his easel and went to work. Behind it, you will find the Roman ruins of Les Antiques (including the Arc de Triomphe, dated to approximately 20

ANGLADON MUSEUM IN AVIGNON

Although Van Gogh created nearly 200 paintings during his time in Arles, he shipped most of them back to his brother, Theo. Today, only one painting by Van Gogh can be seen in the region of Provence. *The Railway Wagons*, a brilliant canvas with Van Gogh's characteristically intense palette and a diagonal composition influenced by the Japanese woodcuts Van Gogh loved, hangs in the Musée Angladon in Avignon, a small but exquisite museum created in 1996 by the Avignon-born heirs of famed Parisian couturier and art collector Jacques Doucet.

> [top] **Town of Saint-Rémy** [middle] **Saint Paul de Mausole Asylum** [bottom] **Arc de Triomphe**

ARTWORK IN SAINT-RÉMY

Starry Night (1888)
Museum of Modern Art, New York

Starry Night captures the eastern evening view from Van Gogh's window at the mental hospital where he stayed in Saint-Rémy near the end of his life. Though the painting is his most famous nocturnal scene, Van Gogh painted the canvas by memory during the daylight hours, and the artist took considerable liberties with its composition—adding the cypress tree and repositioning the stars to please his eye. Likewise, the painting's colors and movement are exaggerated in thick brushstrokes, creating one of the most expressionistic paintings of Van Gogh's career—one that captures the feeling of night, without directly recreating it.

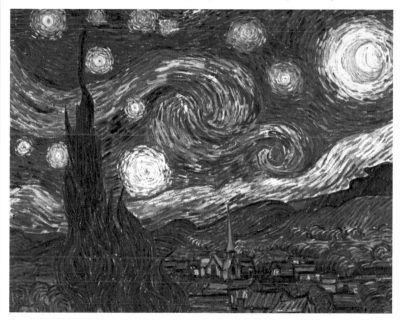

A view from Glanum located just behind the Saint Paul de Mausole Asylum, which may have inspired Van Gogh to paint the *Starry Night*.

AD, and the Mausolée des Jules, a well-preserved funerary monument dating from 30–20 BC) and Glanum (initially a Celto-Ligurian sacred site and one of the most important Roman excavations in France), where we imagine the artist might have spent some afternoons walking and reflecting during his time there.

The city has mapped out signposts for 21 of Van Gogh's Saint-Rémy paintings. A one-hour tour begins near the asylum and winds up in front of the Centre d'Art Presence Vincent Van Gogh in the Hôtel Estrine. This art center features full-size reproductions and slide shows of Van Gogh's work alongside a changing roster of international contemporary artist exhibitions.

NOSTRADAMUS

After moving into the Saint Paul de Mausole Asylum, Van Gogh continued to paint, creating some of his most iconic paintings, including the *Starry Night*, a view of Saint-Rémy from his hospital window. But Van Gogh wasn't the only resident of St. Rémy known for his sometimes-turbulent "vision." Michel de Nostradamus, the 16th-century French physician and astrologer who made apocalyptic predictions about the future, was born in Saint-Rémy on the Rue Hoche in 1503. Could Nostradamus and Van Gogh have shared something else though: the source of their unique "points of view"? They're both reputed to have made frequent use of absinthe, the powerful French liqueur made from wormwood that is said to induce hallucinations and strange visions.

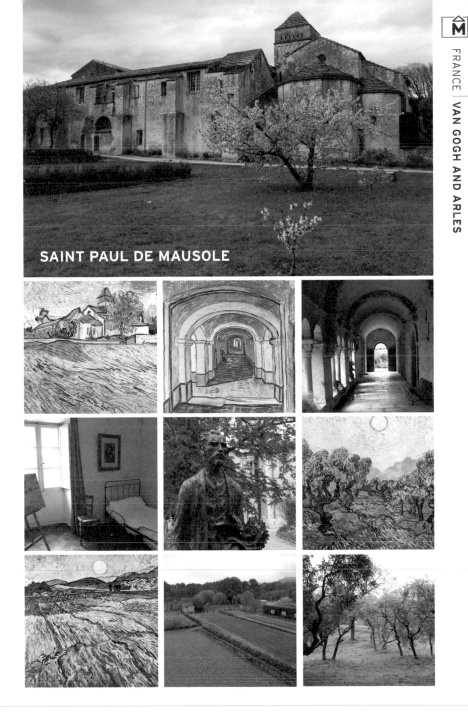

SAINT PAUL DE MAUSOLE

⌃ Scenes from Van Gogh's paintings—[second row left] *View of the Church of Saint Paul de Masole* (1889), [second center] *Corridor in Saint Paul* (1889), [third right] *Olive Trees* (1889), [fourth left] *Enclosed Field with Rising Sun* (1889)—can still be seen in and around the hospital

VAN GOGH MUSEUM, AMSTERDAM

What happens in Arles doesn't necessarily stay in Arles, at least not when you're Vincent Van Gogh and your brother is an art dealer. The best collection of Van Gogh's dazzling work from Arles can be found in the Van Gogh Museum in Amsterdam, which is also the largest collection of Van Gogh's art in the world.

Van Gogh drew and painted feverishly in the 15 months he lived in Arles, but as quickly as he produced his masterpieces of intense light, vibrant color, and swirling brushwork, he sent them back to Paris—to his brother Theo, hoping for sales.

When Theo died, only a few months after Vincent's own death in 1890, Theo's young widow, Johanna van Gogh-Bonger, moved back to the Netherlands, taking Van Gogh's paintings, drawings, and letters with her. There, she devoted herself to promoting Van Gogh's reputation—and value—through memorial exhibitions, careful loans, and sales to museums all over Europe. When she died in 1925, the remaining family collection was inherited by her son Vincent

^ **Van Gogh Museum and Exhibition Wing** by Kisho Kurokawa

41

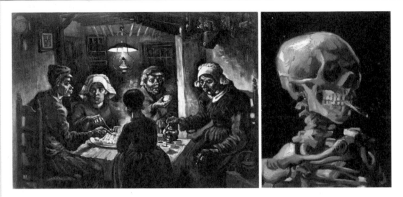

The Potato Eaters (1885)
Van Gogh painted this genre scene to realistically depict the lives of manual laborers—dirt and all. Dark and grim, yet full of energy, it is a stark contrast to his later work in Arles, and while the artist considered this portrait a failure, it has become one of the most famous of his early works.

Skull of a Skeleton with Burning Cigarette (1885-86)
The early work of Van Gogh features a darker palette and subject matter to match. However, the addition of a lit cigarette to this seemingly macabre painting is thought to be a tongue-in-cheek commentary on the rigid art academy system, which he considered "damned boring."

Willem, an engineer who lent the collection to the Stedelijk Museum and other important museums around the world. In 1962, the Dutch government offered to create a home for the works and the Van Gogh Museum was born.

Designed by renowned De Stijl architect Gerrit Rietveld, the museum opened in 1973 with over 200 of Van Gogh's paintings, plus drawings, letters, and his collection of Japanese prints. The collection also includes works by Van Gogh's friends, contemporaries, and admirers as well as by painters who influenced Van Gogh.

A second building, the Exhibition Wing, was added in 1999. Designed by Japanese architect Kisho Kurokawa, its combination of Eastern and Western themes is fitting, given Van Gogh's enthusiasm for Japanese prints and the important influence the country's art had

on his work and artistic philosophy. Many of Van Gogh's paintings from Arles reflect his love of the sun-soaked color, flattened planes, and the spiritual vision of nature he admired in Japanese art. In addition, his idea of the artists' community he hoped to establish in Arles (of which Gauguin was the first and only member) was based on what he'd learned about Japanese artist colonies.

Van Gogh's works have steadily increased in value (thanks to his sister-in-law's careful planning), and in 1990 his *Portrait of Dr. Gachet* was sold for $82.5 million—the highest price any painting had been sold for to that date. Masterpieces from Arles in the Van Gogh Museum's collection include *The Yellow House, The Bedroom, The Sower,* the elegant *Sprig of Flowering Almond Blossom in a Glass* (one of his first paintings in Arles), and Van Gogh's own copy of his iconic *Sunflowers.*

SOUVENIRS

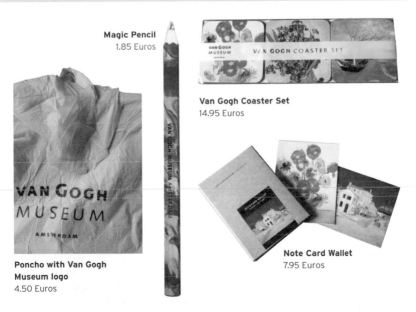

Magic Pencil
1.85 Euros

Van Gogh Coaster Set
14.95 Euros

Poncho with Van Gogh Museum logo
4.50 Euros

Note Card Wallet
7.95 Euros

^ [top right] ***The Courtesan (after Eisen)***, 1887, illustrates Van Gogh's interest in Japan and Japanese prints.

ANATOMY OF A MASTERPIECE

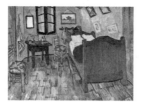

Café Terrace on the Place du Forum at Night, 1888
Kröller-Müller Museum, Otterlo
This painting marks the first time that Van Gogh explored the night sky, painting an early version of what would become his signature—swirling, whirling stars. Today, visitors to Arles can see the café—now known as Café Van Gogh—painted to match the golden glory with which Van Gogh imagined it.

Portrait of Père Tanguy
1887-88
Musée Rodin, Paris
Like many artists in France in the 19th century, Van Gogh was fascinated by the graphic quality of Japanese ukiyo-e woodblock prints. In addition to copying several prints, he also used them as the background for his portrait of Parisian paint seller Julien "Père" Tanguy.

at 2 Place Lamartine in Arles (the address of his famous Yellow House), using flat areas of bold color to suggest a dreamlike state. The room was his home during a period of extreme productivity, matched in vigor only by his madness.

The Red Vineyard, 1888
Pushkin Museum of Fine Arts, Moscow
This is the only painting that Van Gogh sold during his troubled life. Fellow artist Anna Boch bought it for the equivalent of $1,000 during an annual exhibition of Les XX in Brussels in January and February of 1890, shortly before his death.

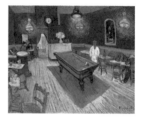

The Night Café, 1888
Yale University Art Gallery
Van Gogh captured *The Night Café* over the course of three sleepless nights at the Café de la Gare, located at 30 Place Lamartine in Arles, where he rented a room before moving to the Yellow House. By this point in his career, Van Gogh had abandoned naturalism in his use of color, opting instead to use thickly applied strokes of clashing colors to capture the emotional atmosphere in the café.

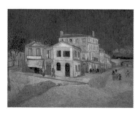

The Yellow House, 1888
Van Gogh Museum, Amsterdam
The house where Van Gogh stayed in Arles no longer exists, but the artist faithfully recorded his surroundings in contrasting blue and yellow hues. He was sure to include the gaslight and the railroad tracks, two symbols of 19th-century modernity.

Bedroom at Arles, 1888
Van Gogh Museum, Amsterdam
Van Gogh made three versions of this painting of his bedroom

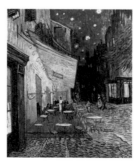

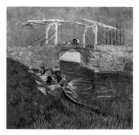

Bridge at Arles (Pont de Langlois), 1888
Kröller-Müller Museum, Otterlo
Van Gogh often painted the local landscape, though visitors today will find much of it has changed. The Pont de Langlois, the so-called Van Gogh Bridge, is one example, having been moved downriver following the bombings of 1944.

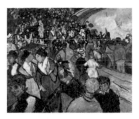

Les Arénes, 1888
The State Hermitage Museum, St. Petersburg
This scene of bustling Provençal life was painted from memory, including portraits of residents of Arles. Today visitors can see bullfights at the ancient Roman arena twice a year.

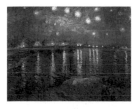

Starry Night Over the Rhône 1888
Musée d'Orsay, Paris
Van Gogh continued his exploration of nocturnal scenes by focusing on the stars over the river near his home at the Yellow House. The darkness allowed him to experiment with the effects of acidic yellow gaslight reflecting off the water's surface.

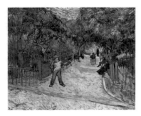

Entrance to the Public Garden 1888
The Phillips Collection, Washington, D.C.
The Jardin d'Ete on the Boulevard des Lices is where you'll find a memorial to Van Gogh—a bronze bust of the artist, missing ear and all.

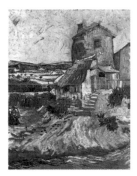

The Old Mill, 1888
Albright-Knox Art Gallery, Buffalo, New York
Van Gogh's cheerful rendering of an old mill in Arles shows his impressionistic use of color, as well as the careful way he used different types of brushstrokes to represent different forms.

The Trinquetaille Bridge, 1888
Private Collection
Modern life was a favorite subject of Van Gogh, as seen in this painting of an iron pedestrian bridge over the Rhône.

Memory of the Garden of Eden, 1888
The State Hermitage Museum, St. Petersburg
Van Gogh experimented with the artistic developments of his day, including divisionism—a style based on optical science and color theory—as seen in the use of dots of contrasting colors in this vibrant canvas.

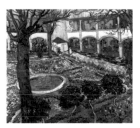

Le Jardin de la Maison de Santé à Arles, 1889
Private Collection
Van Gogh frequently found inspiration in his surroundings, even in the gardens of the Arlesian hospital where he was a patient. Today you can see the grounds as they were during the artist's stay, though the hospital is now the Espace Van Gogh.

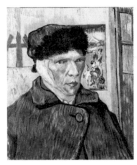

Self-Portrait with Bandaged Ear, Easel and Japanese Print
1889
Courtauld Institute Galleries, London
Over the course of his career, Van Gogh painted his own image repeatedly, though in this version his bandaged right ear contrasts with medical reports of his self-inflicted injury. That's because the artist painted his self-portraits using a mirror.

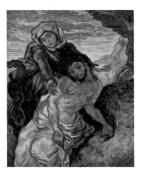

The Pieta, 1889
Van Gogh Museum, Amsterdam
The Virgin Mary mourning over the dead Christ—painted at the hospital in Saint-Rémy—is based on a lithograph by Nanteuil after a painting by Eugène Delacroix. Van Gogh adopted both the subject and composition, but executed it in his own color and style.

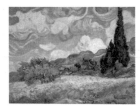

Wheat Field with Cypresses
1889
National Gallery, London
Like the sunflower, the cypress is a motif closely associated with Van Gogh. Filled with swirls of thickly painted impasto, the painting is an excellent example of the artist's experimentation with abstracted forms.

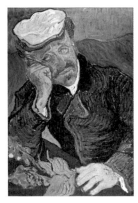

Portrait of Dr. Gachet (second version), 1890
Musée d'Orsay, Paris
When the first version of Van Gogh's portrait of his trusted doctor sold for $82.5 million in 1990, it became the most expensive painting ever sold. The melancholic pose was modeled after Eugène Delacroix's *Tasso in the Hospital of St. Anne Ferrara*, and with it Van Gogh attempted to capture what he considered a specifically modern type of sadness.

Wheat Field with Crows, 1890
Van Gogh Museum, Amsterdam
Painted in July of 1890, the same month that Van Gogh walked into a wheat field and shot himself, *Wheat Field with Crows* embodies the torment the artist faced toward the end of his life. Crows made of thick black and gestural strokes fly across the double canvas, over a golden wheat field that lies under the troubled skies of Auvers.

Irises, 1889
J. Paul Getty Museum, Los Angeles
Van Gogh painted his lyrical *Irises* while in the asylum in Saint-Rémy in an effort to stave off madness. Painted from life in the asylum's garden, though imbued with the decorative flatness of Japanese prints, the irises are yet another of Van Gogh's experimentations with the everyday object.

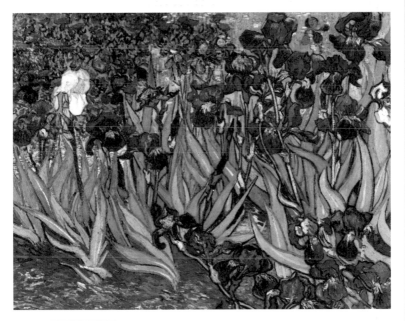

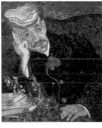

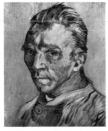

Irises, 1889
Price: $53.9 million
Irises sells for $53.9 million to Australian businessman and convicted fraudster Alan Bond in 1987. When he fails to repay Sotheby's the painting goes to the J. Paul Getty Museum in 1990.

Portrait of Dr. Gachet (first version), 1890
Price: $82.5 million
Portrait of Dr. Gachet sells for $82.5 million to Japanese businessman Ryoei Saito at a 1990 Christie's auction. Since the 1996 death of Saito, who once threatened to torch the painting, its whereabouts have been a mystery, though it is believed the painting was sold to an Austrian investment banker.

Portrait de l'Artiste sans Barbe, 1889
Price: $71.5 million
A lesser-known self-portrait of the artist sells for $71.5 million in 1998 to an unknown buyer at Christie's, a surprise given the weak art market at the time.

VERMEER and Delft

Vermeer, who painted exquisite light-infused scenes of middle-class life in Delft, was a slow craftsman and produced few works in his lifetime. Many of his paintings were scooped up by wealthy Delft patron Pieter van Ruijven, which may be why his fame didn't spread to other Dutch art centers. In fact, Vermeer was relatively unknown until 1866, when French critic Théophile Thoré saw his *View of Delft* in The Hague. One thing we know about the artist, who died penniless at 43–leaving his wife and 11 surviving children to fend for themselves–is that he loved expensive blue paint and often spent more for costly lapis lazuli and natural ultramarine pigments than he could charge for his work. Not surprising for a painter from a town that lent its name to the distinctive color, "Delft Blue," of its prized blue and white pottery.

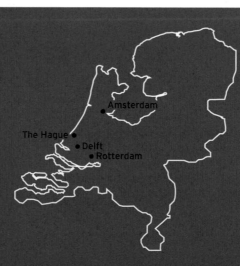

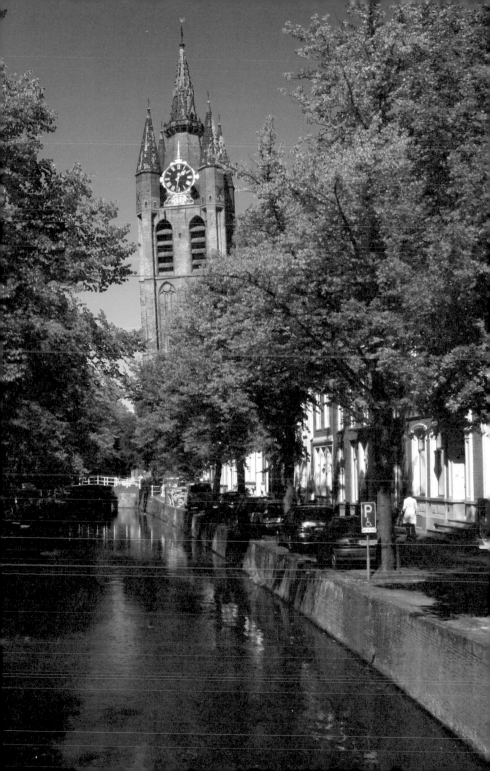

BY SANDRA SMALLENBURG

In Peter Webber's film *Girl with a Pearl Earring* (2003), Dutch painter Johannes Vermeer is portrayed as quiet and introverted. He is a handsome, long-haired man who tries desperately to get his work done in his overpopulated household, inhabited by 11 children, his wife, and his mother-in-law. Apart from the occasional outburst of rage, Vermeer keeps to himself in his studio, where he watches the light change and finds inspiration in the good-looking maid Griet.

It's a beautiful story, based on Tracy Chevalier's best-selling novel from 2000, but it is all fiction. In fact, we don't know what Vermeer looked like, and we think he must have been a silent man only because there's so much silence in his paintings. We cannot be sure, and there's no shred of evidence that Griet ever existed. Vermeer didn't tell us about his inspiration or working methods. He didn't leave any letters or diaries. The little information we do have comes from official documents such as testaments and inventory lists. Vermeer is one of the most famous painters in the history of art, and yet he remains a mystery. That's why he has been given the moniker the Sphinx of Delft.

Johannes Vermeer was born in 1632 in a house at Voldersgracht 25 in Delft, a picturesque city with cobblestone streets and tranquil canals where even today you can still hear the hooves of horses carrying the tourist tram. His father, Reynier Jansz, owned a tavern called De Vliegende Vos (the Flying Fox), but he also made money from his weaving mill and art business, selling paintings from Delft artists like Balthasar van der Ast, Jan Baptista van Fornenburgh, Pieter Steenwijck, and Pieter Groenewegen. When Vermeer was nine, the family moved to a larger house on the other side of the street at the corner of the Oude Manhuissteeg and the busy Markt Square. This house, also a tavern, was called Huis Mechelen. It is unknown if and where the young Vermeer went to school, but because Huis Mechelen was a lively meeting place for Delft artists at the time, he might have met painters like Evert van Aelst, Egbert van der Poel, and Leonaert Bramer. Pieter de Hooch, who was a few years older than Vermeer and arrived in Delft in 1654, is often mentioned as a possible teacher. Vermeer admired the work of Carel Fabritius, the Delft painter who tragically died in a gunpowder explosion that destroyed a large part of the city in 1654.

< [previous page] self-portrait detail from **The Art of Painting** (1662-1688), Kunsthistorisches Museum, Vienna; The **Oude Kerk** and a canal in Delft

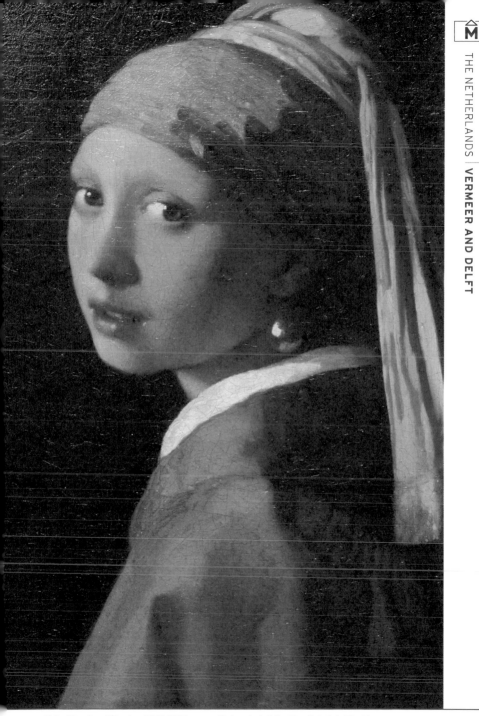

⌃ *Girl with a Pearl Earring* (1665–1667), currently located at the Mauritshuis in The Hague

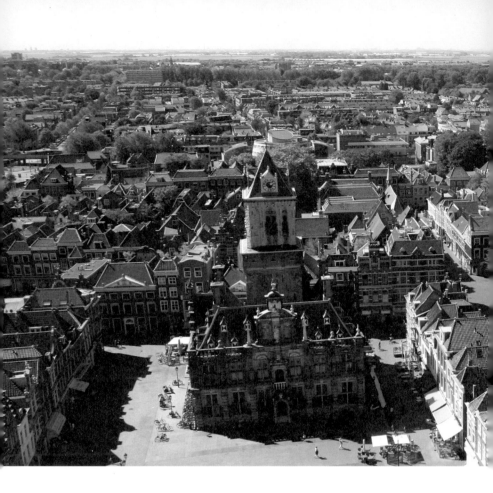

Today the site of Huis Mechelen is directly across from the Vermeer Center (formerly St. Luke's Guild), an institution created to carry on and explore his cultural legacy, and one of the tour guides there, Louk van Riet, says that the area is considered holy ground. "This is as close as you can get to Vermeer. This is the street where he played as a young boy. Here you can hear the same carillon as he did, and this could very well be the location of *The Little Street* (1657–58)." But van Riet is quick to point out that there are many different theories surrounding the artist.

^ [top] Panorama of Delft taken from the tower of the **Nieuwe Kerk (New Church)**, including the **Stadhuis (City Hall)** (left) and **Oude Kerk (Old Church)** (right)

[bottom] *Explosion of the Gunpowder Magazine* (after 1654), by Egbert van der Poel

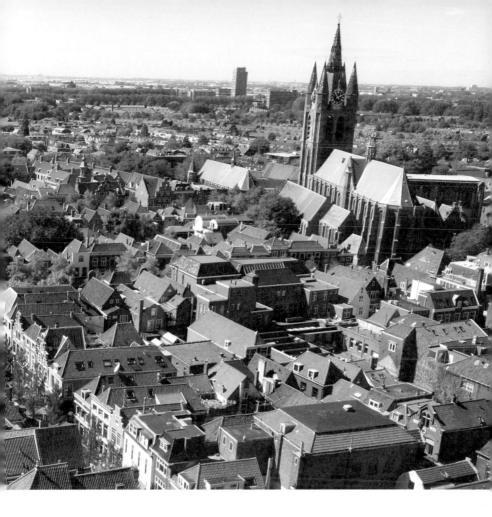

In truth, the only facts that documents can reveal to us about Vermeer's life are that he was baptized as a Protestant in the New Church on October 31, 1632, and that he got engaged to Catharina Bolnes on April 5, 1653. Catharina was a Catholic girl from a well-to-do family, and in order to marry her, Vermeer had to convert to Catholicism. The marriage ceremony took place in the small town of Schipluiden on April 20, 1653. For 15 years the couple lived with Vermeer's wealthy mother-in-law, Maria Thins, who owned a large house on the Oude Langendijk in the so-called Papenhoek (Papists' Corner). Here, each of Vermeer's 15 children was born, four of whom died at a young age. It was also at this house, in a room on the second floor with excellent light from a northern window, that Vermeer probably painted most of his works.

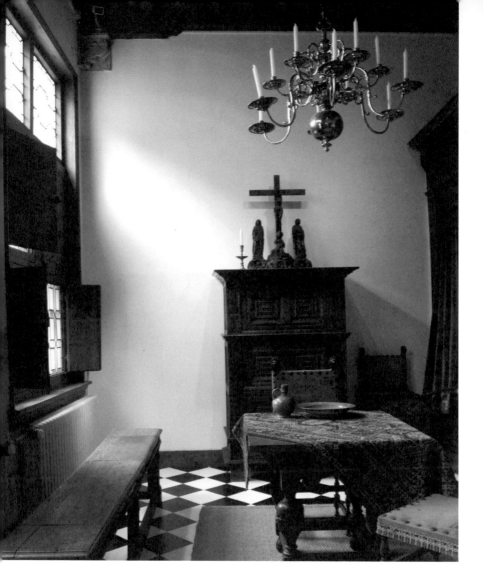

It's easy to see why he found so much inspiration in Delft: The city is a sensory treat for any traveler. It's a place where the local delicacy—fresh and raw herring with onions—is sold on almost every street corner and the many restaurants offer smells and flavors from all over the world. Delft is a multicultural place with people from Morocco, Turkey, Surinam, and the Dutch Antilles. In summertime, the canals are covered with water lilies, everyone eats outside in front of their houses, and the terraces—many of which are built on boats

⌃ This 17th-century period room in the style of Vermeer is located at **Lambert van Meerten Museum**

› [next page] *Girl with a Flute* (1665-70) National Gallery, Washington, D.C

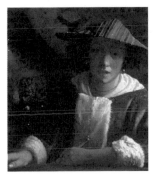

that line the canals—ring with the laughter of students and tourists. You'll notice an enormous number of bicycles in the city, parked in front of the train station or tied to a bridge railing; they are the preferred vehicle of transportation by many locals. The pace of life is slower here, and people like it that way.

Vermeer also appreciated taking his time, working exceedingly slowly and painstakingly producing only two or three paintings a year. He was a perfectionist, using only expensive paints such as clear blue ultramarine, a rare pigment costing 60 guilders per quarter pound—an amount much more than the price of many of his paintings. During his lifetime, Vermeer painted an estimated 40 to 60 works; 36 of them are still known today. The attribution of only one of these works, *Girl With a Flute* (1665–70), is considered dubious. It is located in the National Gallery in Washington, D.C, and is marked as "attributed to Vermeer." The majority of Vermeer's extremely small oeuvre consists of scenes of interiors with one or two persons in it (26 works in total), but he also painted four portraits featuring women, two city views of Delft, and four allegorical scenes.

Light is the principal element in all of Vermeer's paintings. In his interior scenes, the sun shines through high windows to light up a woman playing music or reading a letter. In his city views, the sun brightens the Delft rooftops and is also reflected in the city's tranquil waters. His contours are always blurred instead of sharp, making his compositions soft and radiant. Vermeer gave his compositions their dazzling luminosity with millions of

TIMELINE

October 31, 1632
Johannes Vermeer is baptized in the Nieuwe Kerk

1652
Vermeer's father passes away; the artist takes his place as a merchant of paintings

1653
Vermeer marries Catharina Bolnes on April 20

The artist joins St. Luke's Guild , an association for artists and artisans

1654
Delft suffers terrible explosion that destroys a large section of the city

1657
Vermeer meets Pieter van Ruijven, a local art collector and future patron

1662
The artist becomes the head of St. Luke's Guild

1665
Vermeer creates his iconic *Girl with a Pearl Earring*

1672
The "Year of Disaster" strikes in the Netherlands, as a severe economic downturn takes place

in the wake of the Franco-Dutch War

1675
The artist borrows 1,000 guilders from a merchant in Amsterdam

December 16, 1675
Johannes Vermeer dies penniless and is buried in the Oude Kerk in Delft, leaving behind his wife and 11 children

HAN VAN MEEGEREN

The most brilliant and ingenious art forger of the 20th century, Han van Meegeren (1889–1947), was a Dutch painter and portraitist who became enchanted by the masterpieces of the Dutch Golden Age while still a child. A promising student of architecture, van Meegeren won a gold medal from the General Sciences Section of the Delft Institute of Technology for a drawing of a church interior in the 17th-century style. After finishing his studies, van Meegeren set out to become a painter but critics were not kind to his work. He was stung by their criticism and decided to "prove" his talent by forging paintings by some of the Netherlands' greatest masters, including Frans Hals, Pieter de Hooch, Gerard ter Borch and Delft's own Johannes Vermeer.

Arguably his most successful "Vermeer" was *Supper at Emmaus*, which he completed in 1937 while living in Roquebrune, France. Many of the world's foremost art experts were taken in by the work, calling it the finest Vermeer they had ever seen. Van Meegeren continued to produce fake Vermeers through the early 1940s and might never have been caught if one of them, *Christ and The Adulteress*, hadn't been seized in Nazi Reichsmarschall Hermann Göring's collection. Van Meegeren was arrested in 1945 and charged with collaboration and selling important Dutch cultural property to the Nazis.

To exonerate himself from that very serious charge, Van Meegeren surprised Dutch authorities by claiming that it, as well as most of the works he had sold, was not important cultural property but simply a forgery he had painted himself. To prove it he painted a "new" Vermeer during the trial, demonstrating the various techniques he used to make the paintings appear several hundred years old. He became extremely popular as a result of the revelations for having fooled not only Göring, but some of the world's greatest art connoisseurs as well. Van Meegeren was convicted in 1947 and sentenced to one year in prison, but died of a heart attack before the token sentence could be carried out.

colorful dots, and the way he used this pointillé technique is unique for his time.

On December 29, 1653, Vermeer enlisted with St. Luke's Guild, an association for artists and artisans. The enrollment fee was 6 guilders, but because of his bad financial circumstances Vermeer paid only 1.5 guilders; the remaining amount he paid more than two years later, on July 24, 1656. It is quite possible that Vermeer's mother-in-law supported the family financially, but the artist also had a private patron, the wealthy Delft art collector Pieter van Ruijven, who ultimately bought 21 of Vermeer's paintings. Vermeer sometimes borrowed money from van Ruijven, and when the patron died in 1674, he left the painter a legacy of 500 guilders.

This inheritance couldn't prevent Vermeer's serious financial problems during his final years of life. In 1672, the so-called "Year of Disaster", the French and the English had invaded the Dutch

^ **The St. Luke's Guild** was an association for artists and artisans, of which Vermeer was a member

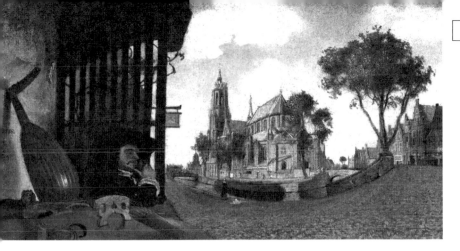

Republic causing an economic downturn. Numerous businesses went bankrupt, and Vermeer, who also traded in the paintings of other artists, was forced to borrow money in order to feed his children. In addition to what he received from van Ruijven, Vermeer also traveled to Amsterdam on July 20, 1675, to borrow 1,000 guilders from an unknown person. It was still not enough. When he died suddenly on December 16, 1675, Vermeer left his family penniless. In turn, his widow had to pay off a debt of 617 guilders to the baker—the equivalent of three years' bread supply—by selling two of her husband's paintings.

Shortly after his death, the work of Vermeer fell out of favor. In 1696 the 21 Vermeers from van Ruijven's collection were auctioned for average prices. *The Milkmaid* (1658), for example, sold for only 175 guilders. During much of the 18th and 19th centuries, Vermeer was forgotten completely. It was only after 1866, when the French art critic Théophile Thoré (writing under the pen name Bürger) published three essays in the *Gazette des Beaux-Arts* extolling the work of Vermeer, that people started to take notice again. Yet even in 1881, *Girl with a Pearl Earring* (1665) was sold at an auction for only 2 guilders and 30 cents, an extremely low price even for that time. By the end of the 19th century, the Impressionists were rediscovering Vermeer, praising his use of light and the contemplative stillness of his work.

Today art lovers are again drawn to Vermeer, and the public's interest—as well as the prices of his work—continues to rise. In 2004, *Young Woman Seated at the Virginal* (1670), the first Vermeer painting to come to auction in over 80 years (and long suspected to be a fake), was sold for $30 million at Sotheby's in London. It went for over five times the presale estimate.

⌃ *A View of Delft* (1652), by Carel Fabritius

ART IMITATING ART: THE ARTIST'S IMPRINT ON POPULAR CULTURE

MOVIES

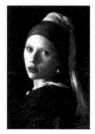

ON LOCATION
Girl with a Pearl Earring (2003) Director: Peter Webber
This imaginative interpretation of the story behind Vermeer's famous painting opens with sweeping shots of real-life Delft, including the city hall and town square as seen from the Nieuwe Kerk, as well as the church itself. Though fictional, the film provides a rare glimpse into Vermeer's world, about which little is known. We see inside his studio—the alchemical process of mixing lapis, ruby shellac, and other precious pigments—and the harsh realities of painting the whims of a wealthy patron. Other than the film's opening shots, the 17th-century Delft portrayed in the film was actually shot in Luxembourg, on a set originally built for the film *Secret Passage*, in which it played another canal-crossed city, Venice.

Light in the Window: The Art of Vermeer (1952)
Director: Jean Oser
This 10-minute movie from the renowned filmmaker Jean Oser, is an innovative profile of the artist that was awarded an Oscar in the Dramatic Short Film category in 1953.

Vermeer: Master of Light
(2001) Director: Joe Krakora
This documentary, narrated by Academy Award-winning actress Meryl Streep, takes an in-depth look at Vermeer's artistic technique. Through the use of high-tech equipment, the film provides a detailed study on the use of composition and lighting within his work.

A Brush with Fate (2003)
Director: Brent Shields
Originally made for TV, this film, starring Glenn Close and Ellen Burstyn, is based on the novel *Girl in Hyacinth Blue* by Susan Vreeland. The painting featured in the movie—which was created by a reproduction of Vermeer's technique—was made by American painter

Jonathan Janson, author and webmaster of the Essential Vermeer website.

LITERATURE

Girl in Hyacinth Blue
by Susan Vreeland
(Penguin, 2000)
This popular novel follows the ownership of a supposed Vermeer painting, which is traced back to the moment of its inspiration and moves through various owner's hands and poignant moments in their lives. The common thread of each tale is the collective admiration for the painting and the power of beauty to transform.

In Quiet Light: Poems on Vermeer's Women by Marilyn Chandler McEntyre
(Wm. B. Eerdmans, 2000)
Inspired by Vermeer's famous portraits, this imaginative collection of poetry imagines the lives of subjects he painted. Each poem lies alongside color reproductions of such works as *The Lacemaker*, *The Milkmaid*, *Girl*

with a Pearl Earring, and *The Girl with a Red Hat*.

Vermeer's Daughter
by Barbara Shoup
(Clerisy Press, 2003)
Written for young adults, this fictional account of Vermeer's 17th-century world is told from the viewpoint of his daughter, Carelina. It explores daily life and the aspirations of a young woman with artistic ability living in an art world dominated by men.

The Dance of Geometry
by Brian Howell
(Toby Press, 2002)
Three accounts imagine events connected to Vermeer: the artist's own childhood and apprenticeship; a modern-day forger who gets blackmailed into creating a masterpiece to save the woman he loves; and a French connoisseur who journeys to see Vermeer and finds himself entangled in a secret and dangerous debate about a new invention.

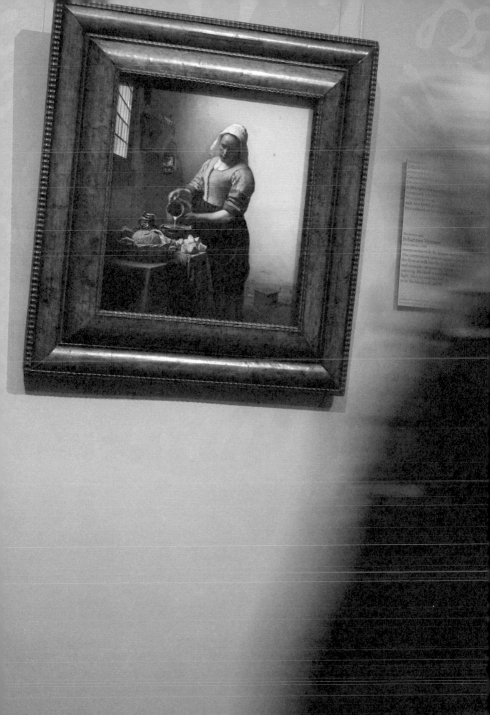

Vermeer's masterpiece ***The Milkmaid*** (1657-1658) on view at The Rijksmuseum in Amsterdam

ACCESS

AIRPORTS: ✈
Amsterdam Airport Schiphol
🏠 Evert v/d Beekstraat 202
🖥 www.schiphol.nl
☎ 31 (0) 20 794 08 00

Rotterdam Airport
🏠 Rotterdam Airportplein 60
🖥 www.rotterdam-airport.nl
☎ 31 (0) 10 446 34 44

There are several trains from Amsterdam Central Station to Delft daily. It takes about one hour. From Rotterdam it takes 15-20 minutes. Tram runs between The Hague and Delft every 20 minutes.

TRAIN/BUS: 🚎/🚌
Station Delft
🏠 Van Leeuwenhoeksingel 41
🖥 www.ns.nl
☎ 31 (0) 15 212 98 80
(*NOTE: The Delft bus terminal is located directly in front of Station Delft)

TOURISM OFFICE: 🌐
Tourist Information Point Delft
🏠 Hippolytusbuurt 4
☎ 31 (0) 15 215 40 51
🖥 www.delft.nl
○ Apr-Sep Sun-Mon 10AM-4PM, Tue-Fri 9AM-6PM
Sat 10AM-5PM
Oct-Mar Sun 10AM-3PM
Mon 11AM-4PM
Tues-Sat 10AM-4PM

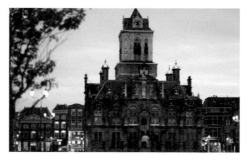

FOR YOUR INFORMATION...

Delft is a small Dutch city located between Rotterdam and The Hague. It is perhaps best known for the distinctive blue-and-white tin-glazed pottery known as "Delftware," which was developed in the 16th century by Italian immigrant artisans, who copied fine porcelain imported from China. Delft—a visual delight with narrow streets lined with canals and 17th- and 18th-century houses—was founded in 1075 and first flourished in the 13th and 14th centuries thanks to weaving and trade. The city was devastated by a deadly gunpowder explosion and fire in 1654, yet Delft recovered to become an important trade center once again in the 16th and 17th centuries—home to one of the Dutch East India Company's offices.

Flourishing 17th-century Delft was captured by one of its most celebrated citizens, Johannes Vermeer, who painted his idealized vision of the town in the 1659 painting *View of Delft*. Two other important citizens of Delft are celebrated for their distinctive vision as well: William of Orange, the founder of the modern Dutch nation, and Anton van Leeuwenhoek, father of the microscope.

Weather 🌊

Weather in Delft is similar to the rest of the Netherlands with a maritime climate that includes chilly winters and balmy summers. Wind and rain are often the greatest issues to contend with. July and August are warm, while autumn can be rainy, and winter can mean freezing temperatures and snow.

∧ **Stadhuis (City Hall)**

BEFORE YOU GO, GET IN THE KNOW: SUGGESTED WEBSITES AND BOOKS

WEBSITES

Delft Online
💻 www.delft.nl
The official site for the city of Delft provides general information on tourist attractions, sights, events, and shops, as well as dining, bars, and suggested hotel accommodations. There's also an extensive section for travel information and transportation.

Vermeer Center
💻 www.vermeerdelft.nl

The Vermeer Center celebrates the life, work, and city of Vermeer, and its website offers travelers information on tours, exhibits and activities, upcoming events, Vermeer's world and work, and historic Delft.

Essential Vermeer
💻 www.essentialvermeer.com
Created and maintained by Jonathan Janson (an American painter and independent art historian), this site contains hundreds of pages and images, a complete interactive artist catalogue, audio files of Dutch pronunciation and period music, plus a newsletter focusing on everything Vermeer.

Vermeer Foundation
💻 www.vermeer-foundation.org
This website showcases the artist's complete works, and also features a detailed biography, slideshow, and links to additional resources including museums, galleries, exhibitions, and sites for general research.

BOOKS

Vermeer and His Milieu: A Web of Social History by John Michael Montias
(Princeton University, 1991)
This biography recounts the artist's life, the social history of his extended family, and the city of Delft in the era in which he lived. It explores several different worlds including Delft's Beestenmarket, where the artist's paternal family settled early in the century, as well as the artists, military contractors, and Protestant thieves who frequented Vermeer's father's tavern.

Vermeer: The Complete Paintings
by Walter Liedtke (Abrams, 2008)
Written by the curator and organizer of the Metropolitan Museum of Art's 2001 exhibition "Vermeer and the Delft School," this book studies Vermeer's work in the historical context of the artistic movement known as the

School of Delft. The annotated color catalogue features Vermeer's complete paintings and is part of the Classical Art Series, explore in detail the meaning, technique, and style of his work.

Vermeer's Hat: The Seventeenth Century and the Dawn of the Global World
by Timothy Brook
(Bloomsbury Publishing PLC, 2008)
Award-winning historian Timothy Brook examines Vermeer's paintings to uncover how daily life and thought in Delft were altered in the 17th century. Through the artist's work (using an example of the fur hat worn by one of his painting's subjects), the author reveals how the desire to acquire the goods of distant lands changed the world.

Vermeer's Family Secrets: Genius, Discovery, and the Unknown Apprentice
by Benjamin Binstock (Routledge, 2009)
This book—illustrated with more than 180 black-and-white images, 60 color plates, and a two-page color spread of the artist's work—is organized in chronological order, delving into Vermeer's life and artistry through new interpretations of several critical documents about the artist, plus some newer revelations and visual comparisons of his oeuvre.

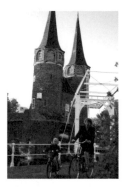

CALENDAR...YEARLY EVENTS

De Mooi Weer Spelen/ Street Theater Festival (June)

This weekend-long street festival transforms the center of Delft into a colorful explosion of street performances, dance, comedy, theater, and special exhibitions.

Delft Ceramica (July)

Ceramic artists come from all around the world to participate in this outdoor art fair and market, usually held in July. Prizes are awarded based on the quality, originality, and innovation demonstrated by their work.

Delft Chamber Music Festival (August)

An annual international event attracting some of the most important chamber music performers in the world.

Open Monumentendag/ European Heritage Days (September)

Once a year, European countries celebrate their cultural heritage in an initiative created by the Council of Europe in 1991. Heritage Days, which are known as Open Monument Days in Holland, are a weekend during which many historic buildings and sites—nearly 4,000 throughout the Netherlands—are open to the public free of charge. Each year is centered around a specific theme.

Taptoe (September)

This annual festival of military music usually takes place during the first weekend of September. The "taptoe," a combination of two Dutch words which mean "shut" and "faucet," dates from the 17th century, when the British Army was fighting in the Low Countries. Drummers from the garrison were sent out each evening to signal to the innkeepers that it was time to stop serving beer so the soldiers would return to the barracks. The event was later expanded to include any performance with marching drum units and military music. In 1952, after the Dutch Royal Military band was invited to participate in a similar event in Edinburgh, the Dutch government revived the practice.

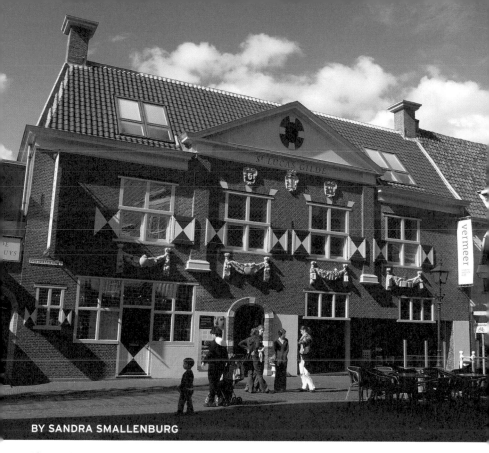

BY SANDRA SMALLENBURG

If you're standing in Markt Square, the huge central meeting place in Delft, it is not difficult to imagine what the city looked like when Johannes Vermeer lived here between 1632 and 1675. Just imagine away the terraces with their modern beer advertisements and the numerous souvenir shops. Look at the fronts of the small houses around the square, some dating back to the 17th century, and admire the richly decorated **Stadhuis (City Hall)**, designed by architect Hendrick de Keyser in 1618. Delft, a beautiful and lively university town in the south of the Netherlands, hasn't changed much since that time, when it was a busy and prosperous city, home to numerous artists and artisans. The map of the old city center still looks the same, and the streets and canals still have the same names as they did in Vermeer's day.

∧ The Vermeer Center

The **Nieuwe Kerk (New Church)** that dominates the Markt Square was built in the late 14th century. This is where Vermeer was baptized. The painter must have witnessed the devastation after the gunpowder disaster of 1654, which destroyed the building's roof and stained-glass windows, and from his nearby home he would have heard the same ringing bells that we hear now. The church tower, however, looks different today. It had to be restored after lightning struck the steeple in 1872. The current tower, designed by architect Pierre Cuypers, is much taller than the one in Vermeer's time. The church itself is well worth a visit, and it is still used as the burial place for the House of Orange. The crypt serves as the final resting place for 46 members of this royal family. There is also a large mausoleum where William of Orange (1533–1584) is buried. Designed by Hendrick de Keyser in 1614, it is one of the finest examples of Dutch baroque sculpture.

WALKING TOUR

The best way to start a walking tour through Delft is with a visit to the **Tourist Information Point**, around the corner from **City Hall** at Hippolytusbuurt 4. There you can find maps marked with all points of interest related to Vermeer. At each of these sites, you will find a cube with background information on the painter's life and work. You will need a little bit of imagination, though, because there is not much physical evidence to remind of Vermeer: The houses in which he once lived have been demolished to make room for roads, or more contemporary buildings have replaced them; and unfortunately, no paintings by Vermeer remain in Delft. In the past few centuries, his artwork has been spread around the world. Most of it is now housed in prestigious international museums, including the Metropolitan Museum of Art in New York City and the National Gallery in London. The nearest establishment at which to see a work by Vermeer is the Mauritshuis, in The Hague (see sidebar on page 118), which owns the famous *Girl with a Pearl Earring (1665)* and *View on Delft (1659–60).*

At the **Vermeer Center**, only a few steps away from the Tourist Information Point on Voldersgracht 21, you have the chance to see high-resolution reproductions of all of Vermeer's works. The museum is housed in the reconstructed building of St. Luke's Guild, the artists' society where Vermeer was dean of painters for many years, and which functioned as a meeting place for artists until 1870. On

⌃ The Vermeer Center

the ground floor, the gift shop offers a wide range of Vermeer-themed books, posters, cards, and souvenirs. Upstairs, in the studio, you can learn about Vermeer's mastery of light, composition, and color with the aid of 17th-century lenses, "goggle boxes" (which have two holes through which you can look to see a three-dimensional diorama). There's also a camera obscura, a kind of early webcam that projects live images from the Markt Square. Art historians, however, doubt that Vermeer ever used the camera obscura to help him paint the right perspective. A recent study of inventory lists of 17th-century Delft households shows that no such instrument was found in Delft at that time.

Walking out of the Vermeer Center into the Oude Manhuissteeg and facing the Markt Square once again, you are now standing on the site where Huis Mechelen once was. Vermeer's father, Reynier Jansz, bought the tavern—a meeting place for local artists—in 1641 for 2,700 guilders. In 1885 the house was demolished to make room for traffic. A remembrance stone was placed in the wall of the house on **Markt 52**.

There are art historians who believe that Vermeer painted his famous work *The Little Street* (1657–58) (now in the Rijksmuseum, in Amsterdam) from the back room

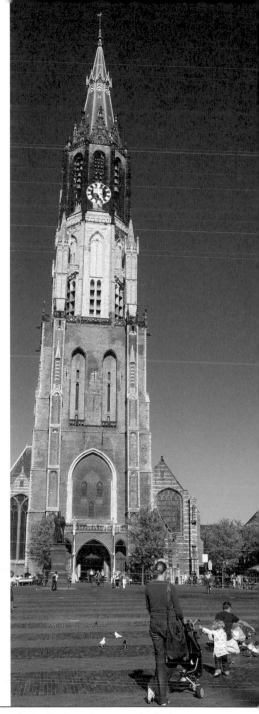

^ **Nieuwe Kerk (New Church),** located in Markt Square is the site where Vermeer was baptized

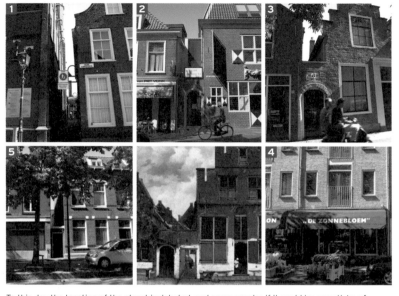

WHERE IS THE LITTLE STREET?

To this day the location of the street is debated, and some wonder if it could be a pastiche of architecture typical of the city. [clockwise from top left] **Oude Langendijk 25, Voldersgracht 21, Achterom 47, Nieuwe Langendijk 22-24-26**, *The Little Street*, and **Vlamingstraat 22.**

of Huis Mechelen. Around 1658, when Vermeer painted his masterwork, the old people's home on Voldersgracht 21 was demolished to make room for the new St. Luke's Guild. It is possible that Vermeer wanted to capture the view before it was lost, but there is no evidence to support this theory. Over the years, art historians have come up with several possible locations for the scene depicted in the painting. The most plausible one is a little row of houses on the **Nieuwe Langendijk** at numbers 22, 24 and 26. These houses were demolished in 1982, but archaeological research has proved that there could have been two parallel alleyways as shown in the painting. It's also possible that the street and houses depicted in the work never existed.

Walking farther, you will pass **Voldersgracht 25,** Vermeer's birthplace, then the location of his father's tavern De Vliegende Vos. Today, it is a center for dental surgery. Though nothing is known about Vermeer's childhood, it can be assumed that this is the street where he played as a young boy.

At the end of Voldersgracht, make a right turn on Vrouwenrecht and another right turn on the Oude Langendijk. On this street, now a major shopping area, Vermeer and his wife, Catharina, lived for at least 15 years with his mother-in-law. The house was situated near the Molenpoort on the corner of the Jozefstraat, now the site of a church named **Maria van Jessekerk**. Thanks to the inventory that was written two months after Vermeer's death, in 1675, we know a lot about the interior and decor of the house, which had numerous rooms and contained three paintings by Carel Fabritius. For a detailed description of all the rooms, visit www.johannesvermeer.info, which also offers a virtual reconstruction of the house.

Take a left turn at Jozefstraat and another left on Burgwal. You will now reach the **Beestenmarkt**, an old square where livestock was sold in Vermeer's time. Today it is filled with bars, restaurants, and terraces. Vermeer's father was born at Beestenmarkt 26. Later on, he started his own family at number 14, above what was then a tavern called De Drie Hamers (The Three Hammers).

Leave the Beestenmarkt on the opposite side and make a right turn on Molslaan. Here you'll find the **Hotel Johannes Vermeer** from numbers 18 to 22. This hotel, situated in a former cigar factory, has 30 rooms named after Vermeer's paintings, and reproductions of his works hang in every room. There is also a Delft Blue Suite. The hotel's restaurant is called Brasserie 't Straatje van Vermeer, named after Vermeer's painting, *The Little Street*.

Walking farther on Molslaan and turning left on Brabantse Turfmarkt, which leads into Achterom, you will reach a small harbor called De Kolk. On the other side of the water lies the Hooikade, the place where Vermeer painted his magnificent **View on Delft**. To see the view for

⌃ **Beestenmarkt** was an old square where livestock was sold during Vermeer's time. Today it is a popular tourist area filled with bars and restaurants

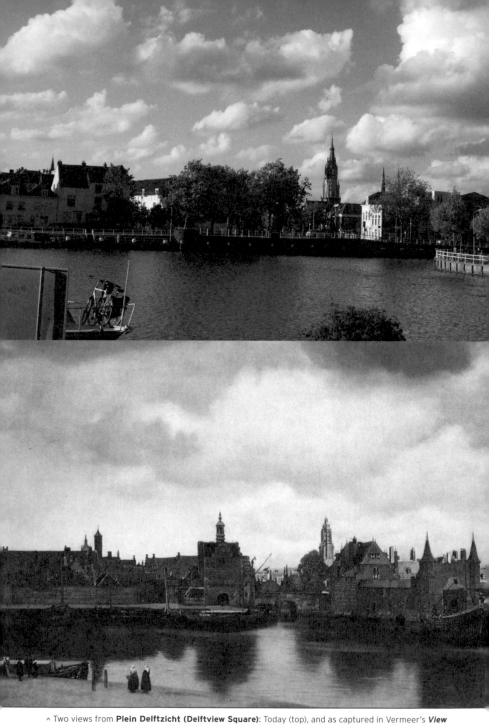

^ Two views from **Plein Delftzicht (Delftview Square)**: Today (top), and as captured in Vermeer's ***View of Delft***, painted between 1660-1661 and currently on display at Mauritshuis, The Hague

yourself, climb the elevated **Plein Delftzicht (Delftview Square)**, which features a semicircular terrace that allows you to view Delft from exactly the same perspective that Vermeer did. You will notice there is little that evokes the painting's skyline. Not a single stone remains of the two city gates, the Schiedamse Poort and the Rotterdamse Poort, both destroyed between 1834 and 1836. Heavy traffic, motorboats, and trains have replaced the once-serene atmosphere. The tower of the New Church, brightly lit by the sun in Vermeer's painting, looks different today. Only the tower of the Old Church, on the left side of the painting, remains unchanged. In the 17th century, De Kolk was a busy harbor. The Schie canal linked Delft directly to cities like Rotterdam and Schiedam and was a major transportation route. Vermeer painted his *View of Delft* only a few years after the enormous gunpowder explosion in the arsenal, on October 12, 1654, which destroyed a quarter of the city; but in the painting, everything is peaceful again.

Crossing the street back to the city center, you can follow the picturesque canal of Oude Delft to the **Prinsenhof Museum**. This wonderful city museum, housed in a former convent, gives an impression of the artistic and scientific life in the 17th century and also displays paintings by Vermeer's contemporaries. Here you'll find, for example, the painting *Mountain Landscape with Travelers* (1626), by Pieter Anthonisz van Groenewegen, a work that Vermeer referred to twice in the background of ***A Lady Standing at a Virginal*** (1670–72). (He did, however, take the artistic liberty of making small adaptations where he deemed necessary.) Also noteworthy is the facsimile of the master book of St. Luke's Guild, containing the registration of Johannes Vermeer in 1653. In the courtyard of the museum, you'll find the small shop Winkeltje Kouwenhoven. The shop sells traditional Dutch candies and toys and its interior dates from the end of the 19th century.

Opposite the Prinsenhof Museum is the **Oude Kerk (Old Church)**, with its striking leaning tower. This was Vermeer's final resting place. The original grave was cleared at the end of the 18th century, like all the other graves in the church, and Vermeer's remains were thrown away in an anonymous mass grave. Today, a simple tombstone marks the location of the former grave, and in 2007, the Vermeer Center placed a new and bigger stone in one of the aisles to commemorate the greatest painter who ever lived in Delft.

∧ A stone marking Vermeer's grave located in the **Oude Kerk (Old Church)**

WHERE TO SEE...THE WALKING TOUR

Stadhuis, Nieuwe Kerk and Tourist Information Point

3 Tourist Information Point
Markt Square
🏠 Hippolytusbuurt 4
☎ 31 (0) 15 215 40 51
🖥 www.delft.nl
○ Apr-Sep Sun-Mon 10AM-4PM,
Tue-Fri 9AM-6PM, Sat 10AM-5PM;
Oct-Mar Mon 11AM-4PM, Tue-Sat
10AM-4PM, Sun 10AM-3PM
Located in Delft's city center, this
is the place to go for all your
traveling needs.

5 Markt Square 52
Though only a plaque marks
its place, this is the location
of Vermeer's childhood home,
which is no longer in existence.
Huis Mechelen was the second
tavern that his father owned.

6 Voldersgracht 25
This is the location of
Vermeer's birthplace and his
father's tavern De Viegende
Vos (The Flying Fox).

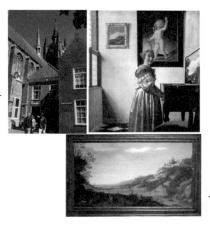

9 Plein Delftzicht /
Delftview Square
This is the site from
where Vermeer painted
View of Delft.

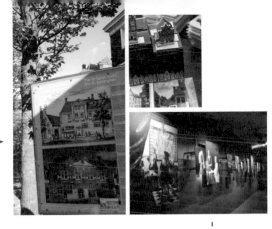

4 **The Vermeer Center**
🏠 Voldersgracht 21
☎ 31 (0) 15 213 85 88
🖥 www.vermeerdelft.nl
○ Daily 10AM-5PM
💲 6 Euros
Formerly St. Luke's Guild, the Vermeer Center features exhibits about the artist, including high-resolution reproductions of all his work.

8 **Beestenmarkt**
A popular square, and, at number 26, the place where Vermeer's father was born.

7 **Maria van Jessekerk**
Burgwal 20
The church where Vermeer's home once stood now features a plaque honoring the artist.

10 **Princenhof Museum**
🏠 Sint Agathaplein 1
☎ 31 (0) 15 260 23 58
🖥 www.princenhof-delft.com
○ Tue-Sun 11AM-5PM
This museum displays work by many of Vermeer's contemporaries.

‹Vermeer's 1670-72 painting, **A Lady Standing at a Virginal**,(National Gallery, London) references **Mountain Landscape with Travelers** (1626) [below] by Pieter Anthonisz van Groenewwegen, (Princenhof Museum).

11 **Oude Kerk / Old Church**
🏠 Heilige Geestkerkhof 25
☎ 31 (0) 15 212 30 15
🖥 www.oudekerk-delft.nl
○ Apr-Oct Mon-Sat 9AM-6PM
Nov-Mar Mon-Fri 11AM-4PM, Sat 10AM-5PM
💲 3.30 Euros
The landmark church where Vermeer was buried.

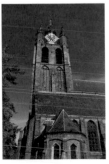

KONINKLIJKE PORCELEYNE FLES / ROYAL DELFT FACTORY
⌂ Rotterdamseweg 196
☎ 31 (0) 15 251 20 30
🖥 www.royaldelft.com
○ Mid Mar-Oct Daily 9AM-5PM
Nov-Mid Mar Mon-Sat 9AM-5PM
● Dec 25, Dec 26, Jan 1
$ 6.50 Euros

LEGER MUSEUM (ARMY MUSEUM)
⌂ Korte Geer 1
☎ 31 (0) 15 215 05 00
🖥 www.legermuseum.nl
○ Tue-Fri 10AM-5PM
Sat-Sun 12PM-5PM
● Mondays, Dec 25, Jan 1
$ 7.50 Euros

LAMBERT VAN MEERTEN MUSEUM
⌂ Oude Delft 199
☎ 31 (0) 15 260 23 58
🖥 www.lambertvanmeerten -delft.nl
○ Tue-Sun 11AM-5PM
● Dec 25, Jan 1, Easter
$ 3.50 Euros

PAUL TÉTAR VAN ELVEN MUSEUM
⌂ Koornmarkt 67
☎ 31 (0) 15 212 42 06
🖥 www.museumpaultetar vanelven.nl
○ Apr-Oct Tue-Sun 1PM-5PM, or by appointment
$ 3.50 Euros

WHERE TO SEE... SCENE STEALERS

1 Koninklijke Porceleyne Fles / Royal Delft Factory

There are several potteries in Delft that still make the world-famous Delft Blue earthenware. The Royal Delft Factory, which has been in existence since 1653, is the only remaining outpost of the 32 earthenware factories that were established in the 17th century. Here you can still see the painters at work. A guided tour leads visitors through the factory and exhibition rooms.

2 Leger Museum / Army Museum

Discover the military history of the Netherlands through a massive collection of tanks, uniforms, firearms, paintings, and more. Located in the city center, the museum has a special connection to the House of Orange and Queen Wilhelmina (1880–1962). Numerous events and exhibitions take place here. During weekends and holidays a number of activities are offered for the entire family to enjoy.

3 Lambert van Meerten Museum

Located in the former home of Lambert van Meerten (a well-known Dutch art and antiques dealer), this museum features an important collection of art, furniture, and paintings. It also has an extensive display of Delftware and a 17th-century period room in the style of Vermeer.

4 Paul Tétar van Elven Museum

Formerly the residence of the painter and collector Paul Tétar van Elven, this museum contains period rooms from the 17th, 18th, and 19th centuries. It features antiques, painted ceilings, and a reproduction of the artist's workshop all in Old Dutch style.

^ Lambert van Meerten Museum

THE PRINSENHOF MUSEUM

Delft's Stedelijk Museum Het Prinsenhof dates from the beginning of the 15th century when it was built as a convent for a community of Catholic nuns and dedicated to Saint Agatha. When Delft fell into Protestant hands in 1572 the convent was confiscated and handed over to the Dutch royal family, who were known as the House of Orange. William I of Orange (William the Silent) took up residence in the cloister, which was then rechristened the Prinsenhof. William opposed the persecution of Dutch Protestants and led the uprising against Philip II of Spain and the Spanish Occupation in what would become known as the Eighty Years' War. In 1584, William I of Orange was assassinated by Balthasar Gerards, a Catholic fanatic who was loyal to Philip II. On the staircase leading from the dining room in the Prinsenhof, Gerards shot William at close range. To this day, two bullet holes are still visible in the stone wall of the stairway. William I of Orange, who would later be hailed as the founder of the new Dutch state and the father of his country, bears the unfortunate distinction of having allegedly been the first head of state to be assassinated with a handgun.

The Prinsenhof has been used as a museum since 1887 and contains a rich overview of Delft life, with particular attention paid to the 16th and 17th centuries. Its permanent collection features work by well-known artists and artisans from Delft, including collections of antique Delftware, tapestries, and works in silver. It also feature exhibits devoted to the House of Orange and the Eighty Years' War of 1568-1648 (also known as the Dutch War of Independence against Spain). The art collection includes still-lifes, portraits of the royal family, city scenes, religious pieces by Dutch masters such as Maerten van Heemskerck, and church interiors by Gerard Houckgeest and Emanuel de Witte. While the Prinsenhof does not contain any works by Vermeer, it does contain several paintings that echo his *View of Delft*, including similar scenes painted by H.C. Vroom and Daniel Vosmaer. The museum is also an excellent place to see maps and paintings that illustrate what Delft looked like in Vermeer's time, including several paintings by Egbert van der Poel portraying the "Delft Thunderclap," the catastrophic gunpowder magazine explosion in 1654 that damaged much of the old city.

⌃ [top]The **Prinsenhof Museum** and bullet holes from the assassination of William I
[bottom center] ***Explosion of the Gunpowder Magazine on 12 October 1654*** painted by Daniel Vosmaer,
[bottom right] ***Map of Delft*** (1536), the oldest painted map of a city in the northern Netherlands

**LA VIE RESTAURANT &
BRASSERIE**
🏠 Binnenwatersloot 7
☎ 31 (0) 15 214 47 22
🖥 www.lavie-delft.nl
○ Mon-Sun 12PM-10PM
$ 25-45 Euros

**RESTAURANT VAN DER
DUSSEN**
🏠 Bagijnhof 118
☎ 31 (0) 15 214 72 12
🖥 www.
restaurantvanderdussen.nl
○ Mon-Sat 5:30PM-Close
● Sundays
$ 35-40 Euros

DE VERBEELDING
🏠 Verwersdijk 128
☎ 31 (0) 15 212 13 28
🖥 www.
eetcafedeverbeelding.nl
○ Lunch 11AM-3PM
Dinner 5PM-Close
$ 12-23 Euros

**DE KURK RESTAURANT
AND CAFÉ**
🏠 Kromstraat 20
☎ 31 (0) 15 214 14 74
🖥 www.dekurk.nl
○ Sun-Sat 5:30PM-10PM;
Café: Sun-Wed 4:30PM-
1AM, Thu 4:30PM-3AM,
Fri-Sat 4:30PM-5AM
$ 25-60 Euros
Bar: 5:30PM-8PM
$ 7-10 Euros

WHERE TO...EAT AND SLEEP

EAT
A La Vie Restaurant & Brasserie
Brasserie La Vie features fresh, seasonal French and Mediterranean dishes in a warm and sophisticated environment. In spring and summer, enjoy lunch and dinner outside on the restaurant's terrace barge.

B Restaurant Van Der Dussen
Located in a building complex that dates back to 1286, this restaurant has been a convent, a bakery, and a garrison for Napoleon's officers. With its historic ambiance, open kitchen and summer boat service, Restaurant Van Der Dussen is a unique way to enjoy fresh, Mediterranean-style cuisine while staying in Delft.

C De Verbeelding
A friendly, inexpensive spot for Dutch, French, and Italian dishes, De Verbeelding has a cozy feel, with book-lined walls and eclectic art. It features a lunch buffet from 11-3 and a terrace barge in the summer months.

D De Kurk Restaurant and Café
Serving Dutch, French, and international cuisine for over 35 years, De Kurk recently underwent a facelift, adding a glass-roofed "winter garden." While you're here, don't miss the broodjes, traditional Dutch sandwiches.

SLEEP

E Hotel de Ark

On a brick-paved street beside one of Delft's most beautiful canals, Hotel de Ark occupies three beautifully restored canal houses. Most guest rooms have views of the canal and the breakfast room is true to the houses' 17th-century style. The Hotel de Ark is centrally located, just a five-minute walk from the marketplace or the train station.

F Bridges House Hotel

Famed Dutch Master Jan Steen once lived—and painted—in this elegant boutique hotel located on the oldest canal in Delft. Listed as a national historic landmark, the Bridges House has suites as well as rooms, and the breakfast area overlooks the tree-lined canal.

G Hotel Johannes Vermeer

A former cigar factory that was built in 1907, this modern hotel has a unique feature: One of its guestrooms is the former factory's boardroom. Located on a quiet canal in the center of Delft, the hotel has 25 rooms and five junior suites and features reproductions of most of Vermeer's best-loved paintings.

H Best Western Museumhotels Delft

This hotel consists of 12 elegant canal houses just steps from the Prinsenhof Museum. The reception area is filled with the hotel's collection of art and antiques. Many rooms are uniquely furnished. Ask for one in the back, since the church bells across the street ring all night.

⌃ Café at **Hotel Johannes Vermeer**

SLEEP

HOTEL DE ARK
⌂ Koornmarkt 65
☎ 31 (0) 15 215 79 99
🖥 www.deark.nl
$ 115 Euros-

BRIDGES HOUSE HOTEL
⌂ Oude Delft 74
☎ 31 (0) 15 212 40 36
🖥 www.bridges-house.nl
$ 90 Euros-

HOTEL JOHANNES VERMEER
⌂ Molslaan 18-22
☎ 31 (0) 15 212 64 66
🖥 www.hotelvermeer.nl
$ 110 Euros-

BEST WESTERN MUSEUMHOTELS DELFT
⌂ Phoenixstraat 50A
☎ 31 (0) 15 215 30 70
🖥 www.museumhotel.nl
$ 110 Euros-

MAP OF VENUES AND CITY LANDMARKS

1 Stadhuis (City Hall)
2 Nieuwe Kerk (New Church)
3 Tourist Information Point
4 The Vermeer Center
5 Markt Square 52
6 Voldersgracht 25
7 Maria van Jessekerk
8 Beestenmarkt
9 Plein Delftzicht (Delftview Square)
10 Princenhof Museum
11 Oude Kerk (Old Church)

1 Koninklijke Porceleyne Fles (Royal Delft Factory)
2 Leger Museum (Army Museum)
3 Lambert van Meerten Museum
4 Paul Tétar van Elven Museum

1 Oude Langendijk 25
2 Voldersgracht 21
3 Achterom 47
4 Nieuwe Langendijk 22-24-26
5 Vlamingstraat 22

A La Vie Restaurant & Brasserie
B Restaurant Van Der Dussen
C De Verbeelding
D De Kurk Restaurant and Cafe
E Hotel de Ark
F Bridges House Hotel
G Hotel Johannes Vermeer
H Best Western Museumhotels Delft

B Oude Delft
Voorstraat

3
Oude Kerkstraat
11
Helige Geestkerkolf
10
H
3 i
Haist
Phoenixstraat

aan
Kloksteeg
Peperstr
F
Havenstraat
Bolwerk
A
Smitsteeg
Buitenwatersloot
Westvest

Raamstraat
DELFT STATION
Van Bleyswijckstraat

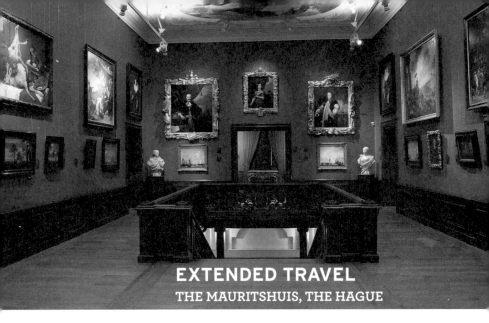

EXTENDED TRAVEL
THE MAURITSHUIS, THE HAGUE

THE MAURITSHUIS
⌂ Korte Vijverberg 8
The Hague
☎ 31 (0) 70 302 34 56
🖥 www.mauritshuis.nl
○ Tue-Sat 10AM-5PM
Sun 12PM-5PM
● Mondays from Sep-Mar,
Dec 25, Jan 1
$ 10.50-13.50 Euro

ACCESS:
To get to The Hague from
Delft, take the tram #1
to Den Haag HS, then
change to tram #10, 16,
or 17 to Korte Voorhout.
Total traveling time is
approximately 25-30
minutes.

The Mauritshuis is home to an impressive collection of Dutch masters, including works by Vermeer, Pieter Bruegel, Rembrandt, Rubens, Rogier van der Weyden, Jan Steen and Paulus Potter. The former residence of Prince John Maurice, a cousin of the ruling family in Holland, The Mauritshuis became a state museum in 1822 and a private foundation in 1995. Its renowned collection of three masterpieces by Vermeer includes *Girl with a Pearl Earring*, which Dutch citizens voted "the most beautiful painting in Holland," as well as *View of Delft*, which Marcel Proust once called "the most beautiful painting in the world." The Hague, which is the seat of government in Holland (while Amsterdam is the capital), is known as the International City of Peace and Justice, and is also headquarters for many international judicial organizations, including the judicial branches of the United Nations. The Hague, which is only a short tram or train ride from the center of Delft, is also home to the Gemeentemuseum, which houses the world's largest collection of works by Dutch painter Piet Mondrian, and a museum dedicated to the work of Dutch graphic artist M.C. Escher.

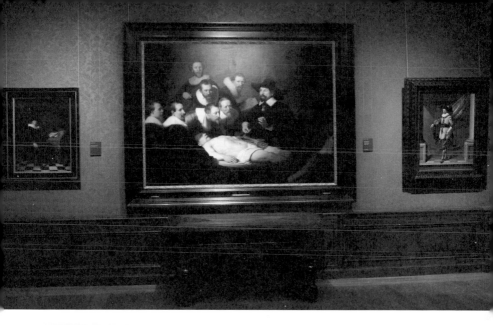

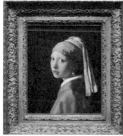

Girl with a Pearl Earring, 1665-1667
Mauritshuis, The Hague

The painting that inspired the novel that inspired the film, this tronie–a generic painting of a head or bust–focuses on a single pearl. The painting has been dubbed "The Mona Lisa of the North," in part because of the girl's mysterious gaze.

Diana and Her Companions, 1653-1656
Mauritshuis, The Hague

This early work follows the tradition of mythological painting, quite popular at the time. The subject matter suggests that Vermeer studied with a master history painter, most likely in Amsterdam or Utrecht.

View of Delft, 1660-1661
Mauritshuis, The Hague

The artist's idealized depiction of his hometown features local landmarks including the Nieuwe Kerk and the Rotterdam Gate. Vermeer painted the scene from a house on the opposite side of the Schie River, and today visitors to Delft can get a glimpse of what Vermeer would have seen from Plein Delftzicht.

∧ [top] *The Anatomy Lesson of Dr. Nicolaes Tulp* (1632), painted by Rembrandt van Rijn, can be found at The Mauritshuis in The Hague.

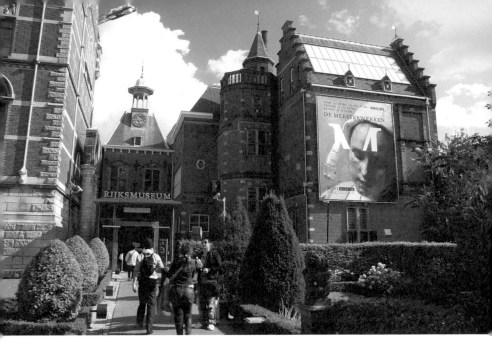

EXTENDED TRAVEL

THE RIJKSMUSEUM, AMSTERDAM

Amsterdam's Rijksmuseum, which is perhaps best known for Rembrandt's *The Night Watch*, also includes four works by Vermeer in its permanent collection. The Rijksmuseum (or literally "National Museum") was founded in 1800 in The Hague but was moved to Amsterdam in 1808 by Louis Bonaparte, who had been installed as King of Holland by his brother Napoleon. Construction of the current building began in 1876 and was completed in 1885. Of the museum's four paintings by Vermeer, perhaps the best known is *The Milkmaid* (also known as *The Kitchen Maid*) from 1658. In it, a woman wearing a bright yellow dress and blue apron is depicted pouring milk in a room, which appears unadorned except for traditional Delft tiles along the floor. *The Love Letter*, *The Little Street* and the regal *Woman in Blue Reading a Letter* round out the Rijksmuseum's collection of Vermeers. The museum's permanent collection also includes works by such Dutch masters as Jacob van Ruysdael, Franz Hals, and, of course, Rembrandt and his students. Although the Rijksmuseum is under renovation until 2013, one of the building's wings will stay open until the work is completed and is well worth the 45-minute train ride from Delft.

^The **Rijksmuseum**; [opposite page clockwise from top] Vermeer's signature, *The Little Street, The Milkmaid, Woman in Blue Reading a Letter,* Rembrandt's *The Night Watch* and *The Love Letter*

THE RIJKSMUSEUM
⇧ Jan Luijkenstraat 1
Amsterdam
☎ 31 (0) 206 74 70 00
🖥 www.rijksmuseum.nl
○ Daily 9AM-6PM
Fri 9AM-8:30PM
$ 11 Euro

ACCESS:
To get to Amsterdam from
Delft, take the train to
Amsterdam Central Station
(traveling time is about
45 minutes) or take tram
2 or 5 to Hobbemastraat
(traveling time about 20
minutes).

THE MILKMAID

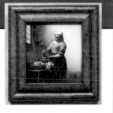

Painted between 1657 and 1658, *The Milkmaid* marks an important moment in Vermeer's career: His break from Dutch tradition to a polished style all his own.

The image shows a kitchen maid pouring milk into a bowl, possibly making bread pudding, lit by the light from a nearby window. Though it appears she has been caught candidly performing her daily chores, the image is carefully composed. The maid and her work are arranged in a pyramid; she is dressed in primary colors. The painting's color palette has become closely associated with Vermeer—rich lead-tin yellow and the artist's signature tint, the luxurious Vermeer blue, an ultramarine hue made from crushed lapis lazuli.

Vermeer's illusionistic, near-photographic realism is painstakingly detailed, and the artist was notorious for working slowly. His subtle use of light was created with a combination of brushstrokes and pointillist dots, which give a shimmering light to the objects on the table. His figure is substantial, almost tangible. Perspective gives the maid a heroic quality, shown as she is from below.

The image is laden with the subtle erotic symbolism of the day, possibly at the behest of his patron Pieter van Ruijven. From the milky white skin of the maid's bare forearms to the tiny cupid on a tile on the floor, the painting is filled with an idealized yet unattainable sexuality—though with much more restraint than similar contemporary milkmaid scenes.

More than 350 years after she was painted, Vermeer's humble milkmaid still captivates viewers. In 2009, New York's Metropolitan Museum of Art dedicated an entire show to the canvas.

ANATOMY OF A MASTERPIECE

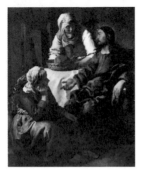

Christ in the House of Martha and Mary, 1654–1655
National Gallery of Scotland, Edinburgh
Vermeer's early history paintings were larger in scale and warmer in pallete than the genre scenes for which he became known. Compared to later paintings, his treatment of drapery is overly simplistic and his pigments inexpensive.

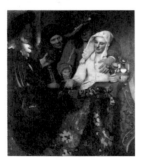

The Procuress, 1656
Gemäldegalerie Alte Meister, Dresden
The Procuress marks a dramatic change for Vermeer—his first experiment with contemporary figures. It was a common practice for artists of the day to insert themselves in such scenes, and the figure staring out at the viewer (with his goofy grin and elaborate costume) may be Vermeer himself.

A Maid Asleep, 1657
Metropolitan Museum of Art, New York
With this painting, Vermeer began to explore the interior scenes for which he would become famous. The cupid in the painting within the painting suggests that the female figure is dreaming of love. The shadowy scene calls to mind Rembrandt and Caravaggio, both influential in Holland at the time.

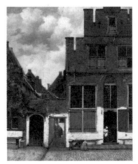

The Little Street, 1657–1658
Rijksmuseum, Amsterdam
One of the artist's few signed paintings, *The Little Street* is a quaint image of daily life in Delft. The painting features children playing—Vermeer's only known portrayal of childhood—as well as working maids, perhaps a nod to the Protestant values of cleanliness and hard work prevalent in Holland at the time.

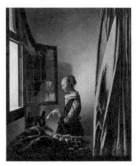

A Girl Reading a Letter by an Open Window, 1657–1659
Gemäldegalerie Alte Meister, Dresden
As Vermeer explored interiors, his compositions became denser and filled with careful detail—all the better to please wealthy patrons. Vermeer used a variety of brushstrokes—from thickly applied impasto highlights to nearly pointillist daubs of color—to realistically render light, shadow, and texture.

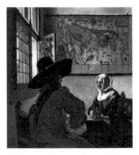

Officer and a Laughing Girl
1655–1660
Frick Collection, New York
The relationship between

the figures in this painting is ambiguous, but what is obvious are some recurring themes in Vermeer's work—the primary color palette, the sumptuous treatment of clothing, the strong natural lighting, and the decorative use of maps.

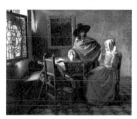

The Glass of Wine, 1658-1660
Gemäldegalerie, Berlin
This painting shows the influence of artist Pieter de Hooch in subject matter, setting, and scale. In it, we see Vermeer maturing as an artist, with smoother brushstrokes and finer detail in the architecture, decorations, and figures. It also shows a heightened sense of composition—the figures are invisibly inscribed in a circle, linking them subconsciously.

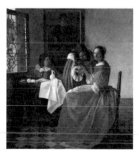

The Girl with a Glass of Wine 1659-1660
Herzog Anton Ulrich-Museum, Brunswick
Smoother than Vermeer's earlier work, the painting's careful application of paint matches its genteel

subject matter—the rights of courtship. The female figure in the stained glass may symbolize temperance or restraint, a counter to the gentleman slumped over in the background.

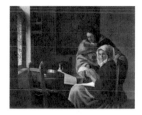

Girl Interrupted in Her Music 1658-1661
Frick Collection, New York
Like the larger picture, *The Glass of Wine*, this painting shows two figures arranged in a circular composition. One difference is the much more intimate relationship between the viewer and the figures, which are jammed right up to the edge of the canvas.

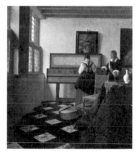

The Music Lesson, 1662-1664
The Royal Collection, Windsor Castle
The Music Lesson explores a popular theme in Dutch painting—the harmony expressed in both love and music. Though we cannot see the woman's face, the painting utilizes perspective to draw the viewer's eye directly to her.

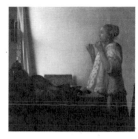

Woman with a Pearl Necklace 1664
Gemäldegalerie, Berlin
Vermeer was a master of painting light, underscored in this painting by the stark contrast between the dark blue drapery of the foreground and the creamy whitewashed walls in the back. The work showcases items commonly found in 17th-century Dutch homes, including blue-and-white Chinese-style pottery.

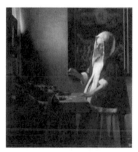

Woman Holding a Balance 1662-1665
National Gallery of Art, Washington, D.C.
While it was once thought that the woman in this painting was weighing pearls, it is now understood that the balance she holds is empty. Standing before a painting of the Last Judgment, she is seemingly pregnant and wearing the traditional blue robes of the Virgin Mary—giving the painting a spiritual meaning.

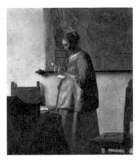

Woman in Blue Reading a Letter, 1662-1665
Rijksmuseum, Amsterdam
Much simpler in composition than Vermeer's earlier work, this painting features a central figure lost in her thoughts, possibly modeled after the artist's own wife, Catharina. By this point in his career, Vermeer was utilizing a more subdued color palette, though extravagant ultramarine remained his hue of choice, dominating this canvas.

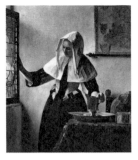

Young Woman with a Water Pitcher, 1662-1667
Metropolitan Museum of Art, New York
Harmonic in composition without the rigid geometry of the artist's earlier work, this painting delights in many of his familiar motifs: the single figure, the map on the wall, the contemporary dress—rendered of course, in his signature shade of blue.

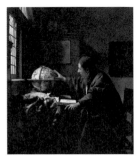

The Astronomer, 1669
Musée du Louvre, Paris
Science was a favorite subject of 17th-century Dutch painters, and the astronomer painted here is believed to be Anton van Leeuwenhoek, the Delft scientist who invented the microscope. A strong control of perspective draws the eye directly to the astronomer's hand.

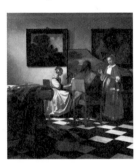

The Concert, 1663-1666
Isabella Stewart Gardner Museum, Boston
The musical gathering was a popular theme, as seen in this canvas, and in the Dirck van Baburen painting on the wall. Stolen from a Boston museum in 1990, it remains unaccounted for. It is considered the most valuable painting ever stolen.

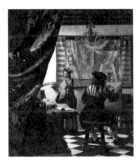

The Art of Painting, 1662-1668
Kunsthistorisches Museum, Vienna
Today, this allegorical painting is the closest thing we have to a self-portrait of Vermeer. The largest of his works, it is extremely complex—from the drapery in the foreground to relationship between the two figures. The female figure holds a trumpet, the symbol of Clio, the muse of history.

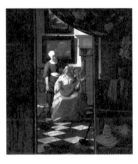

The Love Letter, 1667-1670
Rijksmuseum, Amsterdam
In this interior scene with incredible depth, a draped curtain at the corner of the painting gives the illusion that the viewer is secretly witnessing a candid moment. Subtle clues in the paintings in the background lead us to believe that the woman's lover is on a journey, though Vermeer often left the meaning of his works ambiguous.

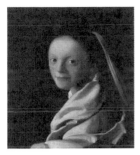

Study of a Young Woman
1665-1674
Metropolitan Museum of Art, New York

Similar to his famous *Girl with a Pearl Earring*, this study lacks the rich interior settings seen in most of Vermeer's work. This version also lacks the luminosity that made the artist famous. The figure's plain, unidealized face suggests it may have been a commissioned portrait.

The Allegory of Faith
1671-1674
Metropolitan Museum of Art, New York

This unusual—and unusually large—picture stands out among Vermeer's work and was probably commissioned by a Catholic patron. It features standard symbols from Cesare Ripa's *Iconologia*, a handbook of iconography.

A Young Woman Standing at a Virginal, 1670-1675
National Gallery, London

A woman at a virginal was a recurring theme towards the end of Vermeer's career. This canvas may have been intended as a pendant—or partner—to *A Young Woman Seated at a Virginal*, also at the National Gallery. At the time, the virginal was a symbol of the tie between music and romantic love.

SOUVENIRS

Key Chain
4.40 Euros
Mauritshuis

Delft Blue Plate
3.50-7.50 Euros
Vermeer Center

Vermeer Stamp Sheet
4.50 Euros, Vermeer Center

johannes VERMEER DELFT

computer mousemat

Computer Mouse Pad
11.50 Euros
Mauritshuis

GOYA and Madrid

Courtier and Old Master portraitist, harsh social critic, and modern Expressionist—perhaps no artist personifies Madrid at the crossroads of the 18th and 19th centuries more than Francisco José de Goya y Lucientes. Arriving in Madrid to work at the Royal Tapestry Factory in 1775, Goya served the Bourbon court and Madrid society. In 1786 Goya was given the post of painter to the king, and then went on to paint four kings and countless noble families at the Royal Palace of Madrid. His passions and his political canvases turned him into one of the first truly "modern" artists. Goya served the court for over 50 years, only leaving Madrid in 1824 when the repressiveness of the new regime led him to choose exile in France. He died there at the age of 82.

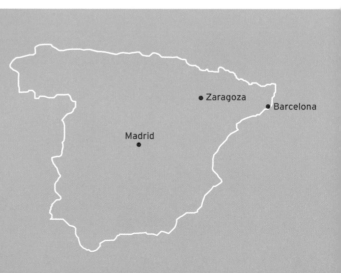

BY GEORGE STOLZ

Francisco José de Goya y Lucientes (1746-

1828) first came to Madrid in 1763. A city rich in cultural diversity and historical significance, Spain's capital is known for its vibrant nightlife and the easygoing nature of its residents. It's also a place celebrated for its ability to constantly reinvent itself—a characteristic closely associated with the artist. In 1763, Goya was a teenager from the provinces, aspiring to be an artist, and hoping—but failing—to earn a scholarship from the Royal Academy of Fine Arts of San Fernando (although nearly 30 years later, he would become director of painting at the same institution). After a sojourn in Italy and a brief return to his hometown of Zaragoza, Goya was summoned back to the capital in 1775 to work at the newly established Royal Tapestry Factory.

At the factory the artist composed the images that were to be woven into the tapestries that decorated the palaces and hunting lodges favored by the 18th-century Spanish Bourbon monarchs. Always an ambitious artist, Goya chafed at the limitations of the onerous and often formulaic tapestry commissions. Most of the images he created depict folkloric scenes documenting the local customs and costumes of the era. Many are festive, others bucolic—children playing, young people courting, the privileged classes at the hunt. More than a few, however, sound a different note: a brawl at a country inn, an injured workman, even cats squabbling. Taken together, they showcase what were then the sights and sounds of Madrid. They also point to the direction that Goya's art would maintain over the decades, even as his style underwent radical and far-reaching change: a sustained interest in society and social mores, a shrewd observation of his surroundings, the freedom and even need to imbue both with darker and more sinister undercurrents.

In 1781, when a more promising opportunity presented itself in the form of his first important public commission, Goya seized it, producing a large canvas titled *Sermon of San Bernardino of Siena* (1784), which

< [previous]Self-portrait detail from **The Family of Carlos IV of Spain** (1800), Prado; a **flamenco dancer**
∧ **Royal Tapestry Factory**
> ***Sermon of San Bernardino of Siena*** (1784) at the **Basílica de San Francisco El Grande**

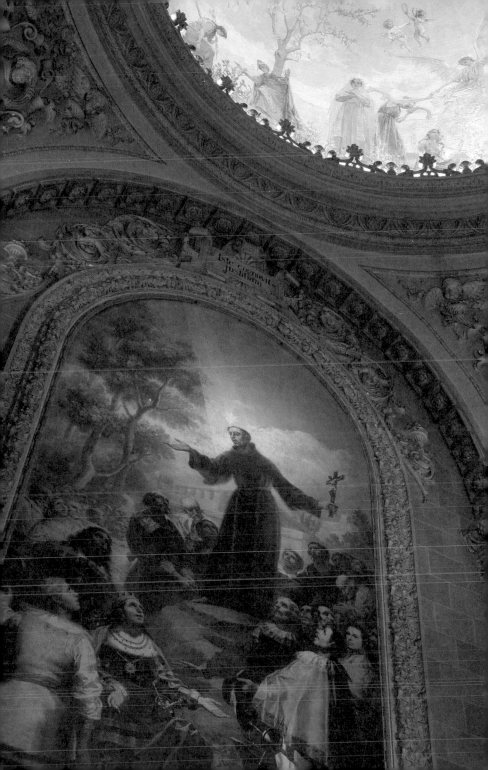

immediately established the determined young artist's position in Madrid. Today, this rare early work—found at The Basílica de San Francisco El Grande—is a popular sight for travelers.

In the following years Goya built on his success at court and in Madrid society. His services as a portraitist were prized among the Spanish aristocrats and intellectuals of the Enlightenment, and Goya developed lasting relationships with many of them. He also continued to rise in status at the royal palace and was named painter to the king in 1786, court painter in 1789, and first court painter in 1799.

Goya married Josefa Bayeu in 1773. Despite Josefa's many pregnancies, only one child (Javier, born in 1784) would survive into adulthood. They lived at various addresses in the center of Madrid—Calle del Desengaño, Calle de Valverde, Calle del Reloj, Calle del Espejo—although none of the buildings still stands. This area is currently buzzing with numerous restaurants, hotels, shops, and attractions.

∧ *Family of Carlos IV* (1800), Prado Museum, Madrid
> Frescoes depicting a miracle performed by Saint Anthony of Padua at **San Antonio de la Florida**

In 1792 Goya was struck with a near-fatal illness that left him severely debilitated, with symptoms that included tremors, dizzy spells, altered vision, and some sort of psychological disturbance that the artist himself described as a "damaged imagination." The illness, which to this day has not been reliably identified, also left him permanently deaf. This period of illness and recovery marked a turning point in Goya's long career, ushering in what is sometimes considered his "tragic period."

Throughout his lengthy convalescence Goya continued painting and drawing, and upon recovery he created some of his most monumental works, such as the stunning group portrait *The Family of Carlos IV* (1800) and the still-extant circular, ceiling frescoes (1798) at the church of San Antonio de la Florida. The frescoes depict a miracle performed by Saint Anthony of Padua, who caused a murder victim to rise from his grave in order to absolve the innocent man falsely accused of the crime. Goya converts the event into yet another typical Madrid street scene, with the common folk—children playing, women gossiping, couples flirting, beggars begging—mostly oblivious to the miracle taking place in their midst. Moreover, although the scene occupies the

TIMELINE

March 30, 1746
Francisco José de Goya y Lucientes is born is the village of Fuendetodos

1749
The artist's family moves to Zaragoza, Goya enters a religious school presided over by the Piarists

1760
At age 14, apprentices to the Zaragoza painter José Lúzan y Martinez

1763-1766
Submits entries for the Spanish Royal Academy and is denied

admission; journeys to Italy to study art

1773
Marries Josefa Bayeau, the sister of the painters Francisco and Ramon Bayeau, already established artists in Spain

1775
Moves to Madrid; selected to work in the Royal Tapestry Factory under the supervision of his brother-in-law Francisco

1778
Goes to the Royal Palace to study Velázquez's paintings

1780
Accepted into the Royal Academy of Madrid

1785
Named Deputy Director of Painting at the Royal Academy

1786
Appointed Painter to the King

1812
Josefa Bayeau Goya dies

1819
Buys the Quinta del Sordo (The House of the Deaf Man), where he later begins painting his *Black*

Paintings (Pinturas Negras) on the wall

April 16, 1828
Goya dies in Bordeaux and is buried there

1901
The artist's remains are unearthed and relocated to the church of San Antonio de la Florida in Madrid

Self-Portrait detail (1815)

ALMUDENA CATHEDRAL

dome of the church, neither the vectors of its composition nor its narrative thrust are oriented upward toward the heavens: what is taking place is very much of this world, the same world that we, the viewers, are occupying even as we observe. This was a radical gesture on the part of Goya, as was his depiction of the angels who float *below* the earthly scene. Breaking not only with tradition but with orthodoxy, Goya presents these angels as women, full-bodied and graceful and possessed of a gentle human beauty. During this period, Goya also created one of his masterworks, *Los Caprichos* (1797-98), a series of prints that were privately printed and sold at the perfume shop underneath his home and that brilliantly combine Goya's uncompromising intellect with his mastery of the graphic medium.

GOYA'S HOUSES

Housing options were not a problem for Goya, who came from a middle-class family and enjoyed early and continued success as a painter to the royal court. Born near Zaragoza, he soon moved to Madrid, where he lived in a series of comfortable homes and studios before going into exile in France at the end of his life.

Calle del Reloj 7-9
Goya was invited to Madrid in 1775 to work in the Royal Tapestry Factory. There, he and his new bride, Josefa Bayeu, moved in with Bayeu's family on the Calle del Reloj.

Carrera de San Jeronimo 66
In 1778 Goya and Bayeu moved to the Carrera de San Jeronimo, to an apartment that was the property of the Marquis de Campollano.

Calle del Desengaño 1
In 1782 Goya moved with his family to the Calle del Desengaño (the Street of Disillusionment) in northeast Madrid where he would keep a studio for over 20 years. His apartment there was above the perfume shop where the 80 images known as *Los Caprichos* were famously offered for sale in 1799 before Goya removed them 15 days later to prudently avoid issues with the Inquisition.

Calle de Valverde 15
Goya's growing prosperity as a court painter, and busy portraitist, allowed him to purchase two houses in Madrid. The first, which he bought in 1800, was on the Calle de Valverde 15, where he lived until 1819.

Calle de los Reyes 7
In 1803 Goya bought a second house on the Calle de los Reyes, which the artist gave to his only surviving child, Javier, when he married in 1805.

Quinta del Sordo
In 1819, seven years after the death of his wife, Goya bought a two-story country house on the banks of the Manzanares River and moved in with his new companion, Leocadia Weiss. The house was known as Quinta del Sordo, or House of the Deaf Man, after a previous occupant who was deaf—ironic given that Goya had lost his own hearing in 1792. It is there that Goya painted his *Pinturas Negras*, or the *Black Paintings*, directly on the walls as if their dark themes were decoration for him alone. Goya lived in this home until moving to France for political reasons in 1824.

The house where Quinta del Sordo once stood and view from a neighboring building

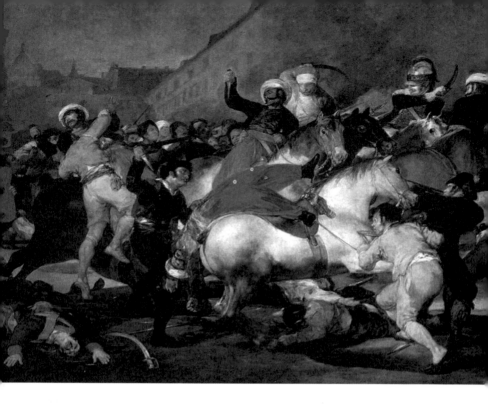

Spain, which had remained on the periphery of the Napoleonic Wars and the violent revolutionary upheavals that wracked Europe at the turn of the 19th century, found itself fully embroiled in the conflict after the 1808 French invasion of the Iberian Peninsula. The invasion, coupled with a disastrously confused political situation at the Spanish court, provoked the bloody uprisings and merciless reprisals in Madrid that Goya would later commemorate in his huge paintings *The 2nd of May, 1808* and *The 3rd of May, 1808* (both 1814). Goya also examined the war in a series of prints, commonly referred to as *The Disasters of War* (1810-20), that unflinchingly focuses on war's victims, its aftermath, and its unspeakable savagery and atrocities.

Although the war with France ended in 1814, anarchy and violence persisted in Spain. Ultimately, the restored monarch Ferdinand VII imposed a despotic regime, which engaged in bloody purges of the king's enemies—real and perceived. Goya, politically vulnerable because of his service as court painter to Napoleon's brother (who had been placed on the Spanish throne during the French occupation), managed to escape the reprisal—although barely. He was also brought before (but not condemned by) the

‸ [top] ***The 2nd of May, 1808*** [next page] ***The 3rd of May, 1808*** (both 1814), Prado Museum, Madrid

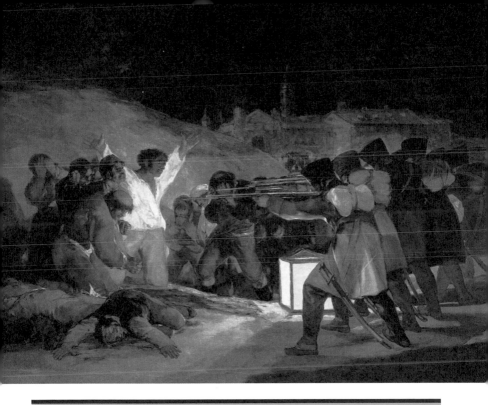

THE 3RD OF MAY, 1808

At the end of the French occupation of Spain in 1814, Goya reflected on the brutality of the previous six years in a series of revolutionary paintings, the most famous of which is *The 3rd of May, 1808*.

The painting depicts the early morning hours following a civilian uprising against the French that occurred shortly after the invasion (which Goya portrayed in the painting *The 2nd of May, 1808*). After the uprising, the French retaliated, executing thousands of Spanish citizens.

In his portrayal of the massacre, Goya focuses on an anonymous victim, just one in a series of slaughtered and condemned figures. He is shown with arms spread wide like Christ on the cross and stigmata-like marks on his open palms. A lantern casts a dramatic spotlight on the tragic figure, while a firing squad of French soldiers faces him like a wall of faceless assassins.

Goya departs dramatically from the tradition of heroic history painting, giving his work a sense of journalistic immediacy rather than monumental stillness. Here, Goya chooses emotional impact over artistic perfection. The painting was completed in just two months, a stark contrast to his polished royal commissions.

Contemporary records, as well as prints made by Goya, suggest *The 2nd of May, 1808* and *The 3rd of May, 1808* may have originally been part of a larger series. But the paintings were not warmly received, as reinstalled Spanish officials may have been displeased with Goya's depiction of civil uprising.

ART IMITATING ART: THE ARTIST'S IMPRINT ON POPULAR CULTURE

MOVIES

ON LOCATION
Goya's Ghosts (2006)
Director: Milos Forman
The 2006 film stars Stellan Skarsgård as Goya, Natalie Portman—cast for her resemblance to the subject of the painting *Milkmaid of Bordeaux*—as his young muse, and Javier Bardem as a monk caught in the era's political upheaval.

Inspired, in part, by a visit to the Prado, the fictional film offers beautiful shots of Spain, including footage filmed inside the royal palaces of El Pardo, Vinuelas, and La Quinta. The film captures Madrid at the turn of the 19th century through a pastiche of Spanish cities, including sweeping footage of Madrid's Retiro Park and the city of Ocaña in Toledo, which hosted a decisive French victory against the Spanish during the Peninsular War. Much of the shooting was done in the town of San Martin de Vega. There, an abandoned farmhouse played Goya's studio, where viewers catch a glimpse of the artist's painstaking printmaking process.

Goya: Crazy Like a Genius (2008)
Director: Robert Hughes
Written and narrated by art critic Robert Hughes (author of the definitive biography *Goya*), this film journeys into the world of the artist and covers the changes that took place in his work throughout his lifetime. It also includes some detailed analysis of several of his masterpieces.

Goya in Bordeaux (1999)
Director: Carlos Saura
This dramatic biopic is told as a series of flashbacks from the aging artist while he was living in exile. In it, he reveals the story of his life to his caretaker's daughter Rosario through his dreams and the demons that haunted him, both of which played a critical role in his work.

Goya: History of a Solitude (1971)
Director: Nino Quevedo
This biopic uses Goya's works to introduce each scene. The film covers his humble beginnings as a portrait painter to the aristocracy and his later, more controversial work. It also explores his relationship with the Duchess of Alba, who was a model for some of his work.

Goya: Awakened in a Dream (1999)
Director: Richard Mozer
In this made-for-TV film, the ailing artist meets a young girl whose faith inspires him to return to work and create some of his greatest masterpieces. The film is part of a highly acclaimed series geared toward children 8 years and older.

LITERATURE

Old Man Goya
by Julia Blackburn
(Pantheon, 2002)
Follow Goya's footsteps during the final 35 years of his life, after he loses his hearing and during an era full of political turmoil. Not only does the author see the world as he did, she dons earplugs to share the silence.

The Last Portrait of the Duchess of Alba: A Novel
by Antonio Larreta
(Woodbine House, 1988)
This book, which found huge success in Spain with critics and consumers alike, delves into the mysterious death of the Duchess of Alba (one of Goya's favorite subjects) at the age of 40 in 1802.

reestablished Inquisition on charges of obscenity, based on the painting known as *The Naked Maja* (1797–1800).

In 1819, Goya purchased a farmhouse called the Quinta del Sordo (The House of the Deaf Man, named for its previous owner) in what were then the outskirts of Madrid. It was here that the artist, a semi-recluse from a world torn to shreds and suffering yet another serious illness, painted what would come to be known as *The Black Paintings* (1821–23), a group of fatalistic, nightmarish, yet all-too-recognizable visions of humanity that are perhaps his best-known works today. These paintings—the howling crowds, the abandoned dog, the father devouring his child—are among the most macabre images in the history of painting. Yet the horror they convey is not only because of their deformation, but precisely because they do not represent sheer fantasy. They are neither surreal inventions nor bizarre hybrids. They are much closer to the murky underside of lived experience, just across the necessary psychic veil that allows us to function individually and collectively. They are no more than the flip side of the images of his tapestry designs from some 50 years earlier—and as a result, they are all the more terrifying. Around this time, Goya also painted his last great religious work, *The Last Communion of Father José Calasanz* (1819), still on view at the church of San Antonio Abad.

In 1824, with the political situation in Spain growing still more unfavorable, the 78-year-old Goya abandoned Madrid, first going into hiding in Zaragoza, the town where he grew up, and later settling in France with a small circle of Spanish political exiles. Despite his age and deteriorating health, Goya continued working, creating prints, miniatures, and the occasional portrait. Among his final works is a small drawing of a bent old man supported on two canes as he strains to make progress—a likeness of its author, if not in physical appearance, then perhaps in spirit. Its caption reads: "I am still learning."

Goya died in 1828 in Bordeaux and was buried in a local cemetery. More than seventy years later, his reputation had grown to legendary status, and Goya's remains (mysteriously missing his skull) were exhumed and brought back to Madrid, where they were relocated to the church of San Antonio de la Florida.

∧ **San Antonio de la Florida**

ACCESS

AIRPORTS: ✈
Madrid Barajas
International Airport
🏠 Avenida de la Hispanidad
☎ 34 90 240 4704
🖥 www.aena.es

TRAIN: 🚃
RENFE
☎ 34 90 232 0320
🖥 www.renfe.es

Atocha Train Station
🏠 Glorieta Carlos V
☎ 34 90 224 3402

Chamartin Train Station
🏠 Calle de Agustin de Foxá
☎ 34 91 315 9976

BUS: 🚌
South Station
☎ 34 91 468 4200
🖥 www.
estaciondeautobuses.com

TOURISM OFFICE: 🌐
Madrid Tourism Center
🏠 Plaza Mayor 27
☎ 34 91 588 1636
🖥 www.esmadrid.com
○ Daily 9:30AM-8:30PM

FOR YOUR INFORMATION...

A complex city full of contradictions, Madrid has been the site of great wealth and great suffering, of deep passions and cutting-edge innovation, but most of all, of dramatic transformations. Originally a Roman outpost, Madrid was under Islamic rule until 1110, and was still a small, sleepy city when Philip II declared it Spain's capital in 1561. But as the Spanish Empire grew—becoming Europe's leading power in the 16th and 17th centuries—Madrid flourished, as did the lifestyles of its ruling classes. Portraits by Diego Velázquez and Francisco Goya in the Prado and the nearby Thyssen-Bornemisza Museum show the power and opulence of Imperial Spain. Madrid's famous passion can still be experienced at the Plaza de Toros arena with its traditional bullfights, as well as the modern arena where Real Madrid plays soccer. When Spain's long-standing dictatorship ended 1975, an exciting period of artistic and economic freedom (known as La Movida) began and Madrid saw an explosion of arts, architecture, fashion, food, and nightlife. Today Madrid is undergoing yet another transformation, with futuristic architectural and planning projects joining its opulent palaces, Baroque churches, and elegant plazas.

Weather 🌤

Weather in Madrid is most comfortable (warm and mild) between May and mid-July, as well as September and October. From the end of July through August, it becomes very hot; however, there is not a lot of humidity. Winters can get chilly, but there's usually not much snowfall.

⌃ [top] **Gran Via**

BEFORE YOU GO, GET IN THE KNOW: SUGGESTED WEBSITES AND BOOKS

WEBSITES

Madrid Tourism
🖥 www.esmadrid.com
Madrid's tourism board offers general information for travelers, including yearly events, how to get around, as well as podcasts and live segments about the city at esmadrid.tv.

Francisco Goya: The Complete Works
🖥 www.franciscodegoya.net
This site features reproductions of the artist's complete works in addition to biographical information, a slideshow, and assorted related links to museums, exhibitions, and more.

The Prado Museum
🖥 www.museodelprado.es
The official website of the Prado Museum includes comprehensive information about the collection, as well as details on special exhibitions and events. It also provides education and research resources, plus interactive features.

Royal Academy of Fine Arts of San Fernando
🖥 rabasf.insde.es
The online hub of the Museum of the Royal Academy of Fine Arts of San Fernando offers visitors a basic overview of the museum as well as information about hours, ticket prices, and guided tours.

BOOKS

Goya: The Origins of the Modern Temper in Art by Fred Licht (Icon, 1983)
Respected art historian Fred Licht demonstrates how the artist and his work led the charge of modern art and culture, through exquisite color reproductions and an extensive survey of his prints and paintings.

Goya
by Robert Hughes (Knopf, 2003)
In his biography of Goya, renowned art critic, writer, and TV documentary filmmaker Robert Hughes explores the artist's life story and work in conjunction with the bloodstained history of the era in which he lived.

Goya
by Jose Gudiol (Harry N. Abrams, 1985)
Here readers will find an overview of the artist and his work as well as full-page reproductions of Goya's paintings with extensive commentary on the opposing pages. The author, who has penned numerous essays and monographs on Spanish art and other painters, offers a detailed introduction to everything Goya.

Black Paintings of Goya
by Juan Jose Junquera (Scala Publishers, 2008)
The author presents new interpretations of what might have been Goya's intentions behind *The Black Paintings* and how his work during these years was a foreshadowing (or some would argue, the foundation) for the evolution of 20th-century art.

Francisco Goya: Life and Times
by Evan S. Connell (Counterpoint, 2006)
This book is a biographical account of the artist's life and the era in which he lived. It includes anecdotes about several people he painted and worked for in rich detail. It should be noted that information on Goya's artwork, though it is mentioned as well, is not the central premise for this book.

LA FIESTA DEL 2 DE MAYO / THE 2ND OF MAY FIESTA

⌂ Plaza Dos de Mayo, Jardines de las Vistillas and others

🖥 www.fundaciondosdemayo.es

SAN ISIDRO FIESTA/ SAN ISIDRO FESTIVAL

⌂ Plaza Mayor and various locations throughout city

🖥 www.esmadrid.com/sanisidro

CUMBRE FLAMENCA / FLAMENCO SUMMIT

⌂ Madrid Metro Stations

🖥 www.deflamenco.com

INTERNATIONAL JAZZ FESTIVAL

⌂ Various locations throughout city

🖥 www.esmadrid.com/festivaljazzmadrid

CALENDAR...YEARLY EVENTS

La Fiesta del 2 de Mayo / The 2nd of May Fiesta (May)

May 2nd is the day Madrileños commemorate their uprising against Napoleon's invading army, a rebellion that triggered the Spanish war of independence. With concerts, sporting events, military parades, and dancing in the streets, La Fiesta del 2 de Mayo is an opportunity for Madrid to show off its civic pride. While the Plaza Dos de Mayo hosts some of the most impressive events, festivities begin the night before with an enormous fireworks display in the Jardines de las Vistillas.

San Isidro Fiesta / San Isidro Festival (May)

The San Isidro Fiesta, a nine-day festival held every May, is a citywide celebration of the Patron Saint of Madrid. While many activities take place in the center of town, the whole city celebrates, so it is hard not to participate. The festival marks the official start of bullfighting season, and activities—many of which are free—range from skateboarding contests to costume parades and from 19th-century music and flamenco to the latest in pop and rock.

Cumbre Flamenca / Flamenco Summit

(September or October) Flamenco Summit—an event not to be missed by flamenco enthusiasts—is a five-day extravaganza of flamenco music, which takes place each fall in one of Madrid's subway stations. Since 2005, Cumbre Flamenca has been featuring top-ranking flamenco artists, with a different musician or dancer performing each night. Space is limited, so overflow crowds watch the performances on a giant screen. The concerts are

free, but a subway ticket is required.

International Jazz Festival

(late October–early November)

For over 25 years, Madrid has been hosting one of Europe's most important jazz festivals. The festival brings top-name performers to various venues across the city, including the Teatro Fernán Gómez and Teatro Real.

Festival de Otoño / The Autumn Festival

(October/November)

The Festival de Otoño is a month-long event that celebrates the arts with dozens of dance, theater, and musical groups from all around the world. Events include everything from chamber music to flamenco to hip-hop to circus acts, as well as a number of workshops and lectures. While most of the activity is centered in Madrid, there are also events in the surrounding towns.

FESTIVAL DE OTOÑO / THE AUTUMN FESTIVAL
🏠 Teatro Españo, Teatro del Canal and other locations
🖥 www.madrid.org/fo

BY GEORGE STOLZ

Goya spent most of his adult life in Madrid, and much of his greatest work is still found in the city's museums and churches. But beyond the number of years or paintings, a particularly powerful bond—arguably unparalleled in art history—was forged between artist and place. Over the course of 50 tumultuous years, Goya portrayed Madrid in times of peace and in times of war, in pleasure and in pain, in hope and in despair, in growth and in grief. He fixed his marksman's eye on all strata of society—royalty, the Enlightenment intelligentsia, the hardworking poor, criminals and lowlifes, the demented, the doomed, even the deceased—and always with an unflinching, uncompromising commitment to bearing witness. Yet Goya was no mere chronicler: The power of his art—in its darkness, its variety, its political engagement, its poetry, even the nightmares to which it occasionally succumbs—was such that in many ways he created the lasting image by which Madrid still sees itself today.

∧ [top] **Prado Museum**

WALKING TOUR

There is no greater place to appreciate Goya's art than the **Prado Museum**, which offers a rare opportunity to trace the development of this singular artist. It features more of his works than any other institution and the collection includes consummate works such as *The Dressed Maja*

(1800–05), *The Naked Maja* (1797–1800), *The Family of Carlos IV* (1800), *The 2nd of May, 1808* (1814), *The 3rd of May, 1808* (1814), and the *Black Paintings* (1821–23), among many others. (See "Goya and the Prado" on page 106 for more details.)

Upon leaving the Prado, you can find a convenient place to pause and catch your breath at the **Royal Botanical Garden**, a verdant and aromatic oasis within the bustling city. The 18th-century garden, with its grid of footpaths and methodically arranged plant specimens, may provide a welcome sense of order after the Prado's display of Goya's intense vision and turbulent life.

Just across the tree-lined and traffic-filled Paseo del Prado, **La Platería** is a busy outdoor café with a basic selection of tapas and wines. For a full meal, the excellent and quirky **La Vaca Verónica** offers homemade pasta—pasta con carabinero (giant prawns) is the specialty of the house—and, unusual for Madrid, an assortment of well-crafted salads.

Madrid's second-most important collection of work by Goya is at the **Real Academia de Bellas Artes de San Fernando (Royal Academy of Fine Arts of San Fernando).** Goya taught at the academy and was the director of painting until his deafness forced him to resign. Today the museum collection includes, among other works by Goya, two self-portraits and the troubling *The Burial of the Sardine* (1816).

The Royal Academy also houses the **Calcografía Nacional**, founded in 1789 as the official institution

^ [top] **Royal Botanical Garden** [bottom] **Royal Academy of Fine Arts of San Fernando**

dedicated to printmaking in Spain. Among Goya's many artistic mediums, his graphic work was among the most remarkable. A master draftsman, Goya skillfully handled the complex technical elements of printmaking, which allowed him to maximize the dramatic impact of his compelling images. Moreover, he frequently used prints as a vehicle for expressing the most urgent aspects of his vision, ranging from the bitterly satirical *Los Caprichos* (1797-98) to the unflinching *The Disasters of War* (1810-20). Today the Calcografía Nacional displays the original plates of many of Goya's prints and has a small bookshop specializing in publications about them.

The Royal Academy is situated just off the **Puerta del Sol**—the site of the bloody uprising depicted in *The 2nd of May, 1808* (1814) and that today is a bustling transportation and commercial hub for all Madrileños. In and around the large plaza, there are a number of shops with traditional Spanish garb and accessories. **Capas Seseña** specializes in old-fashioned (and expensive) Spanish capes; **Casa de Diego** offers typical Spanish fans and parasols; and **Gil** still supplies women in Madrid with the traditional lace veils (mantones) and silk shawls (mantillas) that are often worn by women in Goya's images.

On any tour of Goya's work in Madrid, if possible, a visit should be made to the ceiling frescoes at the church of **San Antonio de la Florida,** though to get there you'll need to take a taxi or the metro. Goya painted these frescoes for the newly constructed church in 1798, finishing the entire work in only four months, despite attacks of vertigo that made painting from such high scaffolding not only difficult but also dangerous. The frescoes are extraordinary in many ways: their narrative power, the formal genius of their composition and execution, their integration of image and architecture, and the radicalism of their implications.

San Antonio de la Florida is also the site of **Goya's grave**. Goya died in Bordeaux in 1828, at the age of 82, and was buried without fanfare in a local cemetery. But by the end of the 19th century, Goya's posthumous fame

⌃ [top] **Puerta del Sol**, site of the uprisings on May 2, 1808

had become such that the Madrid government lobbied to have his illustrious bones exhumed and returned to the city. However, when the tomb in Bordeaux was opened, it was discovered that the Goya's skull had been removed. The remaining bones were shipped back to Madrid and duly reburied, but the skull has never been found.

Next door to San Antonio de la Florida is the 19th-century tavern **Casa Mingo**, almost a Madrid institution in itself, with long rows of tables and barrels and simple hearty Asturian fare: roasted chicken, chorizo, cheese, and—above all—homemade sidra, a fizzy hard apple cider.

There are other important works by Goya scattered around Madrid: his first public commission (including a brash self-portrait), titled *The Sermon of San Bernardino of Siena* (1784), at the **Basílica of San Francisco el Grande**; the scenes of witchcraft and satanic rites at the **Lázaro Galdiano Museum**; the portraits of the monarchs at the **Royal Palace**; and at the **Thyssen-Bornemisza Museum**, the delicate *Portrait of Asensio Julià* (1798), depicting Goya's loyal assistant. All are certainly worth seeing.

But Goya's last major commission in Madrid, still hanging in situ at the church for which it was painted, is the ideal place to conclude your tour. *The Last Communion of Father José Calasanz* (1819), at the **Church of San Antonio Abad** was painted at roughly the same time as the *Black Paintings*. It shares with them a similar palette (although lighter in tone) and a similar expressive technique; but unlike them, although death is in the air, so is something else—sanctity, perhaps even serenity, albeit of a rather grim variety.

The saint in the painting devoted his life to educating poor children, eventually founding the Piarists, a religious order dedicated to education. Goya himself seems to have attended the order's schools as a boy in Zaragoza. Perhaps for these reasons, the notoriously tightfisted Goya returned nearly his entire fee for this great painting.

Goya's frescoes (detail) at **San Antonio de la Florida**

GOYA AND THE PRADO

The Prado is the crown jewel of Spain's cultural heritage. With nearly 20,000 works in its collection—including drawings, paintings, prints, and decorative objects—it is widely accepted as among the finest museums in the world, and is one of Madrid's premier tourist destinations.

The museum was founded in 1819 from the former Spanish Royal Collection, and many of the works that Goya had made for the court can be seen in the Prado today. The museum holds some of his best portraits, such as that of *Gaspar Melchor de Jovellanos* (1798), a political theorist and high-ranking government official (Minister of Grace and Justice), and that of the *Countess of Chinchón* (1800), a member of the royal family whom the artist painted several times throughout her life. In these paintings, Goya masterfully

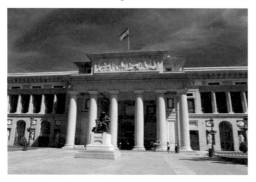

limited his range of colors in such a way as to enhance the overall play of tonalities. His brushwork is dexterous in a way rarely seen in the rest of his oeuvre; and above all, although these are essentially court portraits, there is a discerning yet tender quality to them, a liberation of the individual from the type.

Another set of portraits at the Prado presents a mystery that has yet to be resolved: the twinned paintings *The Naked Maja* (1797–1800) and *The Dressed Maja* (1807-08). Numerous legends notwithstanding, the sitter has never been identified. All that is known is that they exude a defiant eroticism, unprecedented in art at the time of their creation.

The Prado also holds Goya's unforgettable group portrait *The Family of Carlos IV* (1800). An official portrait, the painting is modeled after the composition of *Las Meninas* (1656), and as in Velázquez's masterpiece—also on view at the Prado—a self-portrait of the artist is inserted. Goya's painting is something of a puzzle. From a contemporary vantage, it appears impossibly unflattering to its sitters, bordering on the derisive, at least with regard to the adults. Yet at the same time, each sitter emerges from the canvas with a distinct, vivid character. Perhaps what pleased the royal sitters was the way Goya infused

⌃ The entrance to the **Prado Museum**

his portraits of them with psychological insight, or perhaps, as some suggest, they were simply too vain to notice the subtext of the paintings.

Carlos IV was soon forced to abdicate by Napoleon, and the royal family fled Spain. Years of violence, guerrilla warfare, chaos, and misery ensued, and the era's political turbulence can be traced through Goya's work at the Prado. In 1814, after the French had finally been driven from Spain (which occurred before the country's political situation had stabilized), Goya painted two monumental works in commemoration of Madrid's tenacious yet doomed resistance to the invaders. The spontaneous uprising in the Puerta del Sol in *The 2nd of May, 1808* is a chaotic swirl of bodies, horses, and weapons, while the executions in *The 3rd of May, 1808* are carried out with machinelike efficiency by a column of anonymous soldiers. Even today, these works elicit a visceral response.

At the end of his life, Goya purchased a farmhouse on the outskirts of Madrid known as the Quinta del Sordo. There, on the walls, he painted the *The Black Paintings* (1821–23), images of unimaginable suffering and horror. These highly personal works are a stark contrast to Goya's earlier, commissioned paintings. After the artist left Spain, the Quinta's new owner removed the paintings from the walls of the house and transferred them to canvas. Though damaged in the process, *The Black Paintings* remain some of the artist's most revolutionary works and among the most visited works in the Prado.

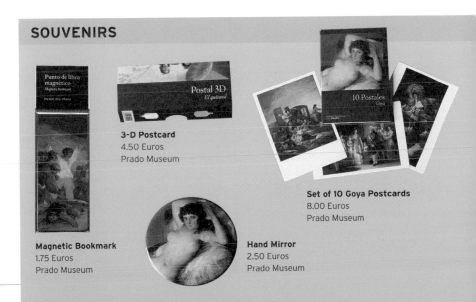

SOUVENIRS

3-D Postcard
4.50 Euros
Prado Museum

Set of 10 Goya Postcards
8.00 Euros
Prado Museum

Magnetic Bookmark
1.75 Euros
Prado Museum

Hand Mirror
2.50 Euros
Prado Museum

WHERE TO SEE...THE WALKING TOUR

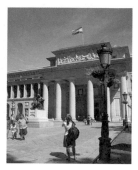

1 **Prado Museum**
🏛 Calle Ruiz de Alarcón 23
🖥 www.museodelprado.es
☎ 34 91 330 2800
○ Tue-Sun 9AM-8PM
● Mondays, May 1, Good Friday, Dec 25, Jan 1
Spain's largest museum is home to more than 20,000 works of art,including some of Goya's finest, from the former Spainsh Royal collection.

3 **Royal Academy of Fine Arts of San Fernando** and **Calcografia Nacional**
🏛 Calle Alcalá 13
☎ 34 91 524 0864
○ Sat-Mon 9AM-5PM, Sundays holidays 9AM-2:30PM
At the same address you'll find the school where Goya was both a student and a teacher, plus an archive containing the plates of some of his most famous prints.

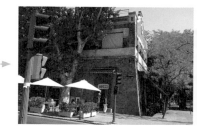

5 **San Antonio de la Florida**
☎ 34 91 542 0722
○ Tue-Fri 9:30AM-8PM Sat-Sun 10AM-2PM
● Mondays
This church features Goya's ceiling frescoes and is his final resting place.

2 **Royal Botanical Garden**
⌂ Plaza de Murillo 2
⌨ www.rjb.csic.es
☎ 34 91 420 3017
○ Mon-Sun opens at 10AM
● Closes Nov- Feb 6PM,
Mar/Oct 7PM, Apr/Sep 8PM,
May-Aug 9PM
An urban oasis near the
Prado Museum.

La Platería La Vaca Verónica

B **C** Across the Paseo del Prado you'll find
a selection of outdoor cafés and restaurants
for a taste of traditional Spanish tapas.

Casa de Diego Capas Seseña Gil

4 **Puerta del Sol**
Located at the center of the city, this popular square was the site of the
uprisings that took place on May 2, 1808. Today, it's home to nightclubs, as
well as the iconic Tio Pepe advertisement seen above.

Metro or Taxi

Metro or Taxi

D **Casa Mingo**
⌂ Paseo de la Florida 34
☎ 34 91 547 7918
○ Daily 11AM-Midnight
Take a break with a chorizo and a
drink at Casa Mingo, a cozy café
known for its fizzy cider.

6 **Church of San Antonio Abad**
⌂ Calle de Hortaleza 36
☎ 34 91 521 7473
End your tour at San Antonio Abad, home to *The Last
Communion of Father José Calasanz*, Goya's final
public commission.

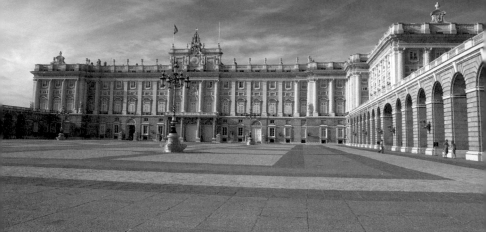

WHERE TO SEE...SCENE STEALERS

SCENE STEALERS

**PALACIO ROYAL /
THE ROYAL PALACE**
🏠 Calle Bailén
☎ 34 91 454 8700
🖥 www.patrimonionacional.es
○ Oct-Mar Mon-Sat
9:30AM-5PM, Sun &
holidays 9AM-2PM;
Apr-Sep Mon-Sat 9AM-6PM,
Sun & holidays 9AM-3PM
● For official ceremonies
$ 8 Euros

**TEMPLO DE DEBOD
THE DEBOD TEMPLE**
🏠 Calle Ferraz 1
☎ 34 91 366 7415
🖥 www.munimadrid.es
○ Oct-Mar Tue-Fri 9:45AM-
1:45PM 4:15PM-6:15PM;
Sat-Sun 10AM-2PM;
Apr-Sep Tue-Fri 10AM-2PM,
6PM-8PM; Sat-Sun 10AM-
2PM
● Mondays and holidays

1 Palacio Real / The Royal Palace

The official residence for the royal family, the opulent Palacio Real is one of the top attractions in Madrid. The largest palace in Europe, it was built during the 18th and 19th centuries to replace the medieval Alcázar, which burned to the ground in 1734. Its lavish interior includes a throne room, dining and banquet rooms, bedchambers, the Royal Armory, and the Royal Pharmacy, as well as priceless works of art by such painters as Velázquez, Goya, and Caravaggio. Though the current king and queen don't actually reside there, the palace is used for official state ceremonies and is open to the public the remainder of the time.

2 Templo de Debod / The Debod Temple

The Debod Temple is an incongruous but elegant addition to Madrid's Parque de Rosales. The ancient temple was constructed in Egypt during the 2nd century BC to honor the powerful god Amon. In 1960 it was endangered by construction of the Aswan High Dam, because it stood less than 10 miles south of Aswan, too close to the rising Nile River. After Spain helped UNESCO save the temples of Abu Simbel, Egypt expressed its gratitude by donating the Temple of Debod to Spain in 1968. It was relocated, and rebuilt in the Parque de Rosales (Park of the Roses) where it opened to the public in 1972.

⌃ **Palacio Royal**

3 Catedral de Santa María la Real de la Almudena / Almudena Cathedral

The principle church of the Diocese of Madrid, the breathtaking Almudena Cathedral is an eclectic mix of 19th-century architectural styles, including a neoclassical exterior, a Gothic Revival interior, and a neo-Romanesque crypt. Although construction began in 1883, it took more than a century to complete and was finally inaugurated in 1993 by Pope John Paul II, making it the only Spanish cathedral to have been consecrated by a Pope.

4 Museo Nacional Centro de Arte Reina Sofia /The Reina Sofia Museum

The Reina Sofia (named for Queen Sofia of Spain) is Spain's national museum of 20th-century art and features outstanding collections of two of the country's greatest 20th-century artists—Pablo Picasso and Salvador Dali—including Picasso's masterpiece, *Guernica*. Other Spanish artists represented include Juan Gris, Joan Miró, and Antoni Tàpies. The museum also boasts a small but significant collection of non-Spanish artists, which includes Man Ray, Robert Delaunay, Yves Tanguy, Lucio Fontana, Yves Klein, Georges Braque, and Francis Bacon.

5 Museo Thyssen-Bornemisza / The Thyssen-Bornemisza Museum

The Thyssen-Bornemisza Museum was created to house one of the finest private art collections in the world, once considered second only to that of the British monarchy. The museum, which opened in 1992 with nearly 1,000 works was a labor of love created by Dutch-born steel and armaments magnate Baron Heinrich Thyssen-Bornemisza (1875–1947) and carried on by his son, Baron Hans Heinrich Thyssen-Bornemisza (1921–2002). While Hans primarily collected Old Masters—with works by Van Eyck, Dürer, Rubens, Velázquez, Rembrandt, Titian, Caravaggio, and Goya—Hans Heinrich concentrated on more recent works from the 19th and 20th centuries, including Renoir, Monet, Degas, Picasso, and Hopper.

CATEDRAL DE SANTA MARÍA LA REAL DE LA ALMUDENA / ALMUDENA CATHEDRAL
⌂ Calle Mayor 90
☎ 34 91 542 2200
🖥 www.spain.info
○ Daily 9AM-7:30PM

MUSEO NACIONAL CENTRO DE ARTE REINA SOFIA / THE REINA SOFIA MUSEUM
⌂ Calle Santa Isabel 52
☎ 34 91 774 1000
🖥 www.museoreinasofia.es
○ Mon, Wed-Sat 10AM-9PM Sun 10AM-2:30PM
● Tuesdays
$ 6 Euros

MUSEO THYSSEN-BORNEMISZA / THE THYSSEN-BORNEMISZA MUSEUM
⌂ Paseo del Prado 8
☎ 34 91 369 0151
🖥 www.museothyssen.org
○ Tue-Sun 10AM-7PM
● Mondays
$ 8 Euros

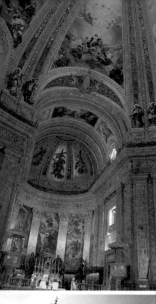

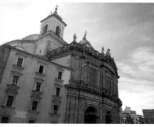

6 Basilica of San Francisco el Grande

The Basilica of San Francisco el Grande is an impressive neoclassical church that was begun in 1760 by King Carlos III on the site of an old convent that was said to have been founded in 1217 by San Francisco de Assisi. The dome of the Basilica, which is 108 feet in diameter, is the third largest dome in Europe (and the largest in Spain). One of the chapels is dedicated to San Bernardino de Siena and contains a masterpiece by Goya depicting San Bernardino preaching

(and includes a self-portrait of Goya to the right of the saint).

7 Lazaro Galdiano Museum

The recently renovated Lazaro Galdiano Museum is slightly off the beaten track but well worth the visit. The three-story building, which was constructed in 1908, is the

former home of Gilded-Age writer, financier, and art collector Jose Lazaro Galdiano (1862–1947). Opening its doors to the public in 1951, it now houses his extraordinary collection of works by Spanish, Flemish, and English masters, as well as arms, silver pieces, ancient bronzes, jewelry, and other precious objects. The collection, which includes over 750 paintings and 12,000 pieces all together, features works by such artists as Cranach, El Greco, Velázquez, Turner, and Reynolds. Highlights include two paintings of witches by Goya and Hieronymous Bosch's *St. John the Baptist in the Wilderness*.

8 Real Fábrica de Tapices / Royal Tapestry Factory

The Royal Tapestry

BASILICA OF SAN FRANCISCO EL GRANDE
⌂ San Buenaventura 1
☎ 34 91 365 3800
○ Jan-Jun, Sep-Dec Tue-Fri 11AM-12:30PM, 4PM-6:30PM Sat-Sun 11AM-1:30PM Jul-Aug Tue-Sun 11AM-12:30PM, 5PM-7:30PM
● Mondays
$ 3 Euros

LAZARO GALDIANO MUSEUM
⌂ Calle Serrano 122
☎ 34 91 561 6084
🖵 www.flg.es
○ Wed-Mon 10AM-4:30PM
● Tuesdays & holidays
$ 4 Euros

Factory of Santa Bárbara—founded in 1721 by Spain's first Bourbon king, Philip V—now houses a collection of tapestries, carpets, and paintings dating back to the 18th century, as well as the looms and tools used to make them. The factory is also a "living museum" where visitors can watch exquisite tapestries, carpets, and ornamental fabrics being produced with the same looms and techniques that were used over three centuries ago. The most illustrious alumni of the Royal Tapestry Factory is Francisco Goya, who worked there when he first arrived in Madrid in 1775, and many of the designs currently being produced are based on his original drawings.

REAL FÁBRICA DE TAPICES / ROYAL TAPESTRY FACTORY
⌂ Calle Fuenterrabía 2
☎ 34 91 434 0550
💻 www.
realfabricadetapices.com
○ Mon-Fri 10AM-2PM

GOYA AT THE ROYAL FINE ARTS ACADEMY

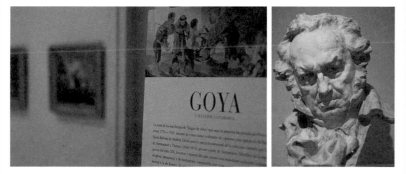

You can find Goya's self-portraits, which are really quite moving, in the Royal Fine Arts Academy of San Fernando. The artist portrayed himself repeatedly throughout his long life, offering us a visual record as much about his artistic development as it is about the man himself. The first self-portrait at the academy dates from the early 1790s and presents a jaunty, self-assured Goya at work in his studio, wearing a rather curious hat–it is ringed by a row of candles, allowing the artist to paint well into the night. The second, from 1815, shows the older, dark-eyed artist at his easel, his body seeming to cede to one side, his shirt is unbuttoned, his hair unkempt, and the totality rendered with a beautifully free, flowing brushwork and a somber, simple palette.

The Burial of the Sardine (1816), also found in the Royal Arts Academy of San Fernando, displays a peculiar Madrid custom as seen through Goya's distinctive lens. The ritual–which still takes place in Madrid today–is part sacred, part profane: On Ash Wednesday, a faux-solemn procession travels through the streets of the city, singing and dancing, en route to a ceremonial Lenten burial of a sardine. As in many similar depictions of public events, Goya imbues the ostensibly festive crowd with a latent frenzy, highlighting the precariously thin line between crowd and mob.

CASA DEL AYUNTAMIENTO / CITY HALL
🏠 Plaza de la Villa 5
☎ 34 91 588 2906
○ Mon 5PM-6PM, guided tours of some rooms with notable art

9 Plaza Mayor

This vast, elegant square with porticoed walkways occupies the site of what was once a marketplace outside the city walls. King Philip II initially called for the creation of a public square around 1560, but the plaza wasn't completed until 1619. During the Spanish Inquisition many executions were held in the Plaza Mayor, and many "heretics" were burned at the stake.

Perhaps because of those public burnings, the buildings surrounding the square were destroyed by fire on three separate occasions—in 1631, 1672, and 1790—and had to be completely rebuilt each time. Today, it is a bustling, lively meeting point lined with stores, restaurants, and cafes, as well as home to the traditional annual festival celebrating San Isidro, the patron saint of Madrid.

10 Casa del Ayuntamiento / City Hall

Home to the Ayuntamiento (or city government), this building was originally designed with a dual purpose in mind: one of its large doors led to Town Hall and the other led to a prison. Begun in 1645 and completed

˄ [top] **Plaza Mayor** [bottom] **City Hall**

in 1693, the Castilian-Baroque-style palace with spire-topped corner towers has been restored and expanded numerous times and the sumptuous interior has many neoclassical touches. Visitors can stroll through its rooms, visit collections of precious objects, and see Goya's painting, *Allegory of the City of Madrid*, from 1810. Although most city functions were recently moved to the Palacio de Comunicaciones, the Ayuntamiento is still used on occasion.

11 The Plaza de España

The Plaza de España is a large, lively square at the end of the stately Gran Via, one of Madrid's busiest streets. The towering monument to literary giant Miguel de Cervantes in the center of the square is a popular destination with tourists who like to pose in front of life-sized bronze equestrian statues of Don Quixote de la Mancha and his trusty squire, Sancho Panza, on his mule. The square was built on a section of the Principe Pio hill, which was used by French firing squads to execute prisoners during the 2nd of May uprising

and depicted by Goya in his painting *The 3rd of May*, 1808.

12 Montaña del Principe Pio

Named after Prince Pius of Savoy, this is one of the highest points in Madrid. It was the site of the massacre of 43 Spanish citizens by French troops on the morning of May 3rd, 1808, which was immortalized by Goya in his famous painting. The barracks that were later built there (known as the Cuartel de la Montaña) played an important part at the beginning of the Spanish Civil War. They were torn down in 1960 to make way for the creation of the Parque del Oeste (Western Park), and the site where the barracks stood is now occupied by the Temple of Debod.

THE PLAZA DE ESPAÑA
⏏ Gran Via

MONTAÑA DEL PRINCIPE PIO
⏏ Parque del Oeste

⌃ [top] **The Plaza de España** [bottom] Memorial at **Montaña del Prinicipe Pio**

MUSEO DEL JAMÓN
🏠 Carrera San Jerónimo 6
*(One of six locations)
☎ 34 91 521 0346
🖥 www.museodeljamon.com
○ Daily 9AM-12:30AM
$ Prix-fixe menus 19-35 Euros, plus an a la carte menu

LA VACA VERONICA
🏠 Calle Moratín 38
☎ 34 91 429 7827
🖥 www.lavacaveronica.es
○ Daily 1PM-4:30PM 8:30-12:30AM
$ Set lunch menu 15 Euros Dinner 10-19 Euros

LA PLATERÍA
🏠 Calle Moratin 49
☎ 34 91 429 1722
○ Mon-Fri 7:30AM-1AM, Sat and Sun 9:30AM-1AM

CASA MINGO
🏠 Paseo de la Florida 34
☎ 34 91 547 7918
○ Daily 11AM-Midnight

WHERE TO...EAT AND SLEEP

EAT

A Museo del Jamón

An institution in Madrid, the Museo del Jamón is a tapas bar that's fast, friendly and reasonably priced. Like so many Spanish bars, hams dangle everywhere and you can order from a wonderful selection of them from different provinces and from inexpensive jamón blanco to pricey jamón ibérico. For sandwiches and other quick meals, just point to photos or to the dishes themselves.

B La Vaca Veronica

Veronica the Cow is a delightful little restaurant, conveniently located near the Prado and has its own art collection decorating the cheerful, bright yellow walls. Spanish, Italian, and Argentinean specialties include steak, sausage, and shrimp dishes but for value, try the menu del día.

C La Platería

A traditional wine bar with over 50 different kinds of wines as well as tapas, La Platería is a charming place that was once an old grocery store. For a sweet snack or light meal, try the typical churros with chocolate pudding. In summer, you can dine outdoors in a little plaza.

D Casa Mingo

Casa Mingo is a casual, rustic spot, with vaulted ceilings and long wooden

tables that customers share, surrounded by bottles of cider and huge wine barrels. Cider is the specialty of the house—they make their own still and sparkling ciders—in the tradition of Asturian cider bars in northern Spain. In summer you can dine outside on the sidewalk or on the roof terrace. Try the roast chicken, traditional Spanish chorizo sausages, and (of course) the cider.

SLEEP
E Casa de Madrid
The walls of this elegant B&B on the second floor of an 18th-century mansion are covered with frescoes and friezes. Owner Doña Maria Medina has furnished and decorated each room distinctively with unique antique furniture, rugs, and art. While lacking some of the amenities of a bigger hotel, it feels like an elegant home away from home; breakfast, for instance, is served on a silver tray.

F Hesperia Madrid
Completely renovated in 2001 by one of Spain's best-known interior designers, the Hesperia Madrid is one of Madrid's

top luxury hotels and a member of the "Leading Hotels of the World." Located on the Paseo de la Castellana, just next to the Plaza de Espana, it is stylishly minimalist with lime trees and tiny Japanese gardens that give it an Asian feel. Special touches include a "pillow menu" and butlers in each of the suites. The restaurant was highly rated by the celebrated *Michelin Guide*, and there is live music in the lobby several nights a week.

G AC Palacio del Retiro
This stylish boutique hotel, across the street from the Retiro Park, is just a short walk away from all three major museums—the Prado, the Thyssen-Bournemisza, and the Reina Sofia. The ornately decorated Edwardian palace—built in 1908—has high ceilings, stained-glass windows, flowery moldings, arched windows, marble floors and columns, and fountains, which are now juxtaposed with minimalist furnishings and quirky contemporary art. Traffic noise can be a problem, but the beautiful park views are a plus.

SLEEP

CASA DE MADRID
🏠 Arrieta 2
☎ 34 91 559 5791
💻 www.casademadrid.com
$ 250 Euros-

HESPERIA MADRID
🏠 Paseo de la Castellana 57
☎ 34 91 210 8800
💻 www.hesperia-madrid.com
$ 140 Euros-

AC PALACIO DEL RETIRO
🏠 Alfonso XII 14
☎ 34 91 523 7460
💻 www.hotelacpalacio delretiro.com
$ 240 Euros-

MAP OF VENUES AND CITY LANDMARKS

1 Prado Museum
2 Royal Botanical Garden
3 Royal Academy of Fine Arts of San Fernando and Calcografia Nacional
4 Puerta del Sol
5 San Antonio de la Florida
6 Church of San Antonio Abad

1 The Royal Palace/Palacio Real
2 The Debod Temple/Templo de Debod
3 Almudena Cathedral/Catedral de Santa María la Real de la Almudena
4 The Reina Sofia Museum/ Museo Nacional Centro de Arte Reina Sofia
5 The Thyssen-Bornemisza Museum/Museo Thyssen-Bornemisza
6 Basilica of San Francisco el Grande
7 Lazaro Galdiano Museum
8 Royal Tapestry Factory
9 Plaza Mayor
10 Casa del Ayuntamiento / City Hall
11 The Plaza de España
12 Montaña del Prinicipe Pio

1 Quinta del Sordo
A Museo del Jamón
B La Vaca Veronica
C La Platería
D Casa Mingo
E Casa de Madrid
F Hesperia Madrid
G AC Palacio del Retiro

Parque de la Montaña

Paseo de la Florida

Cuesta de San Vicer

Campo del Moro

M-30

Paseo Ciudad de Plase

Calle Saavedra Fajardo

Av de Portugal

Paseo de la Virgen del Puerto

Calle de Segovia

Calle 30

Paseo de la Ermita del Santo

Calle de Juan Tomero

Calle de Caramuel

KEY
ⓘ Information
Walking Tour
Scene Stealers
Eat and Sleep
Others

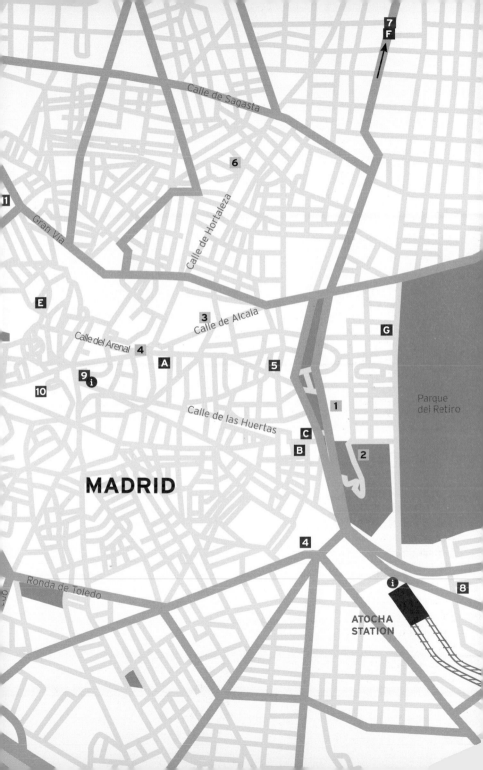

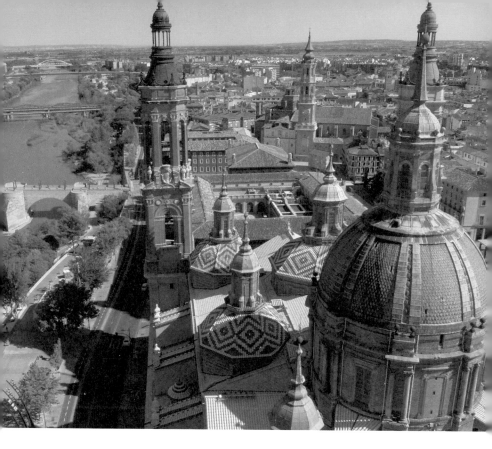

EXTENDED TRAVEL

ZARAGOZA

The center of Zaragoza, which is known as the casco antiguo, may be tiny, but it's packed with history and atmosphere. Originally a Carthaginian military outpost, Zaragoza was invaded in 24 BC by Roman Legions who renamed the city in honor of their ruler, Caesar Augustus. An important city during Roman times with a population of nearly 30,000, Zaragoza had a highly developed urban center, with baths, sewers, a theater, a market and temples, many of which are still being unearthed today. The Moors gained control of the city in 714—changing the name to Saraqusta and carrying out their own monumental building projects—including the splendid Aljafería Palace, which today houses the regional parliament. In 1118, Zaragoza became the capital of the Kingdom of Aragon, which later united with two other powerful kingdoms (Castile and León) in 1469 to create modern Spain, the most powerful empire in Europe

⌃ [top] View of Zaragoza the **Basílica de Nuestra Señora del Pilar**

in the 17th and 18th centuries. It was during that period of power and opulence that Zaragoza's most famous citizen, Francisco de Goya, was born. His family's rustic house in the neighboring town of Fuendetodos has been restored and is now a national monument. Goya's family moved to Zaragoza three years later, in 1749, and it was there that the young Goya studied and apprenticed with a local painter. It was also in Zaragoza that Goya painted one of his masterpieces, *Mary Queen of Martyrs*, a fresco in the cupola of the Basílica de Nuestra Señora del Pilar—which was thought to have been founded on the spot where the Virgin Mary appeared to the Apostle James in AD 40—is a breathtaking example of Spanish Baroque architecture. Other work by Goya can be found in Museo de Zaragoza, which has a collection of fine art that spans from the Gothic period to the contemporary, as well as a rich archaeological collection. Zaragoza has had many ups and down during its 2000 years of history, with periods of great prosperity followed by periods of great strife. Now Spain's fifth largest city and located halfway between Madrid and Barcelona, Zaragoza is investing heavily in 21st-century infrastructure and is reinventing itself once again as city with an distinguished, multicultural past and an equally illustrious future.

ACCESS:
Zaragoza is easily accessible from Madrid by the high-speed AVE train, which takes about an hour and a half. Trains run 12 times a day, with tickets starting at about 50 Euros.

˄ [top] *Mary Queen of Martyrs* at the **Basílica de Nuestra Señora del Pilar**
[bottom] **The Museum of Zaragoza**

ANATOMY OF A MASTERPIECE

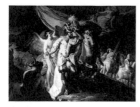

Hannibal the Conqueror, Viewing Italy from the Alps for the First Time, 1771
Museo de Zaragoza, Zaragoza
While in Italy to study art, Goya absorbed the local taste for classicism and subjects from myth and history. Goya created this oil sketch—and later a finished painting—for a contest sponsored by the Academy of Fine Arts in Parma. Though Goya went above the contest's basic requirements, incorporating allegorical figures for the River Po and Victory, he did not win.

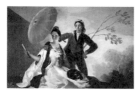

The Parasol, 1777
Prado Museum, Madrid
At the Royal Tapestry Factory, Goya mastered naturalistic representation of the human form, as well as the use of light and shadow. These early works, like *The Parasol*, are filled with the type of cheerful scenes that would be hung on the walls of the Palace of El Pardo.

The Sermon of San Bernardino of Siena, 1784
Church of San Francisco el Grande, Madrid
This early work was Goya's

first major public commission, made at the behest of King Carlos III for the Church of San Francisco el Grande. Along with the carefully rendered scene from the life of the Franciscan missionary, the canvas features a self-portrait of the artist looking directly at the viewer from the right-hand side.

Don Manuel Osorio Manrique de Zuñiga, 1784-1792
Metropolitan Museum of Art, New York
What appears simply to be a commissioned aristocratic portrait may actually be a cautionary tale about the loss of innocence. Here, the heir to the Count of Altamira has let his pet magpie—a Baroque symbol of the soul—out of its protective cage, while three cats wait to pounce. With its ominous tone,

it is possible the painting was made in 1792, after the young boy's death and during a darker period in the artist's oeuvre.

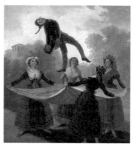

The Straw Manikin, 1791-92
Prado Museum, Madrid
By this point, Goya's tapestry cartoons showed a more mature use of light and shadow to suggest depth, as well as a softer color palette. This seemingly innocent scene of four women at play can also be read as an allegory for the relationship between men and women.

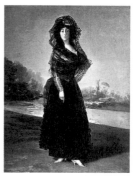

Duchess of Alba, 1797
The Hispanic Society of America, New York

The Duchess of Alba was as vain as she was beautiful, and she captured Goya's heart, though it is not known if she returned his feelings. He painted her a

number of times and in this version, known as the *Black Duchess*, she is dressed in mourning for her dead husband, though still in the dandyish maja manner. But not all love is lost—her ringed finger points to an inscription, rediscovered in a recent cleaning, that translates to "Only Goya."

The Sleep of Reason Produces Monsters
Plate 43 of *Los Caprichos*, 1797-98, published 1799
Metropolitan Museum of Art, New York
This series of 80 aquatint prints was Goya's condemnation of the frivolity and foolishness of the era's Spanish society, exploring such themes as prostitution and witchcraft, as well as satirical portraits of the clergy and aristocracy. Goya's cautionary tales were not heeded, though; he stopped selling the prints after a few days due to their poor public reception.

The Family of Carlos IV of Spain, 1800 (*See page 90*)
Prado Museum, Madrid
In 1800, shortly after he was appointed First Court Painter, Goya embarked on a group portrait of the royal family that would take him two years to complete. But despite his royal post, the artist painted the family exactly as he saw them—blemishes, arrogance, and all. The portrait recalls the Velázquez masterpiece *Las Meninas*, both of which show the artist at work on their canvas.

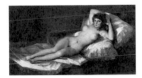

The Naked Maja, 1797-1800
Prado Museum, Madrid
Goya's painting of a lounging nude was controversial for its accurate depiction of the female form. The model may have been a mistress of the painting's owner, the Prime Minister Manuel de Godoy, though her identity remains unknown. In 1815, the artist lost his court position for refusing to reveal to the Inquisition who had commissioned the painting.

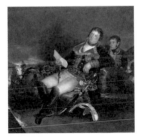

Manuel Godoy, Prince of Peace
1801
Royal Academy of San Fernando, Madrid
Goya paints the Prime Minister of Spain reclining in his chair, much like the *Naked Maja* that he painted for the playboy politician. In fact,

while King Charles IV was busy hunting, Godoy was also busy—conducting an affair with the queen and unintentionally setting up the French invasion.

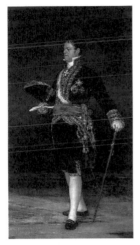

Duke de San Carlos, 1815
Museo de Zaragoza, Zaragoza
This full-length portrait represents one of the greatest examples of Goya's work in portraiture. The canvas is a tour de force from its near-photographic facial rendering to the detail in the golden embroidery of the Duke's opulent uniform.

The Dressed Maja, 1807-1808
Prado Museum, Madrid
Less nuanced than her naked sister, Goya's painting of a maja reclining in her finery may have been a sort of decoy, displayed by its owner when he wanted to hide the naked version.

The 2nd of May, 1808, 1814
(See page 94)
Prado Museum, Madrid
Goya was left deeply scarred by the Peninsular War of 1808-14, and images of violence would haunt him for the rest of his life. In this depiction of an uprising of Madrid's citizens against the Mamelukes—an elite Turkish squadron in the French army—a melee of figures shows the chaos of the riots. Here, Goya portrays the citizens of Madrid heroically, a choice that did not please his patron, King Ferdinand VII. Today visitors to Spain can visit the scene of the massacre at Calle de Alcalá near Puerta del Sol.

The Burial of the Sardine
1812-19
**Royal Academy of
San Fernando**
Painted in Goya's dark and painful post-war period, this image of the Corpus Christi festival in Madrid uses a seemingly cheerful event to express the ugliness of the crowd and mass hysteria.

**The Last Communion of
Father José Calasanz**, 1819
San Antonio Abad, Madrid
Near the end of his life, Goya painted the dying saint José

Calasanz for a local chapel free of charge. In the painting, the saint kneels before a priest and a pious crowd, dwarfed by the vast darkness above them. Shortly after this painting was completed, Goya suffered a devastating illness, after which he began painting in a new, more sinister style.

This is Worse
Plate 37 of **The Disasters of
War**, 1810-20
Staatliche Museen, Berlin
For Goya, art was a form of social protest. In his 80-plus prints from etchings now known as The Disasters of War, Goya explores the horrors of war—namely violence, famine, and political corruption—while exposing the atrocities committed by both sides in the war between the French and Spanish, or, as Goya originally titled the series, "the fatal consequences of Spain's bloody war with Bonaparte."

**Saturn Devouring One of His
Sons**, 1821-23
Prado Museum, Madrid
Alone and deaf in his old age, Goya began work on his *Black Paintings*, dark depictions of suffering painted on the walls of his home, the Quinta del Sordo, or House of the Deaf. In the most famous of the series, *Saturn Devouring One of His Sons*, a monstrous Titan stuffs a bloody, headless, and limbless body into his mouth. The image originally adorned Goya's dining room.

The Fates, 1821-23
Prado Museum, Madrid
One of the *Black Paintings*, this image shows the fates, the three sister who weave the lives of mortals. Goya shows the fates as hags, indifferently creating and destroying lives with the simple cut of a thread.

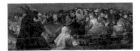

Witches' Sabbath, 1821-23
Prado Museum, Madrid
In his *Black Paintings* Goya explored all types of evil. His image of the *Witches' Sabbath* he shows a crowd of animalistic witches and warlocks gathered around the figure of the Devil in the form of a ram, while a woman on the right looks on. Like the rest of the series, the image is dark both in palette and in subject matter.

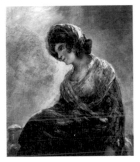

Milkmaid of Bordeaux, 1826
Prado Museum, Madrid
One of Goya's final works, the *Milkmaid of Bordeaux* is a cheerful counterpoint to the *Black Paintings*. Compared to his earlier work, It is much softer in color, brushwork, and even in subject matter. The picture has caused controversy among scholars; experts disagree if it represents a stylistic shift near then end of his life, or if it was actually painted by someone else. In fact, the painting's subject–Rosario, the daughter of Goya's caretaker whom he treated as his own, and who was rumored to be his child–may have painted the image herself.

RECORD PRICES

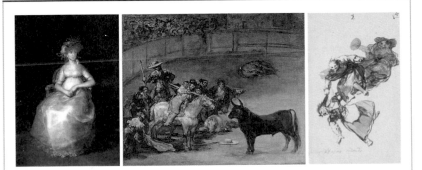

Countess of Chinchón, 1800
Price: $24 million
In 2000, the Spanish government exercised its right of first refusal and purchased what was likely the last major painting by Goya still in private hands, a portrait of a niece of King Charles IV.

Bullfight, Suerte de Varas, 1824
Price: $7.9 million
When the J. Paul Getty Museum bought the painting at a Sotheby's London auction in 1992, it shattered the artist's previous auction record–more than 15 times over.

They Go Down Quarrelling, 1796
Price: $4.5 million
This drawing from Goya's private albums more than doubled presale estimates when it hit the block at Christie's in London in 2008 after being presumed lost for more than 130 years. It currently holds the record for a work on paper by the artist.

CARAVAGGIO and Rome

Master of light and shadow, revolutionary realist, and violent street brawler—Caravaggio's life is shrouded in mystery and myth. Michelangelo Merisi da Caravaggio settled in Rome in 1592, where he painted much of the best work of his brief, but brilliant, career. His violent temper, however, did not serve him well, and in 1606 he was forced to flee Rome. He died in 1610, still hoping for a pardon that would allow his return. Today, he is best remembered for his dramatic use of light, which may have been inspired by the strong sunlight that filters through Rome's narrow streets—influencing not only painters, but countless photographers and filmmakers as well.

BY BARBIE LATZA NADEAU

The year was 1592 and Rome was rising after decades of degradation and decline. The Sack of Rome left glorious palaces in ruins. The Colosseum was filled with garbage and overgrown with weeds. The ancient Roman Forum was a cattle market. Disconnected intellects, poets, and artists filled the streets by day. Beggars, thieves, and whores prowled at night. This was Caravaggio's Rome.

This period marks one of the Eternal City's most important transformations. The Counter-Reformation was underway, and Pope Sixtus V had begun a campaign of rebuilding churches in an effort to save the citizens of Rome from Protestantism. The basilicas of St. Peter, Santa Maria Maggiore, and San Giovanni in Laterano dotted the skyline, replacing the medieval towers that had collapsed in the previous century. Rome was dangerous, but exciting. Young artists flocked here to vie for valuable commissions to fill these new churches with sacred art. One such young artist was Michelangelo Merisi from the village of Caravaggio outside Milan, but the young man who would come to be known simply as Caravaggio was not drawn to Rome just for the art. He was also running away from trouble, setting a pattern that would define

‹ [previous spread] Self-portrait detail from the ***Martyrdom of Saint Matthew*** (1599-1600), Contarelli
Chapel, San Luigi dei Francesi, Rome; Gian Lorenzo Bernini's ***Fountain of the Four Rivers***, Piazza Navona
128 ʌ The Roman Forum

his entire life. After an altercation that wounded a police officer, Caravaggio left Milan with a meager inheritance and a strong desire to be one of the best painters in the new Rome.

Caravaggio had raw talent, but he was also an ardent sinner. Police records in Milan, Rome, Naples, and Malta paint a picture of a passionate artist whose temper often got the better of him. When he first moved to Rome, he floated between small commissions until he found a permanent job in the studio of Giuseppe Cesari, the Cavaliere d'Arpino, but there he was exploited, frustrated, and developed a reputation for violence. Once in a Roman tavern, he assaulted a waiter over a plate of artichokes. "Are they cooked in butter or oil?" asked Caravaggio. When the waiter told Caravaggio to smell them to find out, the artist held the waiter's head to the plate at knifepoint, repeatedly smashing his face into the artichokes.

His reputation worsened as his success grew, and each masterpiece was followed by a tempestuous fury that often landed him in jail. Caravaggio's experiences on the street gave him a sharp take on the real world, and unlike other artists of that time, he had a keen understanding of reality. He redefined emotional realism in his paintings. His power of observation was so acute that his works would be studied for centuries. A young Sicilian artist named Mario Minniti was his muse, sparking rumors of homosexuality. At that time the cardinals wallowed in sexuality, and historians have deduced that Caravaggio painted homoerotic images of young boys with open mouths and supple skin to please his greatest patrons. Minniti wasn't his only model; he also brought animals, gypsies, and prostitutes into his studio to create scenes in front of him. He never sketched his ideas, instead he went straight to the canvas to capture the scenes he had set in front of him.

His attention to detail was so precise that years later, botanists were able to identify the fungus on a fig leaf in *Boy with a Basket of Fruit* (1593). In that painting a young Minniti appears quite seductive with his mouth agape and his muscles straining under the weight of the fruit basket. "It was a time when women were either tucked away in the home having babies or out on the streets as prostitutes," says art expert Jennifer Cavallero, who conducts private

^ *Boy with a Basket of Fruit* (1593) Borghese Gallery, Rome

Caravaggio walking tours in Rome for Through Eternity. "By using these adolescent boys, Caravaggio was able to skirt the taboo and offer sexuality without using women or adult men. These young boys were sensual without being vulgar."

Caravaggio also portrayed the reality of Rome's underclass from a knowing perspective. He even often cast himself as a derelict. In one of his own self-portraits, he paints himself as a *Sick Bacchus* (1593) with gray skin and dirty fingernails. Unlike conventional images of Bacchus, the god of wine, Caravaggio's Bacchus holds such realistic over-ripe grapes that one can almost smell the mold. But despite his grasp on radical realism portrayed in rotting fruit and diseased leaves, two other works would prove far more important. Not long after he moved to Rome, the *Fortune Teller* (1594) and *Cardsharps* (1594) caught the eye of Cardinal Francesco Maria Del Monte, one of the foremost art collectors of the time. Del Monte took Caravaggio into his palatial home in the Palazzo Madama—now home to the Italian Senate—near Piazza Navona. These paintings depicted the underbelly of modern society through the street life Caravaggio knew all too well. He was a breath of fresh air compared to other artists of the era, who used bright colors and lofty scenes to depict religion. Del Monte knew Caravaggio was ahead of his time.

As a sinner, Caravaggio also knew about redemption. His early sacred works show an unrivaled understanding of the liturgy tied to his own devout faith.

TIMELINE

September 29, 1571
Michelangelo Merisi is born in Milan, the capital of Lombardy

1576
Fearing the plague, the family moves to Caravaggio

1584
Begins four-year term as apprentice to Lombard painter Simone Peterzano

1592-93
Flees Milan and heads for Rome after quarrels with police and begins working for Giuseppe Cesari. His

art from this period includes *Boy With a Basket of Fruit*

1594
Cuts ties with Cesari and strikes out on his own creating works such as the *Fortune Teller* and *Cardsharps*. Meets future patron, the influential Cardinal Francesco Maria Del Monte

1599
Contracted to decorate the Contarelli Chapel in the church of San Luigi dei Francesi; creates the *Martyrdom of Saint Matthew* and

the *Calling of Saint Matthew*

1606-07
Flees to Naples with a price on his head after killing rival Ranuccio Tomassoni; paints the *Flagellation of Christ* and the *Seven Works of Mercy*

July 1607
Arrives in Valletta, Malta

1608
Completes the *Beheading of Saint John the Baptist*, possibly as passaggio to join the Knights

of Malta. Arrested after a brawl with a group of knights and imprisoned at the Fort St. Angelo; escapes to Sicily within a week

1609
Heads back to Naples where he is attacked and disfigured. Creates *David with the Head of Goliath*

July 18, 1610
Michelangelo Merisi da Caravaggio dies in Porto Ercole, Tuscany, on route to Rome to receive his pardon and present his works as repayment

He was commissioned to decorate the Contarelli Chapel in the church of San Luigi dei Francesi near Piazza Navona in Rome. What Caravaggio created would change art forever. The *Martyrdom of Saint Matthew* (1599-1600) and the *Calling of Saint Matthew* (1600) are painted in Caravaggio's signature tenebrist style, using chiaroscuro—the contrast between light and shadow—to create dramatic lighting effects. In the *Martyrdom of Saint Matthew*, the light is cast on the assassin—not on Saint Matthew. In the *Calling of Saint Matthew*, Caravaggio spotlights the pointing finger rather than the full figure of Christ. What makes these two paintings especially important today is that they are still in situ—along with his masterpiece *Saint Matthew and the Angel* (1602)—in the back of the church and can be seen in the same natural light and context for which they were created. Visitors can turn a light on in the chapel for a few coins, though Caravaggio would probably have wanted these masterpieces to be viewed in the usual combination of daylight and candlelight.

In 1599, Caravaggio was quickly becoming the most famous painter in Rome. He was winning the most sought-after commissions in the city, yet his personal life was in shambles. He was becoming notorious for his temper, which sometimes spilled into his work. His paintings were increasingly violent and edgy, his earthy naturalism a stark

∧ [top] **Rome** at night [bottom] *Fortune Teller* (1594-95) Louvre, Paris

131

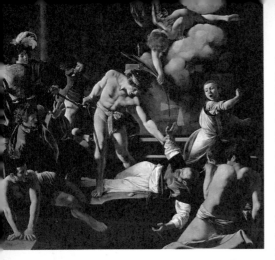

contrast to the stylized Mannerism popular in Rome at the time. When the church outlawed weapons on the streets, he painted his figures with swords. He gave the Virgin Mary an ample bosom spilling out of a screaming red dress. At the time, showing the bottom of one's feet was an insult, yet he painted the dirty soles of a pilgrim's worn feet in full view. In the *Conversion of Saint Paul* (1600), which sits in the church of Santa Maria del Popolo, the backside of a horse is the prominent image. And his *Madonna dei Paláfrenieri (The Madonna of the Papal Grooms)* (1605-06) hung for just two days inside St. Peter's Basilica before it was removed, as the church no longer allowed privately commissioned altarpieces.

In 1606, at the pinnacle of his success, Caravaggio killed a rival during a brawl over a tennis match. He had worn out the patience of his patrons, who could no longer protect him from his lawless spirit. He fled to Naples with a bounty on his head. There he created masterpieces once again, filling Neapolitan churches and producing *Flagellation of Christ* (1607) and the *Seven Works of Mercy* (1607). But by the summer of 1607, he was once again on the run from the law and fled to Malta where he created the only work he ever signed. The *Beheading of Saint John the Baptist* (1608) still hangs above the altar in the cathedral in Valletta, and his name is signed in the painted blood of Saint John the Baptist. He signed his name "f. Michelangelo," the "f" for fra (brother), as a sign of solidarity with the Knights of Malta. But he longed to return to Rome.

Not long after he finished the Maltese masterpiece, he found himself imprisoned once again. He escaped from a prison room on the island of Fort St. Angelo and headed to Sicily in 1608 where he met up with his former muse, Mario Minniti. With Minniti's help, he won commissions in Syracuse, Palermo, and Messina, but he was becoming increasingly eccentric. After less than a year in Sicily, he headed back to Naples for what would be his final days. He longed to return to the churches of Rome and begged for forgiveness. His paintings depicted remorse and sorrow. In Naples, he lived in seclusion while the wealthy Cardinal Scipione Borghese worked to secure a pardon in hopes of

^ ***Martyrdom of Saint Matthew*** (1599-1600) Contarelli Chapel, San Luigi dei Francesi, Rome

> ***Saint Matthew and the Angel*** (1602) and the **Contarelli Chapel**, San Luigi dei Francesi, Rome

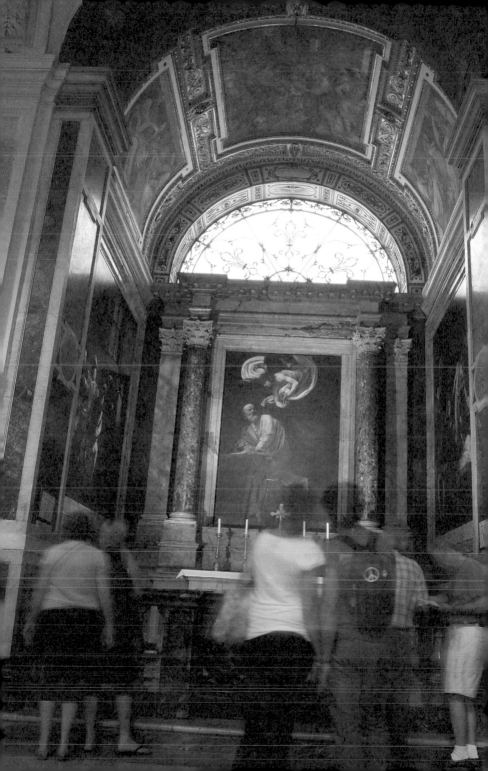

ART IMITATING ART: THE ARTIST'S IMPRINT ON POPULAR CULTURE

MOVIES

SPOTLIGHT ON
Caravaggio (1986)
Director: Derek Jarman
The atmospheric, ambiguous narrative opens with Caravaggio (played by Nigel Terry) on his deathbed, sick and brutally scarred. As he reflects on his life, the artist is shown as a young man in Rome, sick from poverty but reveling in the city's underworld. With success comes controversy, and he becomes involved in a volatile love triangle with Ranuccio (Sean Bean) and his lover Lena, played by Tilda Swinton in her debut role. The pair—an alluring thug and a prostitute—fascinates Caravaggio, and they join his gang of models.

Seven years in the making, the film was a deeply personal project for Jarman, and as he developed the script, elements of his own life began seeping into the work. Likewise, similarities between the two artists are clearly apparent. The film revels in the stark contrast between light and shadow, much like of Caravaggio's work. Taking another cue from Caravaggio, Jarman places his characters in an updated setting—against the stark studio backdrop, Jarman includes anachronistic (and decidedly '80s) touches, including lightbulbs, an electronic calculator and men dressed in blazers.

Caravaggio (2007)
Director: Angelo Longoni
This biopic, shot by award-winning cinematographer Vittorio Storaro (*Reds* and *Apocalypse Now*), was produced by RAI (Radiotelevisione Italiana) and developed as a two-part television presentation. It tells the story of the artist's tumultuous and adventurous life, and it premiered in the U.S. at the Open Roads: New Italian Cinema series at Lincoln Center in 2007 to several positive reviews.

LITERATURE

Murder at the National Gallery by Margaret Truman (Fawcett, 1997)

This book, from the author's Capitol Crime series, features Caravaggio's Medusa on the dust jacket and offers a histrionic portrayal of the artist as a crazed murderer guilty of numerous offenses. In addition to painting violent death scenes, the author also adds incest and rape to his repertoire for dramatic effect.

The English Patient
by Michael Ondaatje
(Vintage, 1992)
In 1992, this novel won the Booker prize; in 1996, it went on to become an immensely popular film. The intricate story includes the fictional plight of one of four protagonists (named David Caravaggio) who, like the artist, has a criminal record and a tormented mind. He also becomes the victim of a violent mutilation, and in the end, desperately seeks to find redemption.

Caravaggio: A Novel

by Christopher Peachment (Thomas Dunne, 2003) This fictional account is intended to be read as Caravaggio's final confession before his death. It's a vivacious tale about an artist whose immense talent still manages to prosper in spite of the troubling circumstances of his life.

finally bringing him back to Rome. However, shortly after he arrived, he was attacked by assailants who cut up his face—leaving him disfigured. As Cardinal Borghese in Rome worked to remove the bounty on his head, Caravaggio created a collection of masterpieces to repay him; among them was *David with the Head of Goliath* (1609–10). He modeled the decapitated head of Goliath after his own. He packed up the paintings and headed north to receive his pardon and present his works as repayment.

On July 18, 1610, he died of fever in Santa Maria Ausiliatrice Hospital near Porto Ercole, Tuscany, most likely from malaria that was rampant in the swamps along the sea. His official death certificate was found in 2001. Though the bounty on his life had been erased, only his paintings—with his final self-portrait as the centerpiece—arrived in Rome.

Immediately after his death, Caravaggio was all but forgotten, written off as a wasted talent; but in the 1920s and '30s, art critics finally began studying his impact on art. He was given credit for his inspiring style, which became a hallmark of the Baroque period. Bernini and Rembrandt were both influenced by his use of light and shadow. The Caravaggisti—followers of his style—came from the Netherlands to study his form, and his influence was felt across Europe.

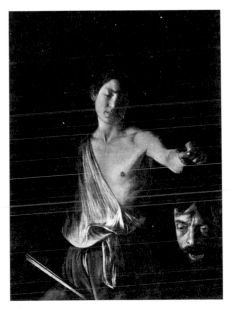

Caravaggio remains a constant presence in Rome, his masterpieces in the most prominent museums and churches. In 1920, art scholar Bernard Berenson aptly said, "With the exception of Michelangelo, no other Italian painter exercised so great an influence."

⌃ [top] **Fort St. Angelo** in Malta
[bottom] ***David with the Head of Goliath*** (1610) Borghese Gallery, Rome

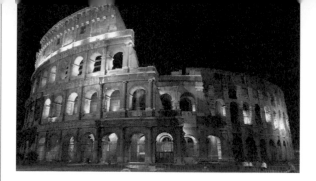

ACCESS

AIRPORTS: ✈
Rome Leonardo da Vinci-Fiumicino Airport
🏠 Via dell'Aeroporto di Fiumicino 320
☎ 39 06 65951
💻 www.adr.it

TRAIN: 🚆
Roma Termini
🏠 Piazza dei Cinquecento
💻 www.ferroviedellostato.it

BUS: 🚌
In front of Stazione Termini
🏠 Piazza dei Cinquecento
☎ 39 06 57003
💻 www.atac.roma.it

TOURISM OFFICE: 🌐
Rome Tourism Board
🏠 Via Leopardi 24
☎ 39 06 06 06
💻 www.turismoroma.it
🕐 Mon-Fri 9AM-7PM

● Note: All offices and shops are closed on the following days for national holidays and/or feast days that honor the city's patron saints: Jan 1, Jan 6, Easter Sunday and Monday, Apr 25, May 1, Jun 2, Jun 29, Aug 15, Nov 1, Dec 8, Dec 25-26.

FOR YOUR INFORMATION...

Rome, the only city in the world to reach a population of more than 1 million before the 20th century, is a study in delightful contradictions. Worldly and provincial, traditional and trendy, a living museum and a world-class commercial and political center, Rome is many cities at once (some literally built on top of each other). There is ancient Rome, the capital that once ruled the known world. There is Renaissance Rome, with its Romanesque basilicas, colorful piazzas, and cobblestone streets where Michelangelo and Leonardo once walked. There is the opulence of Baroque Rome with its extravagant Bernini fountains, magnificent churches, and palaces, which testify to the formidable political power the popes once wielded. And then there is modern Rome, with the elegant shops, innovative art and design, culinary prowess, and cutting-edge technology that make it a vibrant 21st-century capital. The best way to discover Rome is by letting it surprise you, as over 2,000 years of civilization cheerfully coexist in this unique—and Eternal—urban experience.

Weather 🌊
Temperatures in Rome can get pretty hot during the summer—averaging around 85 degrees—although evenings tend to be a pleasant 10 degrees cooler. Winters can be damp (November and December are often rainy), with temperatures between 40–55 degrees. Although Rome is beautiful all year round, spring and early autumn boast nearly perfect weather.

^ **The Colosseum**
< **Tourism Information Booth**

BEFORE YOU GO, GET IN THE KNOW: SUGGESTED WEBSITES AND BOOKS

WEBSITES

Rome Tourism Board
en.turismoroma.it

The official website for Rome's Tourism Board offers visitors information on where to eat and sleep, how to get there and get around, maps and weather, and museums and conventions. A section called "Today's Focus" provides details on numerous activities taking place in the city on that particular day.

Italian Government Tourist Board
www.italiantourism.com

The official site for the Italian Government Tourist Board provides travel tips, an itinerary planning section, a calendar of events, hotel suggestions, a number of downloadable brochures, links to tour operators in the U.S. and Canada, and more. Visitors can also sign up for a weekly newsletter that details upcoming events.

Rome Info
www.romeinfo.com

This website is an independent, non-commercial entity that was created to offer visitors, and those moving to Rome, timely information about the city and its surroundings. Some of the highlights found here include suggested sights and attractions, museums, accommodations, and more.

Enjoy Rome
www.enjoyrome.com

This site, maintained entirely by English speakers, is an independent tourist company that offers a number of services for travelers headed to Rome. They provide general information (including how to get there and money-saving tips), a city guide, hotel accommodation recommendations, and a variety of walking, bus, and museum tour options.

BOOKS

Caravaggio by Howard Hibbard

(Westview Press, 1985) This book, somewhat dated but still worth reading, offers an excellent approach to interpreting Caravaggio's paintings. In it, the author—a leading art historian—provides scholarly evaluation and insight into the artist's work that is helpful for people familiar with Caravaggio as well as those who aren't.

Caravaggio by Catherine Puglisi
(Phaidon Press, 2000)

This book is an excellent, up-to-date, and comprehensive account of the artist's paintings and stylistic evolution. The scholarly and reliable monograph is beautifully illustrated with color plates.

Caravaggio: A Life by Helen Langdon

(Farrar Straus & Giroux, 1999) Known to many Caravaggio scholars as one of the best biographies on the artist, this book delves into the dramatic life of its subject without losing focus on his work and its impact. It includes information and critical insight into his relationship with Cardinal Del Monte, his connection to the Knights of Malta, his imprisonment in Malta (and eventual escape), and more.

CALENDAR...YEARLY EVENTS

Settimana della Cultura / Week of Culture (April)

Each spring, Italy's Cultural Ministry sponsors a week of free admission to all national monuments, museums, and archeological sites. In addition, sites that are usually closed due to lack of funds for staffing are manned by volunteers.

Estate Romana / Roman Summer

(June to September) Summer is traditionally a quiet time in Rome, with most theaters, galleries, and other venues closed. To provide some entertainment for Romans stuck in town, the city created the Roman Summer. A mix of culture, education, and just plain fun, the Estate Romana is a chance to see concerts, opera, ballet, films, and theater under the stars.

Festa de' Noantri (July)

One of the oldest and most traditional Roman festivals takes place in a neighborhood across the Tiber River called Trastevere. It begins with a procession of monks carrying a statue of the Virgin Mary from one church, Sant'Agata, to another, San Crisogono, where it remains on display for eight days. During the celebration, streets are closed, concerts are held in the piazzas, and booths selling traditional Roman delicacies, sweets, and crafts, as well as the inevitable gaudy knick-knacks, fill the narrow streets.

Rome Jazz Festival

(November) This festival brings some of the top names in jazz to the Eternal City. One of the premier jazz festivals in the world, it takes place over two weeks at the state-of-the-art Auditorium Parco della Musica (designed by renowned architect Renzo Piano) and features performances by international stars and exciting up-and-comers.

BY BARBIE LATZA NADEAU

Caravaggio's major museum works are among the favorites of art lovers visiting Rome, but to view an original Caravaggio in a Roman church thick with the smell of incense is a powerful experience. To think that these incredible works of art have not moved since they were originally hung is overwhelming. To know that Caravaggio himself studied his works in those very churches brings the art to life.

WALKING TOUR

Caravaggio is synonymous with the rise of Rome, but many of his best works are not easy to find. The **Vatican Museums** have his most famous sacred masterpiece, *The Entombment of Christ* (1603), depicting Christ's nude body before it was placed in the tomb. The **Capitoline Museums** on the Campidoglio are also great venues at which to see Caravaggio's rendition of *Saint John the Baptist* (1598–99) and the *Fortune Teller* (1594) that so captivated Francesco Maria Del Monte.

Start your tour at the **Borghese Galleries**, which are home to the last paintings Caravaggio created including his self-deprecating portrait *David with the*

∧ The courtyard at the **Capitoline Museums**

Head of Goliath (1607) and **Madonna dei Palafrenieri** (1606). Here you will also find his muse Mario Minniti as **The Boy with a Basket of Fruit** (1593) and his self-portrait as **Sick Bacchus** (1593). To visit the galleries, you must pre-reserve tickets by web or phone. In addition, please note that your visit will be limited to two hours.

Next, head to the exquisite **Palazzo Barberini,** which hosts Rome's **Galleria Nazaionale d'Arte Antica (National Gallery of Ancient Art)** and holds *Judith Beheading Holofernes* (1598–99). This work marks a transitional phase and a new focus on dramatic tension. Note the furrowed brow as young Judith saws through the neck of Holofernes. This piece was in a private collection, only surfacing in the 1950s. Also on view is **Narcissus** (1597–99), a painting of the mythological figure. Its attribution is controversial, however, many scholars credit Caravaggio.

From here, wind down Rome's cobblestone streets past the Trevi Fountain across the Via del Corso to the **Galleria Doria Pamphilj**. Start with Caravaggio's **Rest on the Flight into Egypt** (1595), which has been here since the 17th century, when the gallery was a private residence. In the next room, **Penitent Magdalene** (1593-94) features the same prostitute he used as a model for Judith in *Judith Beheading Holofernes*. Note the same earrings on the Magdalene's dressing table and in Judith's ears.

^ **Galleria Nazaionale d'Arte Antica** at the Palazzo Barberini

THE EXPERT: DAVID M. STONE

Professor David M. Stone is a specialist in Italian Baroque Art at the University of Delaware. He received his B.A. from the University of California, Berkeley, and his M.A. and Ph.D. from Harvard University. A leading expert in the field, he is the co-author (with K. Sciberras) of **Caravaggio: Art, Knighthood and Malta** *(Midsea Books, 2006).*

Museyon Guides: Caravaggio is surrounded by a mythology of drama and violence. How important is that in understanding him as an artist?

David Stone: It's always useful to know something about artists; then you can judge the degree to which they're echoing their own personalities and psychological traits in their art—the degree to which they're amplifying it as opposed to the degree to which they're trying to hide it. Sometimes, knowing the personality of the artist can derail a good, well-rounded interpretation of the art. It's easy to lapse into the situation in which you know something about the artist and then you interpret everything in the art according to the artist's personality and biography.

MG: Can you give an example of Caravaggio's personality?

DS: The problem is when people talk about Caravaggio's personality, what they really mean is his violence or his sexuality; they don't mean his artistic personality from A to Z. I'll give you an example of his competitiveness: the two versions of the *Conversion of St. Paul*. It seems pretty clear that in between making first and second versions, he saw Annibale Carracci's *Assumption of Virgin*, the picture that's on the altar. His second version has Paul with his arms in a V-shaped, out-flung gesture that seems to be almost either imitating or mocking Annibale Carracci's gesture of the ascending Virgin in the altarpiece. He redoes his painting in a tighter, more geometric fashion in what seems a kind of competitive response to what Annibale Carracci has done on his altarpiece.

MG: If someone could only visit one Caravaggio-related location, what should it be?

DS: That's incredibly easy. I would say you have to go to the Contarelli Chapel. There you have three Caravaggios that are relatively untouched since they were done, a complete cycle there that represents some of Caravaggio's greatest achievements. Second to that would be the Cerasi Chapel in Santa Maria del Popolo. You need to visit both of those and then you get a really good sense of who Caravaggio is as a painter during his Roman period.

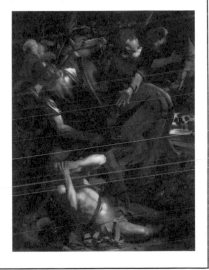

^ ***Conversion of Saint Paul*** (first version, 1600-01), Odescalchi Balbi Collection, Rome (See the second version on page 143)

The church of **San Luigi dei Francesi**, the French national church in Rome, is a short walk from the Galleria Doria Pamphilij and is home to three of Caravaggio's most famous paintings.

Walk towards the back of the church and the **Contarelli Chapel**. The *Calling of Saint Matthew* (1599-1600) and *Saint Matthew and the Angel* (1602) are considered masterpieces and are still in the chapel for which they were commissioned. Note that the angel above St. Matthew is counting by finger to symbolize philosophy. In the *Calling of St. Matthew*, the pointing finger of Christ is the prominent focus—not the figure of Christ himself—marking a departure from traditional versions of this sacred scene. In another radical departure from convention, Caravaggio treats the Biblical scene as a genre painting, dressing his figures in contemporary rather than historical garb. Directly across from the painting is another scene from the life of the saint, the *Martyrdom of Saint Matthew* (1599-1600). These pictures were designed to be seen in dark shadows, although you have the option to turn on a light above the altar. Try to see them both ways.

Just a few steps away is one of Caravaggio's most wonderful treasures in the church of **Sant'Agostino**. *Madonna di Loreto* (1606) depicts the Virgin Mary as a common woman who answers two pilgrims at her door. Mary's feet are crossed, almost as if she is dancing, despite the obvious weight of the baby in her arms, and her head is ringed with only the slightest indication of a halo. The dirty feet of the praying pilgrims face the viewer, symbolizing their journey, as people made these pilgrimages in bare feet.

Heading towards **Piazza del Popolo**, pass Via di Pallacorda. This area,

^ *Judith Beheading Holofernes* (1599) Galleria Nazionale d'Arte Antica, Rome

> *Madonna di Loreto* (1606) Sant'Agostino, Rome

known as **Campo Marzio**, was home to the ancient tennis courts where Caravaggio killed his rival Ranuccio Tomassoni—a questionable character from a family of soldiers and thugs—in a dispute over a game of tennis, for which he was exiled from Rome.

The final Roman works by Caravaggio that are still in their original place can be seen at **Santa Maria del Popolo**, a church which features works by some of Rome's great Renaissance masters, including Raphael and Bernini.

Here, in the **Cerasi Chapel**, Caravaggio depicts key moments from the lives of Apostles Peter and Paul, central figures in the Roman Catholic Church. Caravaggio's paintings are dramatic, his figures illusionistic and boldly lit. Compared to the other works of art in the church, the *Crucifixion of Saint Peter* (1601) and the *Conversion of Saint Paul* (1601) seem to come alive.

^ [top] **Santa Maria del Popolo** and the Piazza del Popolo
Conversion of Saint Paul (1601) Cerasi Chapel, Santa Maria del Popolo, Rome

WHERE TO SEE...THE WALKING TOUR

detail from
Entombment
(1602-04)

1 Vatican Museums
⛪ Viale Vaticano
☎ 39 06 69884676
🖥 mv.vatican.va
○ Mon-Sat 9AM-6PM (Enter by 4PM)
💲 14 Euros
The place to see masterpieces collected by the popes over 500 years—including the Sistine Chapel.

2 Capitoline Museums
⛪ Piazza del Campidoglio 1
🖥 en.museicapitolini.org
○ Tue-Sun 9AM-8PM
💲 6.5 Euros
Dating back to 15th century, the Capitoline Museums include some of Rome's most magnificent archeological treasures.

4 Galleria Nazionale d'Arte Antica
Palazzo Barberini
⛪ Via delle Quattro Fontane 13
☎ 39 06 32810
🖥 www.galleriaborghese.it
○ Tue-Sun 8:30AM-7:30PM
💲 5 Euros
Located in a palazzo built for Pope Urban VIII by Carlo Maderno and Gian Lorenzo Bernini, this is where you'll find *Narcissus*, attributed to Caravaggio, as well as his famously gory *Judith Beheading Holofernes*.

Narcissus (1597-99)

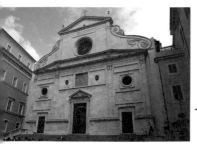

8 Via di Pallacorda
For a taste of Rome's spookier side, walk down this quiet street, not far from the Tiber River. Near where the ancient tennis courts once stood, this is the place where Caravaggio killed his rival, Ranuccio Tomassoni.

7 Sant'Agostino
⛪ Piazza di Sant'Agostino 80
☎ 39 06 68801962
○ Daily 7:30AM-12:30PM 4PM-6:30PM
Behind this deceivingly plain exterior are Caravaggio's *Madonna di Loreto* as well as work by Raphael and Guercino.

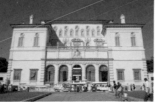

Madonna dei Palafrenieri (1605-06)

3 Borghese Gallery
🏛 Piazzale del Museo Borghese 5
☎ 39 06 32810
🖥 www.galleriaborghese.it
○ Tue-Sun 8:30AM-7:30PM
$ 8.50 Euros
Make sure to make a reservation to see this formerly private collection, which includes prime work by Caravaggio, Correggio, Bernini, and Titian.

detail from *Saint Matthew and the Angel* (1602)

detail from *Rest on the Flight into Egypt* (1595)

5 Galleria Doria Pamphilj
🏛 Via del Corso 305
☎ 39 06 6797323
🖥 www.doriapamphilj.it
○ Daily 10AM-5PM
$ 9 Euros
This private collection dates back to the 16th century, and may be Rome's largest.

6 San Luigi dei Francesi
🏛 Via S. Giovanna d'Arco 5
☎ 39 06 688271
🖥 www.saintlouis-rome.net
○ Daily 8AM-12:30PM, Fri-Wed 4PM-7PM
The French national church is where you'll find the Contarelli Chapel, which features Caravaggio's three paintings from the life of Saint Matthew.

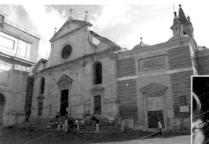

9 Santa Maria del Popolo
🏛 Piazza del Popolo 12
☎ 39 06 3610836
○ Daily 7AM-12PM 4PM-7PM
One of Rome's finest churches, it features work by both Caravaggio and Annibale Carracci in the Cerasi Chapel.

detail from *Crucifixion of Saint Peter* (1601)

145

WHERE TO SEE...
SCENE STEALERS

SCENE STEALERS

PALAZZO MADAMA
⛫ Corso Rinascimento

ARA PACIS MUSEUM
⛫ Lungotevere in Agusta
☎ 39 06 82059127
🖥 en.arapacis.it
○ Tues-Sun 9AM-7PM
● Mondays, Jan 1, May 1,
Dec 25
$ 6.50 Euros

**NATIONAL MONUMENT
TO VICTOR EMMANUEL II**
⛫ Piazza Venezia
☎ 39 06 6991718
○ Daily 10AM-4PM

1 Palazzo Madama

The Palazzo Madama, which has been home to the Italian Senate since 1871, was built in 1505 for the powerful Medici family on the site of the ancient baths of Nero. Many Medicis lived there, including two Medici popes, Leo X and Clement VII, and Clement VII's niece, Catherine de' Medici, but at one point, it was also the home of Cardinal Del Monte, who is best known as Caravaggio's patron.

2 Ara Pacis

The magnificent Ara Pacis, or "Altar of Augustan Peace," is a large, intricately sculpted marble homage to the "Pax Augusta," the era of peace and prosperity ushered in by Emperor Augustus' military victories. The first fragments were unearthed in 1568, but the majority were recovered and reconstructed in the 1930s and enclosed in an austere Fascist-era structure. A luminous, new protective structure was commissioned by renowned architect Richard Meier and opened to the public in 2006. While its design doesn't have many fans, its steps and fountains have found favor with Roman children and weary visitors.

3 Il Vittoriano / National Monument to Victor Emmanuel II

This mammoth Neo-Classical monument that dominates Piazza Venezia, Rome's busy traffic hub, was built to celebrate Italian unification and to honor unified Italy's first king, Victor Emmanuel II. Romans have very mixed feelings about the immense white structure as large swaths of Roman ruins and medieval architecture were razed to make way for it when construction began at the end of the 19th century. Completed in 1935, it was dubbed "The Wedding

Cake" because of its overwrought facade, and later, "The Typewriter." The views from its terraces are stunning and the Museum of the Risorgimento, tucked in the back of the monument, has exhibits that explain the political movement, and the war, that led to the unification of Italy in the 1870s.

4 Spanish Steps

The best time to see the Spanish Steps—the monumental stairway of 138 wide steps that leads from Piazza di Spagna to the church of Trinita dei Monti above—is in the spring, when the landings are decked out with flowering azalea bushes. The Spanish Steps (or Scalinata, as the Romans call them) are always a spectacle though, frequently thronged with students, musicians, and weary tourists who use it as prime seating to watch the panorama—and the people—below. The best time for people-watching is around 6:00 p.m. as chic Italians begin that daily evening stroll known as the "La Passeggiata," ambling past the Spanish Steps to gaze in the elegant shop windows on nearby Via Condotti. Romantics will want to see the steps from the window of the adjacent Keats-Shelley Memorial House, Piazza di Spagna 26, where English poet John Keats lived (and died of tuberculosis) in 1821.

5 The Pantheon

The Pantheon is one of the best-preserved Roman structures in the world as well as one of the most beautiful. The Pantheon, which comes from the ancient Greek words for "everything" and "divine," was built in 27 BC as a small temple dedicated to all the Roman gods. It was destroyed by fire twice—once after having been struck by lightning—and rebuilt in 128 AD by visionary Emperor Hadrian. One of the most impressive engineering accomplishments of its time, its giant portico with

SPANISH STEPS
⌂ Piazza di Spagna

THE PANTHEON
⌂ Piazza della Rotonda
☎ 39 06 68300230
○ Mon-Sat 8:30AM-7:30PM
Sun 9AM-1PM
● Jan 1, May 1, Dec 25

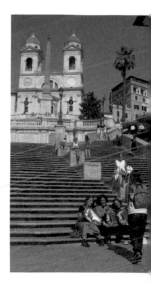

‹ [previous page] Police officer in **Palazzo Madama**; **Ara Pacis**
⌃ [clockwise from top left] The view from **Il Vittoriano**: Musicians in **Piazza Venezia**; Hanging out on the **Spanish Steps**

PIAZZA NAVONA
⌂ Rione Parione

CAMPO DEI FIORI
⌂ Between Piazza Navona
and Piazza Farnese

THE ROMAN FORUM
⌂ Via della Salara Vecchia
5/6
☎ 39 06 699841
○ Daily 8:30AM to one hour
before sunset
● Jan 1, May 1, Dec 25
$ 9 Euros

40-foot marble columns and 20-ton bronze doors leads to a remarkable rotunda, with the largest masonry dome in the world. Several illustrious Italians are buried in the Pantheon, which is also a Catholic church, including Renaissance artists Raphael and Annibale Carracci, and architect Baldassare Peruzzi. After visiting the Pantheon, walk down Via del Pantheon, which has one of the best concentrations of gelaterias in Rome.

6 Piazza Navona

Piazza Navona was built on the site of the 1st-century Roman structure known as the Stadium of Domitian—which at the time held up to 30,000 spectators. It was paved over in the 15th century, following the shape of the original circus, and the elegant oblong piazza, as we know it today, was born. Dominating the center of the piazza is Baroque extravaganza of the towering Fountain of the Four Rivers. Gian Lorenzo Bernini's masterpiece from 1651 features monumental figures, plants, and animals that represent the Nile, Danube, de la Plata, and Ganges rivers. On the southern side of the piazza is the church of Nostra Signora del Sacro Cuore, once known as San Giacomo, which is where—according to police records from 1605—Caravaggio hit a notary clerk on the side of his head with a sword after he insulted a certain "Lena, who stood in Piazza Navona," a young lady who is thought to have had a relationship with Caravaggio and to have posed for several of his Madonnas. Today the piazza is filled with artists, musicians, tourists, cappuccino-sippers, and pigeon-chasing children, all enjoying its beautiful and welcoming space.

7 Campo dei Fiori

Gazing at the colorful and bustling open-air fruit and vegetable market in Campo dei Fiori (which means "field of flowers"),

⌃ [top] The **Pantheon** viewed from Piazza della Rotondo
[bottom] Crowds in **Piazza Navona**
⟩ [opposite] The market at **Campo dei Fiori; Roman Forum**

it's hard to believe that this medieval square was once the site of frequent public executions. The piazza's best-known victim was Giordano Bruno, who was burned at the stake in 1600 by the Roman Inquisition for daring to suggest—among other things—that the sun is the center of the universe. Now, his statue is a popular meeting place for the people who crowd Campo dei Fiori each night to see friends and take a stroll, or sit outside at one of the many traditional restaurants or trendy wine bars.

8 The Roman Forum
Built in a marshy valley between two of Rome's seven hills, the Capitoline and the Palatine, and first paved in 600 BC—the Roman Forum was the center of political and social activity in ancient Rome. Originally a marketplace, it eventually also included temples, the Senate, basilicas, and courts of law. It flourished during the Imperial and Republican periods, fell into disrepair when Rome was sacked by the Visigoths, and was finally brought to light again by excavations beginning in the 18th century. For the best view of what remains of the Forum, climb the steps of the Campidoglio (Rome's City Hall, designed by Michelangelo) and walk around the terraces to see the all of it—from the Arch of Titus to the temples of Romolus, Saturn, Venus and Caesar—spread out before you.

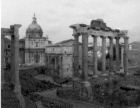

SUGGESTED SOUVENIRS

Caravaggio Mini Monographs
3.00 Euros
Borghese Gallery

Caravaggio Wine Merlot, Limited Edition
16.00 Euros
Malta

Tratto Pen
4.00 Euros
Borghese Gallery

Mini Calendar
1.00 Euro
Borghese Gallery

EAT

Casa Bleve
⌂ Via del Teatro Valle 48/49
☎ 39 06 6865970
🖥 www.casableve.it
○ Tue-Sat 12:30PM-3PM, 7:30PM-10:30PM
$ 25-45 Euros

Ristorante La Pigna
⌂ Piazza della Pigna 54
☎ 39 06 6785555
○ Mon-Sat 1PM-3PM, 8PM-11PM
$ 40 Euros

Giggetto al Portico d'Ottavia
⌂ Via del Portico d'Ottavia 21/a-22
☎ 39 06 6861105
🖥 www. giggettoalporticodottavia.it
○ Tue-Sun 12:30PM-3PM 7:30PM-11PM
$ 35-40 Euros

WHERE TO...EAT AND SLEEP

EAT

A Casa Bleve

Located in what was the courtyard of the 16th-century Palazzo Medici Lante della Rovere, the Casa Bleve, Rome's most luxurious wine bar, is spacious, elegant, and inviting at the same time. Guests choose from one of the best wine selections in Rome and nibble on gourmet antipasti under the Art Deco-style stained glass ceiling. Ask to see the wine storage vault in the building's ancient foundations.

B Ristorante La Pigna

Ristorante La Pigna is an little-known gem and a great place to try simple, wholesome family-style Roman cooking with impeccably fresh seasonal produce. Tucked away in an unpretentious piazza steps from both Piazza Venezia and the Pantheon, the restaurant takes its name from a large, ancient bronze pinecone that was unearthed nearby (and is now on display in a Vatican courtyard). Family-run La Pigna is a great place to try some of those greens—like puntarelle and agretti— that are typical and unique to Roman cooking. In the summer, the terrace dining at the front is an oasis of calm in the busy city.

C Giggetto al Portico d'Ottavia

Located in the "Ghetto"—Rome's Jewish neighborhood—Da Giggetto has been serving artichokes alla giudia, deep-fried salt-cod (baccalà alla Romana), and other Roman specialties to

⌃ A dish from **Casa Bleve** and a view of the dining room

appreciative (and often noisy) crowds of Romans and tourists since 1923. The atmosphere (and service) is no-frills, but the neighborhood more than makes up for it; in the summer, outdoor tables are clustered in the ruins of the Portico d'Ottavia (an ancient fish market) and many of the nearby streets look much the way they did when Caravaggio prowled them. Be sure to try the fried zucchini flowers, if they are in season.

SLEEP
D Rose Garden Palace Hotel

The Rose Garden Palace Hotel, which opened in 2001, is a stylish, modern boutique hotel just a few steps away from elegant Via Veneto and the lush gardens and galleries of Villa Borghese. In addition to its great location, the four-star Rose Garden Palace boasts soothing décor, an attentive staff, and a lovely courtyard with— what else?—a rose garden.

E Daphne Trevi
F Daphne Veneto

A relative newcomer to the Roman hotel scene, the two locations of the serene Daphne Inn Rome are a cross between a boutique hotel and an upscale B&B. With addresses right out of Fellini's *La Dolce Vita*, the Daphne Trevi and the Daphne Veneto offer guests the kind of personalized service you'd expect from a much more expensive hotel. The friendly, attentive staff helps guests who are unfamiliar with Rome plan their itineraries, and all guests are given a cell phone to use during their stay. Of special note: the incredibly comfortable beds.

G Hotel Domus Aventina

The Domus Aventina is a charming, relatively inexpensive three-star hotel, located a bit off the beaten track on the elegant and remarkably quiet Aventine Hill. The staff is friendly and many of the rooms have terraces overlooking the beautiful medieval church next door. The hotel is a short walk to the trendy Testaccio neighborhood—home to hot nightclubs, popular pizzerias, and classic Roman restaurants— where even Caravaggio would feel right at home.

SLEEP

Rose Garden Palace Hotel
⌂ Via Boncompagni 19
☎ 39 06 421741
🖥 www.rosegardenpalace. com
$ 220 Euros-

Daphne Trevi
⌂ Via degli Avignonesi 20
☎ 39 06 87450086
🖥 www.daphne-rome.com
$ 130 Euros-

Daphne Veneto
⌂ Via di San Basilio 55
☎ 39 06 87450087
🖥 www.daphne-rome.com
$ 140 Euros-

Hotel Domus Aventina
⌂ Via di Santa Prisca 11/B
☎ 39 06 5746135
🖥 hoteldomusaventina.com
$ 125 Euros-

^ [top] The **Rose Garden Palace Hotel**
[bottom] A typical street scene on a night in Rome

MAP OF VENUES AND CITY LANDMARKS

Lungotevere Michelangelo

Via Cola di Rienzo

1 ←

Piazza Adriana

Castel Sant' Angelo

ⓘ

Tevere River

Corso Vittorio Emanuele II

Lungotevere del Sangallo

ⓘ

6

Piaz
Nov

7
Campo de Fiori

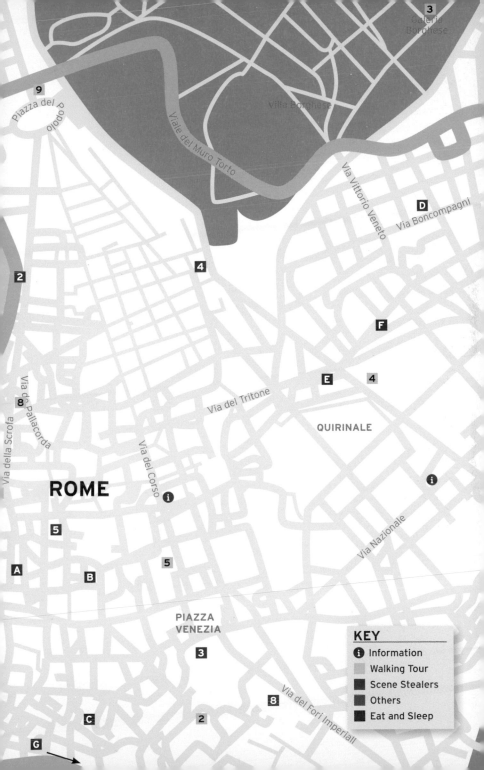

EXTENDED TRAVEL

CARAVAGGIO IN VALLETTA

True Caravaggio lovers will want to visit the island of Malta, off the coast of Sicily, to see the *Beheading of Saint John the Baptist* (1608)—Caravaggio's largest painting and the only one he ever signed. The masterpiece, which is roughly 12 feet high and 16 feet long, was commissioned to hang above the altar in the oratory of St. John's Co-Cathedral—one of the greatest Baroque churches in the world, filled with masterpieces by Mattia Preti, Alessandro Algardi, Ciro Ferri, and others—located in the island's capital, Valletta. The hot-tempered Caravaggio, who had fled to Malta after killing a rival, was quick to ingratiate himself with Alof de Wignacourt, Grand Master of the Knights of Malta, and wangled himself an induction into the storied group, perhaps painting the *Beheading of Saint John the Baptist* as his passaggio, the large sum usually collected from prospective knights.

While in Malta, Caravaggio also painted *Saint Jerome Writing* (1607-08) for another influential knight, the Prior of Naples, Ippolito Malaspina (whose coat of arms is on the wooden panel on the right-hand side of the painting). But the incorrigible Caravaggio was expelled from the Knights in disgrace after another fight that is reputed to have involved seven knights, one broken door and a wounded senior knight. He was imprisoned in the Fortress of St. Angelo but executed a daring, unprecedented escape using ropes to lower himself down the sheer stone wall where a boat waited to help him flee to Sicily.

ACCESS:
There are daily flights to Malta International Airport from Rome via Alitalia and Air Malta. Make the three-mile trip into town by taxi and or bus (the number 8).

A day in Valetta, which is a UNESCO World Heritage site, should begin at Fort St. Angelo in the Grand Harbor, which is thought to stand on the site of a fortified Roman settlement. A visit is a trip back to the age of knights and pirates. A colorful local bus or taxi will take you back to the city gate for a visit to the Grand Master's Palace in Palace Square. The palace, whose armory contains an impressive collection of spears, swords, shields, and heavy armor, is the historic—and current—seat of government. Next take in Caravaggio's *Beheading of Saint John the Baptist* and *Saint Jerome Writing* in the richly decorated, High Baroque-style St. John's Co-Cathedral, where you can also see intricate, marble-inlaid

‹ [previous page] A view of **Malta**

∧ *Portrait of Alof de Wignacourt* (1607-08) Louvre, Paris; *Saint Jerome Writing* (1607-08), **St. John's Co-Cathedral**, Valletta, Malta

tombstones of 17th- and 18th-century knights. A few steps away, on Merchants Street, is the Auberge d'Italie, built by architect Girolamo Cassar in 1574, where knights of Italian origin were quartered (and therefore, possibly Caravaggio as well).

No trip to Valletta should be without a visit to The National Museum of Archaeology, housed in the Auberge de Provence on Republic Street, also attributed to Cassar. The highlights of its collection, which includes important prehistoric works from Maltese archeological sites, are the lovely *Sleeping Lady* (pictured) and the tiny, headless *Venus of Malta*. An additional sight worth seeing is the National Museum of Fine Arts on South Street, which has masterpieces by, among others, Preti and Valentin de Boulogne.

THE BEHEADING OF SAINT JOHN THE BAPTIST

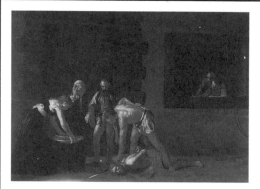

The figures are carefully arranged with a sense of stillness and lit with a seemingly heavenly light. The strong triangle formed by the stark white body of the executioner anchors the painting, while the scarlet robes of St. John mirror the blood pouring from his neck. An arch frames the murder, as though it were a theater stage.

At the bottom of the painting, Caravaggio signs his name in the blood of St. John. He writes "f. Michelangleo," for fra, or brother, a sign of his allegiance to his fellow knights.

In Malta, Caravaggio finally found a bit of respite after his tumultuous time in Rome. His peace would be short-lived, but it is there, in 1608, that he painted one of his great masterpieces, *The Beheading of Saint John the Baptist*, for the oratory of St. John's Co-Cathedral in Valletta.

For his subject, Caravaggio chose the martyrdom of the patron saint of the Knights of Malta, a group also referred to as the Order of St. John. Caravaggio presents the scene in the midst of the action—the executioner has sliced the saint's neck, but is reaching for a dagger to finish the job. The viewer is a witness to the martyrdom in progress.

Despite its gory subject, Caravaggio treats the scene with unprecedented restraint, creating an image that inspires quiet contemplation.

Today, the painting remains in the site where it originally hung. Visitors to the island can also try to find the architecture that may have inspired the painting's setting at the President's Palace (formerly the Grand Master's Palace) on what is now Archbishop Street.

ANATOMY OF A MASTERPIECE

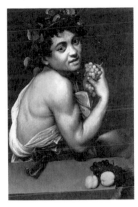

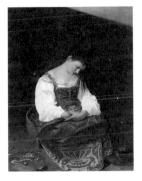

Fortune Teller, 1594-95
Louvre, Paris
A young man smiles, completely clueless to the fact that the gypsy in this painting is stealing his ring. The figures are shown in contemporary dress, in the vibrant palette of Lombard painting.

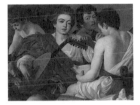

Sick Bacchus, 1593
Borghese Gallery, Rome
Caravaggio painted himself as the god of wine at about the age of 22, when he first settled in Rome. Along with his sickly self-portrait, this image features a still life of fruit, a hallmark of many of his early pictures.

Boy with a Basket of Fruit
1593 (See page 129)
Borghese Gallery, Rome
From the seductive portrait of model and painter Mario Minniti to the still life in his hands, this painting is a virtuosic feat, filled with different textures. Even at this early stage in his career, Caravaggio's figures are remarkable in their naturalism and expressiveness.

Penitent Magdalen, 1593-94
Galleria Doria Pamphilj, Rome
One of Caravaggio's first-known religious paintings, *Penitent Magdalen* shows Mary Magdalen next to a pile of cast-off jewels, symbolizing her rejection of her former sinful ways. Unlike conventional depictions of the theme—usually idealized or allegorical—Caravaggio

paints the Magdalen as a real, contemporary woman, using a model.

Cardsharps, 1594-95
Kimbell Art Museum
Forth Worth, Texas
Caravaggio shows a wealthy and naïve young man being fooled by a pair of tricksters, perhaps symbolizing the fading of youth and the disillusionment that comes with adulthood. This painting found a buyer in the influential Cardinal Del Monte, who invited Caravaggio to join his household.

Musicians, 1595
Metropolitan Museum of Art, New York
Under the patronage of Cardinal Del Monte, Caravaggio painted alluring and androgynous young boys with thick curls and parted lips. The figure eating grapes has the wings and arrows of Cupid alluding to the intoxicating power of both music and love.

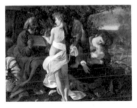

Rest on the Flight into Egypt
1595
Galleria Doria Pamphilj, Rome
Caravaggio painted a number of religious themes for Del Monte, including this biblical scene. The painting features one of the few landscapes painted by the artist, as well as an early example of his mastery of the contrast between light and dark.

Bacchus, 1597
Uffizi, Florence
One of Caravaggio's most iconic paintings, this image of the god of wine reveals some signs of its artificiality, including the prop mattress on which the boy sits and the arrangement of inedible, overripe fruit. As with other pictures made for Del Monte, Caravaggio paints a coy youth, this time toying with the ribbon on his robe and offering a glass of wine.

Judith Beheading Holofernes
1599 (See page 142)
Galleria Nazionale d'Arte Antica, Rome
Caravaggio presents the story of Judith, the Jewish heroine who seduced and beheaded an invading general, at the climax of the story. In this early example the dark and dramatic style that would become his signature, the image is theatrically lit from the side, while the figures are arranged in a row like actors on a stage, a connection heightened by the red curtain in the background.

Martyrdom of Saint Matthew,
1599-1600 (See page 132)
Contarelli Chapel, San Luigi dei Francesi, Rome
One of three paintings by Caravaggio from the life of

Matthew in the Contarelli Chapel, the martyrdom scene was likely the first painted, following guidelines left by the patron. Though the story took place in ancient Ethiopia, the figures wear contemporary costumes, and in the background, a witness—Caravaggio himself—stares out from the canvas.

Calling of Saint Matthew
1599-1600
Contarelli Chapel, San Luigi dei Francesi, Rome
In this scene from the life of Matthew, Caravaggio uses light and shadow as a narrative element, with a diagonal ray of light drawing a line between the pointing figure of Christ and an oblivious Matthew.

Conversion of Saint Paul, 1601
(See page 143)
Cerasi Chapel, Santa Maria del Popolo, Rome
While Annibale Carracci painted the more prestigious altarpiece, Caravaggio contributed two paintings to the Cerasi Chapel. Caravaggio shows the saint at the moment of his enlightenment—sprawled on the ground and enveloped in a heavenly glow—while his earthly companions are unaware of the miracle they are witnessing. The artist omits any architectural elements in favor of a stark black background, which would

help the figures stand out in the dimly lit chapel.

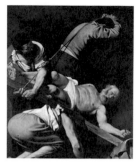

Crucifixion of Saint Peter, 1601
Cerasi Chapel, Santa Maria del Popolo, Rome
Both of the lateral paintings Caravaggio created for the Cerasi Chapel were at first rejected, and replaced by the paintings that hang there today, though it is unclear why. While the original version of the *Crucifixion of Saint Peter* has disappeared, evidence shows that the second set of paintings—with their monumental, seemingly three-dimensional figures—were much more unconventional than the first set.

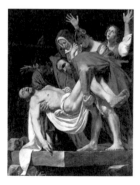

Entombment, 1602-04
Pinacoteca Vaticana, Rome
Caravaggio shows a crowd of

mourners placing the limp body of Christ in his tomb. Unlike the customary reverential treatment of the scene, here Christ's body and sallow skin show the toll of physical death, adding to the painting's emotional rawness.

Death of the Virgin, 1601-03
Louvre, Paris
One of Caravaggio's most controversial works, this painting is an example of his revolutionary naturalism. The Virgin Mary is shown here as an actual corpse, not an exalted figure being assumed into heaven; a prostitute may have been the model. The painting was commissioned for Santa Maria della Scala in Rome, but refused. It was replaced by a more conventional scene by Carlo Saraceni in which the Virgin sits serenely, surrounded by puti playing instruments. But even Saraceni's had to try twice. His first painting, which was more somber in tone, was rejected.

Saint Matthew and the Angel
1602
Contarelli Chapel, San Luigi dei Francesi, Rome
Caravaggio returned to the Contarelli Chapel to paint the

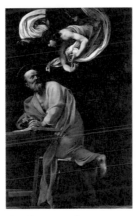

altarpiece. In another scene from the life of Matthew, the saint writes his gospel with the guidance of an angel. In contrast to the first version of this painting, Matthew is shown as a wise, old man while an angel speaks to him from within a swirl of white fabric. In the original, rejected, version (destroyed in WWII) the saint was shown as awkward and unrefined, while a beautiful angel guided his hand.

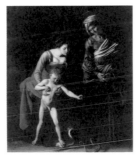

Madonna dei Palafrenieri
(Madonna of the Papal Grooms), 1605-06
Borghese Gallery, Rome
Caravaggio's final Roman altarpiece was originally intended to hang in St. Peter's Basilica, though it was quickly

removed, possibly because private commissions were no longer allowed at the church. The painting is unusual in other ways: Mary is shown with her bust spilling out of a simple, contemporary dress, while her mother—St. Anne, the patron saint of the Papal Grooms—is in the shadows, wrinkled and old.

Seven Works of Mercy
1606-07
Pio Monte della Misericordia, Naples
In Naples, Caravaggio completed one of his most complex altarpieces, an allegorical rendering of Christian charity that deftly incorporates each of the seven charitable acts required for salvation—from feeding the hungry to burying the dead.

David with the Head of Goliath, 1610 (See page 135)
Borghese Gallery, Rome
Tired of running and dejected in his final days, Caravaggio paints himself as the decapitated head of Goliath, the embodiment of evil. Adding to the painting's gloomy interpretation is the figure of David, ambivalent in his victory and disgusted by his trophy.

MUNCH and Oslo

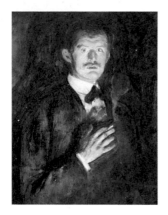

When we think of Edvard Munch, Norway's best-known artist and the so-called "father of Expressionism" we invariably think of his iconic masterpiece, *The Scream*. But Munch was an extremely prolific and influential artist who left thousands of other works to the city of Oslo when he died. Nature and light were always incredibly important subjects for Munch, and in Oslo he created countless powerful landscapes and cityscapes as well as monumental symbolist murals such as those that he painted for the University of Oslo. When he died in 1944, at age 80, the artist bequeathed his extensive archive to the City of Oslo, a collection that is now housed in Oslo's Munch Museum.

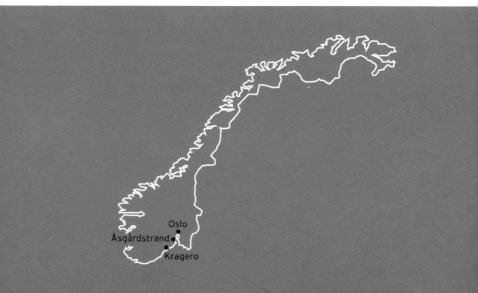

Oslo
Åsgårdstrand
Kragero

BY LEA FEINSTEIN

Lightning flashes across the Oslofjord as a summer squall whips waves into peaks and blackens the sky. As the storm clears, the bay grows calm, opaque as mercury, and the sky tints red, then mauve. The Rådhuset clock tower near the harbor reads ten thirty, and it is still light . . . the end of a long Norwegian summer day. In 1893, Edvard Munch painted *The Scream* with a sky like this, after a harrowing walk along the nearby Ekeberg Heights. He recorded in his diary that he heard all of nature shriek in anguish. The distress was his own, but his image of the contorted face covering its ears in a tortured landscape remains an icon in our own time.

Oslo was Munch's home. He was born in 1863 and moved here a year later, when the city was still known as Kristiana, the capital of a Swedish territory; his life ended here as well, in the occupied Norway of 1944, when he was 80. Though he traveled through European art capitals during the most active years of his career, he always came back to the Oslofjord region every summer for emotional and spiritual refueling. During the years of his travels, the place he called home was Åsgårdstrand—a fishing village and art colony on the coast, about 60 miles southwest of Oslo—where he owned a little house.

Unlike other artists whose limited output is scattered around the globe in the hands of private collectors and museums, Munch was astonishingly prolific, and a large portion of his life's work is here in Oslo. When he died, he left it all to the city. It is too much to cover in a day or two, so if you're a serious fan, give

∧ Sunset over the **Oslofjord** as seen from **Ekeberg Heights**

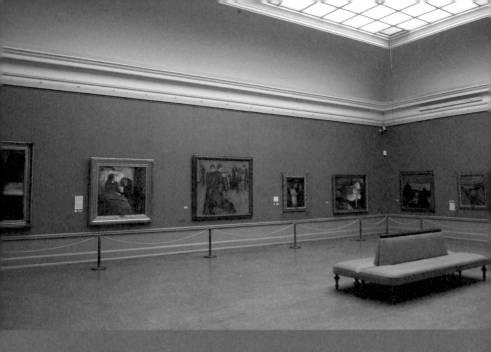

TIMELINE

December 12, 1863
Edvard Munch is born
in Løten, Norway

1864
Family relocates
to Kristiania
(now Oslo)

1868
Munch's mother
passes away

1877
Sister Sophie dies

1879
Starts classes at
Kristiana Technical
College

1881
Abandons his
architecture studies
and enrolls in the

Royal School of
Design in Kristiania
to become a painter

1884
Joins Kristiania's
bohemian community

1885
Journeys to Paris

1889
Arranges his first
one-man exhibition
at the Student
Association in
Kristiania

Studies with Léon
Bonnat in Paris

After the death of his
father, Munch
falls into a deep
depression

1892
Controversial
exhibition in Berlin
closes within a week

1893
Based in Berlin, Munch
creates iconic painting
The Scream

1908
Suffers nervous
breakdown and
delusions; spends
eight months in a
Copenhagen clinic

1909
Awarded the Royal
Order of St. Olav

1916
Relocates to Ekely,
where he remains for
the rest of his life

1930
A burst blood vessel
causes near blindness
in his right eye

1933
Receives the Grand
Cross of the Order
of St. Olav

1937
German officials
confiscate over 80
works of "degenerate
art" by Munch in
German galleries

1940
Bequeaths all works
to the city of Oslo

January 23, 1944
Edvard Munch
dies of pneumonia
in Ekely

⌃ The Munch room at the **National Gallery**

yourself a week, and don't count on Mondays, when everything is shut tight. A traveler can see the originals of *The Scream* (1893), *Madonna* (1893–94), *Puberty* (1894), and *The Sick Child* (1885–86), which together catapulted him to fame, but lesser-known and equally startling works are plentiful, including a whole series of stunning self-portraits and hundreds of innovative prints and drawings. Known for his iconic paintings, Munch was perhaps most gifted as a printmaker, and his images are all here—available for casual study or sharp scrutiny.

Munch painted and reprinted many versions of his most famous works, including *The Scream*. When he sold a work, he painted another to add to his own collection. "He never copies himself; he just goes deeper into the theme," says Toril Andersen, a guide at the Munch House Museum in Åsgårdstrand. This might have been obsessive, but it was also marketing genius. These combined works were called *The Frieze of Life*, and they were a pictorial diary of his own life—a linked narrative of innocence, love, betrayal, loss, and death. He added to it throughout his life, exhibiting in European capitals and in Oslo at venues like the rotunda at the Blomqvist Gallery (now home to the chain restaurant T.G.I. Friday's).

Munch said that his family tree was rotten with madness and disease. He lost his mother when he was 5 and his sister Sofie when he was 14, both to tuberculosis, which was rampant in 19th-century Norway. Another sister, Laura, was institutionalized with severe mental illness, and both his physician father and his only brother, Andreas, died before he was 30. Only Edvard and his sister Inger survived into old age. A sickly child, Munch spent days at home drawing and painting. His early pictures portray his family members and the quiet interiors of the half dozen apartments his father moved them to.

His old neighborhood around Olaf Ryes Plass, in the Grünerløkka borough of Oslo, has changed little in a hundred years, although trees have softened what was a raw square of workers' houses. Trendy shops, clubs, and sidewalk restaurants share the streets with modest apartments. Grünerhaven, a lively beer garden in the square, is a popular watering hole and the kitchen is open until 10 on summer nights.

∧ The lively beer garden **Grünerhaven,** located on **Olaf Ryes Plass**, is a favorite area of locals and tourists alike

Munch's classes at the Royal School of Design, located on the street known as Apotekergaten, lasted a year. (Now called the Museum of Decorative Arts and Design, it is located on the nearby street St. Olavs Gate.) Then he moved to a studio with friends at the yellow Pultosten building at Stortings Plass. The painter Christian Krohg, who also had a studio in the building, provided moral support and lessons in perspective.

In the evenings, Munch walked from this studio along Karl Johan to the Grand Hotel Café, the gathering place of the Kristiania bohemians, local artists and writers. Per Krohg's 1928 mural on the far wall depicts the scene in the 1890s, and it is virtually unchanged today. The booth that Ibsen claimed every day for lunch and dinner (precisely at one twenty and six o'clock) is still there, too. In the painting, Munch slouches against a window, next to the writer Hans Jaeger, who first encouraged the young artist to make his own life story the subject of his paintings—which in turn charted the course of his career.

Following Jaeger's advice, Munch painted the deaths of his mother and his sister, his own lovers, and their betrayals. Works like *The Sick Child*, *Death in the Sickroom* (1893), and *The Day After* (1894) shocked the critics at the daily *Aftenposten*, who condemned Munch's work as rough and unfinished and his subjects as immoral. But his fellow artists and the director of the National Gallery bought his pictures from the beginning. They still hang at the National Gallery, an unpretentious brick building a short walk from the Slottet (Royal Palace), around the corner from the university. The iconic paintings, so often reproduced, are fresh and startling in the original. *The Scream* emits a terrific energy, even on its humble cardboard, and the gouged surface of *The Sick Child* still shocks. Munch's intensity radiates from his eerie *Self-Portrait with Burning Cigarette* (1895).

Oppressed by the long, dark northern winters, and eager to see advanced painting, Munch fled Oslo for Paris when he won a grant in 1889. Upon his return to the city, which he had visited in 1885, he saw the works of Manet,

⌃ A detail from *The Sick Child* (1885-86) on view at the National Gallery

Toulouse-Lautrec, Seurat, Gauguin, and Van Gogh, as well as Japanese woodcuts. He learned etching, lithography, and woodcut techniques, and he translated the simplified forms of his paintings into prints. From 1893 to 1908, he spent the cold months of the year in Berlin, Paris, Copenhagen, and other cosmopolitan cities, arranging exhibitions, painting portrait commissions, and establishing an international reputation.

Every summer he returned to Åsgårdstrand. Munch would take a steamboat and make the trip from Oslo in five hours. There is no longer a boat (and the train-bus-taxi combo is arduous), so renting a car is the best way to get there. Still popular with artists today, it was a favorite summer destination for Oslo artists in Munch's time. The little fishing village was quiet in the winter, but when the population doubled in summer, life became very lively.

Munch summered there with his family, and in 1897, he purchased his little house for 900 kroner—a big sum for that time. "He almost lost the house several times because of financial difficulties, but he kept coming here until 1933, when he was too old to make the trip," Andersen says. "The house is still exactly the way it was in Munch's time." She opens a closet where the artist's coat still hangs; his photos and sketches are still pinned to the walls, and his presence is palpable.

Far from the Oslo gossips, it was an ideal place for trysts, and Munch—known as "the handsomest man in Norway"—had his share of tumultuous love affairs. His first love was Millie Thaulow, a married woman. Their affair, with its innocent beginnings and her eventual betrayal, is portrayed in *The Dance of Life* (1899) and *Ashes* (1894). His affair with Tulla Larsen, the headstrong daughter of a rich Oslo wine merchant, ended in disaster. Engaged to be married to Tulla, Munch kept losing the official papers he was required to file. He was reluctant to commit himself to anything but his art and broke off their relationship. A last desperate rendezvous in Åsgårdstrand was marred by a shooting accident, when Munch lost part of his left middle finger. He transformed the scene into paint and gave it a historical context as *The Death of Marat I* and *The Death of Marat II* (both 1907).

⌃ A statue of the painter **Christian Krohg**, situated in front of the Pultosten building on Stortings Plass

When Munch was drinking, he often picked fights with strangers and shot at his friends. And when he shared a woman with another man, such as the Oslo sculptor Gustav Vigeland (his roommate in Germany), reports of his bad behavior made it back to the local press. In *Self-Portrait with Bottle of Wine* (1906), Munch portrays himself as a dissolute man at the end of his wits, and in 1908, he suffered a nervous breakdown. After an eight-month stay in a Copenhagen clinic, he returned to the Oslofjord. He tried life in Kragerø and in Hvitsten, down the coast from Oslo. With the money from a commission for a mural cycle to decorate the university's Great Hall or Aula, Munch finally returned to his hometown. He purchased Ekely, a two-story house in the western suburbs with enough land for his mural studio. The house was bulldozed in 1960, but space in his former studio building is available for rent to artists. It is closed to the public. (The Munch Museum website features a humorous short film about an artist's move to the utopian studios.) At Ekely, Munch worked on 11-foot sketches (1909–16) for the murals, which he completed in 1916. *The Sun* is the focal point; *The Researchers/ Alma Mater* (often called *Mother Earth*) and *History* (in which an old man instructs a young boy) round out the series. Closed for restoration, the hall is due to reopen in 2011, but full-scale preparatory sketches are on display at the Munch Museum.

THE SCREAM

Since Edvard Munch painted *The Scream* in 1893, it has become one of the most iconic images in art history, a symbol of the alienation and anxiety of modern life.

Munch painted the image in the middle of one of the most creatively fertile moments in his life, around the time that the young artist embarked on *The Frieze of Life*, his monumental study of life, love, and death. Lasting for most of his career, the series explores the same feelings of anxiety and depression that plagued the artist, feelings he himself credited as the inspiration of his art.

In *The Scream*, the viewer is confronted by a horrific figure with a masklike expression frozen in pain. A road disappears in dizzying perspective while a couple walks in the distance, seemingly unfazed by what is happening. The Oslofjord swirls in blue and black, while an angry sky is red and orange. In his writing Munch describes walking in Ekeberg when suddenly, the sky turned "red as blood" and he felt totally isolated from his companions, alone with the all-consuming cry of nature. Whether this vision was real or imagined remains unknown—contemporary scientists note Munch may have actually described the 1883 volcanic eruption of Krakatowa, an event which caused atmospheric changes around the world.

Munch revisited the theme of *The Scream* several times, in pastel, lithograph, and once again in tempera on cardboard (1910), now at the Munch Museum. Over the years, *The Scream*'s iconic status has attracted some unwanted attention—versions have been stolen from both the National Gallery (in 1994) and the Munch Museum (in 2004). Both paintings have since been returned.

> Visitors can view one version of **The Scream** (1893) at the **National Gallery**

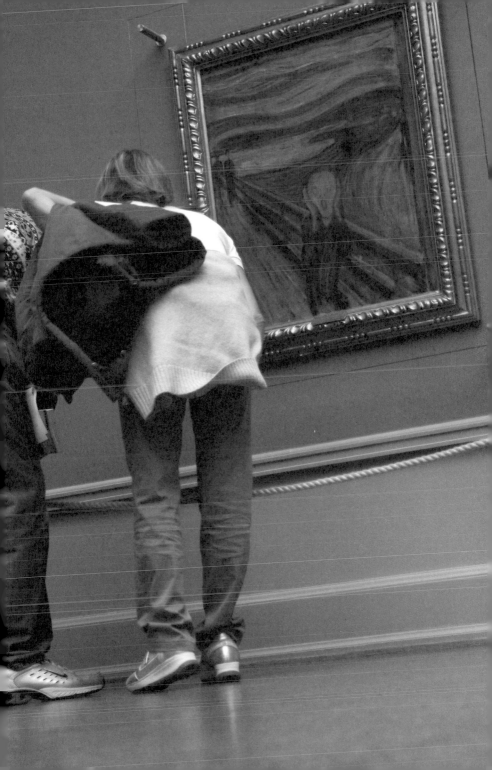

As he aged, Munch avoided people, especially the "interfering meddlers" from "the enemies' city"—Oslo (as he referred to it). Fearful of thieves, he erected a barbed wire fence and kept vicious guard dogs that he couldn't handle. Collectors and dignitaries were kept at arm's length; save a few old friends, no one could visit, not even his sister Inger, who Munch once said "made him tense." Rolf Stenersen was an exception. A local financier and art collector, he acted as agent, financial adviser, and errand boy for the old man, and penned a lively anecdotal biography. In Munch's last self-portrait, *Between the Clock and the Bed* (1940–42), he sees himself as a shrunken old man racing time and awaiting the end. When a cargo of German ammunition exploded in Oslo harbor in December 1943, buildings and windows throughout the city were shattered. Huddled near his basement shelter in the winter cold, Munch contracted bronchitis. He died the following month, in January 1944.

After his death, the "huge mess" at Ekely (as Stenersen describes it) was placed in temporary storage. In 1963, on the centennial of his birth, the Munch Museum was dedicated in Tøyen, in the eastern part of town. His gift to the city included roughly 1,100 paintings, 4,500 drawings and watercolors, 92 sketchbooks, 18,000 graphic works, and 6 sculptures. The well-publicized thefts of *The Scream* and *Madonna* (both recovered) highlighted the need for tighter security. A new, state-of-the-art Munch/Stenersen Museum is under construction next to the new Oslo Opera House. When it opens in 2013–14, Munch will be back where he belongs, with a fine view of his beloved Oslofjord.

⌃ Munch at **Ekely**, surrounded by his work on his 75th birthday in 1938

ART IMITATING ART: THE ARTIST'S IMPRINT ON POPULAR CULTURE

MOVIES

ON LOCATION
Edvard Munch (1974)
Director: Peter Watkins

Peter Watkins's three-hour, made-for-TV movie chronicles 10 formative years in the artist's life, from 1884 to 1894. Known for his docudrama style, Watkins stayed very true to Munch's biography— filming on-location in Oslo and Åsgårdstrand and using Munch's own diaries for narration. The film also introduces the key figures that influenced the young artist, from his mentors Hans Jaeger in Kristiania and August Strindberg in Berlin, to his first love, the married Millie Thaulow, referred to as "Mrs. Heiberg" in Munch's diaries and in the film's narration. The movie stirred a bit of controversy when it was released for Watkins's casting of non-professional Norwegian actors in all the roles. In fact, the director went so far as to intentionally hire actors who disliked Munch's work to portray the unfavorable reception the paintings initially received.

Ansigter (Faces) (1971)
Director: Anja Breien
This Norwegian film is a short documentary about the faces within the art of Edvard Munch. Within it, several portraits are showcased and accompanied by a poem from Poul Borum.

Post Mortem (1989)
Director: Skule Eriksen
Throughout most of Munch's life he was an enthusiastic photographer. This short film uses many of the artist's photographs, several of which were self-portraits, to uncover their inner meaning. It was made in cooperation with the composer Randall Meyers.

Scream (1996)
Director: Wes Craven
In this trilogy of popular horror films, a psychopathic serial killer called Ghostface stalks a group of teenagers while wearing a mask of the face pictured in *The Scream*.

Dance of Life (1998)
Director: Sølvi A. Lindseth
Norwegian Sølvi Lindseth directs this documentary about the life the artist lived and created, following Munch from childhood to old age. and attempting to connect all that he experienced.

TV

A number of television shows have made cultural references to *The Scream*, including *The Simpsons* and *Wizards Of Waverly Place*.

In 2006, M&M's used *The Scream* in an advertisement for its dark chocolate candies. Later on, the company offered a reward of two million candies for the safe return of the painting (which was stolen from the Munch Museum in 2004). Coincidentally, just days after the reward was announced, the painting was found.

LITERATURE

Do Androids Dream of Electric Sheep?
by Philip K. Dick
(Doubleday, 1968)
Bounty hunter Rick Deckard is on the trail of a cultured android and opera singer (Luba Luft) at a Munch exhibit in San Francisco. As Deckard and his partner (Phil Resch) search the area, Phil pauses at *The Scream*. When the duo finally finds Luba, she's stopped at *Puberty* and asks Deckard to buy her a print of it before they take her away.

The Primal Scream
by Arthur Janov
(Dell Publishing Co., 1970)
This book helped *The Scream* reach iconic status after it was used on the cover for several editions. The author, Arthur Janov, is an American psychologist, psychotherapist, and the creator of Primal Therapy.

ACCESS

AIRPORTS: ✈
Oslo Lufthavn,
Gardermoen / Oslo
Airport, Gardermoen
⌂ Edvard Munchs Veg
☎ 47 06400
🖥 www.osl.no

TRAIN: 🚆
Oslo Sentralstasjon /
Oslo Central Station
⌂ Jernbanetorget 1
☎ 47 815 00 888
🖥 www.nsb.no
○ Mon-Fri 6AM-11:15PM
Sat 10-6 Sun 12-11:15

BUS: 🚌
Oslo Bussterminal /
Oslo Bus Terminal
⌂ Schweigaards Gate 10
☎ 47 23 00 24 00

TOURISM OFFICE: 🌐
The Central Station
⌂ Jernbanetorget 1
(Inside the Trafikanten
Service Center)
☎ 47 815 30 555
🖥 www.visitoslo.com
○ May-Sep
Mon-Fri 7AM-8PM
Sat-Sun 8AM-8PM;
Oct-Apr
Mon-Fri 7AM-8PM
Sat-Sun 8AM-6PM

City Hall
⌂ Fridtjof Nansens Plass 5
(Entrance at Roald
Amundsens Gate)
☎ 47 815 30 555
🖥 www.visitoslo.com
○ Jun-Aug
Mon-Sat 9AM-7PM;
April, May, Sep
Mon-Sat 9AM-5PM;
Oct-Mar
Mon-Fri 9AM-4PM

FOR YOUR INFORMATION...

Legend has it that Oslo, located on the north end of the Oslofjord—the large bay that was immortalized in Munch's *The Scream*—was founded in 1049 by a Viking king named Harald Hardråde. Oslo became the capital city under Haakon V around 1300, but lost that distinction from 1397 to 1814 while Norway was part of the Danish kingdom. When a fire devastated old Oslo in 1624, Christian IV, king of Denmark and Norway, ordered the town rebuilt by the nearby Akershus Fortress—renaming it Christiania, or Kristiania, (after himself). Norway, which separated from Denmark in 1814 and then united with Sweden, finally became independent in 1905 and its capital readopted the name Oslo in 1924. Known for its lush deep forests and sparkling fjords, Oslo is now a bustling cosmopolitan capital and has given the modern world two remarkably provocative cultural icons: Munch and Henrik Ibsen, the playwright considered by many to be the father of modern drama. Oslo is also home to the Nobel Peace Prize Award Ceremony, which takes place every December and, until The Nobel Peace Center opened in 2005, the prizes were awarded in The Great Hall beneath Munch's radiant mural *The Sun*.

Weather 🌐

As an inland area of Norway, Oslo has a continental climate that features cold winters and warm summers. Average temperatures in April, May, September, and October are around 40 to 50 degrees Fahrenheit; in June, July, and August, they are in the 60s; November through March they are typically in the 20s to 30s.

CALENDAR...YEARLY EVENTS

Norwegian Constitution Day (May)

May 17, or Norwegian Constitution Day, celebrates the signing of the Constitution that established Norway as a nation (although Norway wasn't a true independent state until 1905) in 1814. The day is celebrated with parades all over the country, but the biggest celebration is in Oslo, on Karl Johans Gate. Over 100,000 people participate, many in traditional costumes.

Norwegian Wood Rock Festival (June)

Norwegian Wood, which takes its name from the classic Beatles song, is an annual four-day rock festival held by the open-air Frognerbadet baths in Oslo. The festival attracts everyone from top-name international stars to Norwegian up-and-comers performing in Oslo for the first time. The festival takes place in mid-June, so performances are enjoyed under the midnight sun.

Øya Festival (August)

The Øya Festival is Oslo's biggest rock festival, drawing close to 60,000 rock-music lovers every year. Held in August in the Medieval Park, there are three main stages where festival goers can enjoy four days of international stars and new Norwegian artists.

Oslo Jazz Festival (August)

Oslo Jazz Festival is a six-day festival in August that's been going strong since it started in 1985. The festival offers a broad range of jazz styles and performers—from classic jazz to gospel, blues, and more experimental electronic music at venues throughout the city.

ULTIMA Oslo Contemporary Music Festival (September)

Norway's biggest contemporary music event was established in 1991. Featuring music across genres, the festival is focused on innovation, and in recent years, ULTIMA has showcased metal, hip-hop, and techno alongside opera, chamber music, and musical theater.

YEARLY EVENTS

NORWEGIAN CONSTITUTION DAY
⌂ Various Locations
🖥 www.visitoslo.com

NORWEGIAN WOOD ROCK FESTIVAL
⌂ Frognerbadet
☎ 47 815 33 133
🖥 www.norwegianwood.no

ØYA FESTIVAL
⌂ Middelalderparken
🖥 www.oyafestivalen.com

OSLO JAZZ FESTIVAL
⌂ Various Locations
☎ 47 22 42 91 20
🖥 www.oslojazz.no

ULTIMA OSLO CONTEMPORARY MUSIC FESTIVAL
⌂ Various Locations
☎ 47 22 40 18 90
🖥 www.ultima.no

OSLO PASS
🖥 www.visitoslo.com
The Oslo Pass provides free travel on public transportation, plus free admission to sights and museums.
24 hour pass NOK 220
48 hour pass NOK 320
72 hour pass NOK 410

BEFORE YOU GO, GET IN THE KNOW: SUGGESTED WEBSITES AND BOOKS

WEBSITES

Oslo Tourism
🖥 www.visitoslo.com
Online, the city's tourism board offers a wealth of information including hints for trip planning, what to see and do, and where to eat and stay, as well as a newsletter.

Munch Museum
🖥 www.munch.museum.no
The Munch Museum's official website features general information about the museum (hours, ticket prices, etc.), a section on programs offered, an extensive area on the artist's life and work, as well as research, conservation, and education sections.

National Gallery of Art, Architecture and Design
🖥 www.nasjonalmuseet.no
The official online destination for the National Gallery features information on exhibitions, events, education, research, and the museum's collection.

BOOKS

Edvard Munch
by Josef Paul Hodin
(Thames & Hudson, 1985)
This illustrated biography of the artist (part of the critically acclaimed "World of Art" series), combines historical information about Munch and his art with exquisite color reproductions of his work.

Edvard Munch: Theme and Variation
Edited by Klaus Albrecht Schröder
(Hatje Cantz Publishers, 2003)
Essays by well-known art experts analyze the emergence and development of theme and variation in the body of work of an artist known for repainting certain subjects throughout his career.

Becoming Edvard Munch: Influence, Anxiety, and Myth
by Jay Clarke
(Yale University Press, 2009)
Delving into the myths about who Munch really was, this book (which features excellent color reproductions of numerous works and was created for an exhibition at the Art Institute of Chicago) describes an artist who was keenly aware of his fellow painters—and had quite a head for business. The author compares Munch's work to that of his European contemporaries and discloses intriguing connections and influences. He also uses the artist's diaries and letters, period criticism, and artwork to show that Munch was (in reality) someone who propagated myths—both visual and personal.

Edvard Munch: The Modern Life of the Soul
by Patricia Berman, Reinhold Heller, Elizabeth Prelinger, and Tine Yarborough
(The Museum of Modern Art, 2006)
Created for an exhibition at New York City's

Museum of Modern Art this comprehensive survey features in-depth documentation of the artist's career development accompanied by a selection of color plates.

The Private Journals of Edvard Munch: We Are Flames Which Pour Out of the Earth
Edited by J. Gill Holland
(University of Wisconsin Press, 2005)
This English translation of the private diaries that the artist kept throughout his entire career is the most extensive collection of his writing to appear in any language. WIth entries spanning from the 1880s to the 1930s, it captures the eloquent lyricism of his original words, which were, at times, as experimental and expressive as his art.

To find Munch's Oslo, you have to look in the right places. Much of 18th- and 19th-century Oslo, or Kristiania, as it was then called, has been torn down and replaced with apartment buildings, businesses, ring roads, and commercial establishments.

BY LEA FEINSTEIN

WALKING TOUR

Head for Upper Karl Johan, where the National Theatre, the palace parks, and Parliament (Stortinget) are, but start by strolling from east to west along the old street named **Rådhusgata**. Blue plaques (in Norwegian) identify historic buildings that date from the early 1600s, when Christian IV of Denmark rebuilt the city after the fire of 1624. Watch for the old **Rådhus**, built in 1641, which has served as city hall and a police station, and is currently a restaurant called Det Gamle Raadhus. On other old buildings, the owners' names and street addresses are spelled out in handsome graphic iron curlicues. The tradition of working in iron dates from the time of the Vikings.

Stop at **Christiania Torv**, an old enclosed square, with a market, a café, and the **Kunstforening** (Art Club, 19 Rådhusgata), founded in 1736 by poet J.S. Welhaven, Prime Minister Fredrik Stang, and J.C. Dahl, a Norwegian landscape painter. It is the oldest art gallery in Oslo but shows edgy contemporary work.

Cut over to Karl Johan via Akersgata and pause at **35 Karl Johan**, now T.G.I. Friday's American Bar.

⌃ [top] Per Krohg's mural of Kristiania notables can be viewed at the **Grand Café**. Munch is second from right, behind the waiter. [bottom] The **Kunstforening**

In Munch's day, the rotunda was Blomqvist Gallery, where, along the walls of the upstairs balcony, the painter exhibited his work arranged as *The Frieze of Life*.

Farther up Karl Johan is the **Grand Hotel**, where Nobel laureates and rock stars stay when they're in town. In the café, where the Kristiania bohemians met, walk past Henrik Ibsen's "office," the first booth on the left, to look at the framed Ibsen memorabilia on the center post. Munch and Ibsen knew each other, and the young Munch gave Ibsen a personal tour of one of his controversial exhibitions. On the far wall is Per Krohg's lively mural of Kristiania notables from the late 1800s. A postcard from the barman will help identify Munch, slouching against a window, and the influential writer Hans Jaeger, who first told him to "write his life." The café's interior, with its bent wood chairs and circular booths, has barely changed since Munch's day.

Stroll up the street to the bar at the **Hotel Continental** to look at the Munch prints on the walls, which are actually excellent copies (even the experts are fooled). The originals were locked in a Swiss bank vault after the theft at the Munch Museum in 2004.

Don't miss the **Theatercafeen** next door, not important in Munch's youth, but a magnet for theater folks like Ibsen and Bjørnstjerne Bjørnson, an illustrious Norwegian writer, poet, and theater director. Lively portrait drawings of famous Norwegian actors and actresses line the walls.

Continue along Karl Johan, where the Norwegian bourgeoisie promenaded and inspired Munch's haunting painting *Evening on Karl Johan* (1892). Then try to imagine the view of the Oslofjord before the new Rådhus (City Hall) was built.

Turn right on Universitetsgata; the **University of Oslo** is on your left. Walk a block and enter the **Nasjonalgalleriet (National Gallery)**, which houses a fine collection of 18th- and 19th-century Norwegian art in a modest turn-of-the-

^ [top] The **Grand Hotel**
[bottom] Portrait drawings of famous Norwegian actors and actresses at the **Theatercafeen**

century building. There are two galleries of Munch paintings, including *The Sick Child* (1885–86) and *The Scream* (1893), in oil, watercolor, and pastel on unprimed cardboard. Jens Thiis, director of the museum from 1908–41, was an early supporter of Munch and purchased works directly from his Kristiania exhibitions. Munch's contemporaries and local influences are well represented: Christian Krohg, Hans Heyerdahl, Frits Thaulow, Harriet Backer, Erik Werenskiold, Ludvig Karsten, and J.C. Dahl.

As you leave the National Gallery, turn left and walk to **Pilestredet**. Find 30A and B, where Munch's mother (Laura Cathrine) died. A museum of Munch's life is being created here, where, despite his mother's death, Munch remembered his years as the happiest of his childhood. Turn left on Keysers Gate, and left again on Akersgata, and walk uphill. Take the left fork at Ullevålsveien to see the **Oslo National Academy of the Arts**, where Munch studied drawing for a year. Then retrace your steps to take the right fork and follow Akersveien up the hill. Glance down the old street Damstredet, but continue walking until you arrive at the gate of **Var Frelsers Gravlund (Our Savior's Cemetery)**. Munch and Ibsen are both buried here, not far from each other. A plan of the cemetery next to the entry chapel will help guide you to the sites, but it's easy to get lost. Find Ibsen's large stone obelisk, with a carved hammer on its face, then turn around. Munch's simple slab is easily overlooked. A bronze portrait bust of the artist, erected in 1993, helps identify it.

Make sure you leave the cemetery the way you came in, and continue up the steep hill towards the Old Aker Church until you reach **Telthusbakken**, then turn right into it. You will have a beautiful view of the city from this vantage point. The wood houses, carefully maintained since the 1800s, suggest what old Kristiania must have felt like. Walk down the hill and, at the bottom, cross busy Maridalsveien, passing the **Oslo School of Architecture and Design** on your left. Follow the walkway to the little pedestrian bridge that crosses Akerselva (the Aker River), keeping right, then turn left onto Gruners Gate. After a block, turn right onto **Fossveien**. Here at number 7, Munch's sister Sofie died from tuberculosis,

^ **Var Frelsers Gravlund** (Our Savior's Cemetery), burial place of Munch and Ibsen

exacerbated by the damp river air. The family also lived briefly at number 9. Take a left on Sofienberg and walk into **Olaf Ryes Plass**. You can see two more Munch apartments from this square at Thorvald Meyers Gate 48 and 4 Olaf Ryes Plass. One more, 1 Schous Plass, is two blocks away. You are at the heart of Grünerløkka, built as a workers' housing district in Munch's day. Now it is a neighborhood of trendy shops and active nightlife. Grab a meal in the beer garden, **Grünerhaven**, in the central park square. Coffee, beer, hamburgers, and good cake are affordable. It's obviously a neighborhood hangout—great for people-watching.

1 Ekeberg Heights
Take the No. 19 tram (direction Ljabru/Mosseveien) up to Ekeberg for a view of the Oslofjord that inspired *The Scream*. Get off at **Sjømannsskolen**, the old Seamen's School, now the Lyceum Academy for Integrated Medicine. There are murals by Per Krohg in the building. Walk toward the water for the view, past the sculpture of the Viking on horseback. Munch supposedly heard the scream of nature from this place, although an alternate location is recognized with a plaque farther up the hill. Now the din of traffic roars

MUNCH LIVED HERE (FROM LEFT)

Nedre Slottsgate 9 (1864-1868) Munch's first home in Oslo, number 9, is now a modern structure and very little is left of the 19th-century brick and timber buildings he must have seen as a child.

Pilestredet 30 (1868-1875) This three-story brick building, which was on the outskirts of town when the Munchs moved there, was Munch's home for seven important years. The year he moved here, he lost his mother to tuberculosis. The houses had fallen into disrepair and were threatened with demolition, but have now been restored.

Thorvald Meyers Gate 48 (1875-1877) This street, in the Grünerløkka section of town, overlooking Olaf Ryes Plass (which was just a grassy field in 1875) is one of Oslo's best-preserved 19th-century neighborhoods and

the Munch family home is in a row of well-kept buildings.

Fossveien 7 & Fossveien 9 (1877-1882, 1883-1885) The Munch family lived in these drafty buildings just one block away from Thorvald Meyers Gate; they too are carefully preserved.

Olaf Ryes Plass 4 (1882-1883) In January of 1882 the family moved to a new, more spacious apartment overlooking the square, which became a park in 1890. Munch painted several views of the square, and number 4 is beautifully restored and part of the now-vibrant neighborhood.

Schous Plass 1 (1885-1889) This Munch home, which is the last Edvard shared with his family, is still standing. However, the façade has been redone in a simpler, less ornate style.

up from the motorway below. The commercial landscape, with its shipping containers, dock, and heavy machinery, adds a discordant note to what must have been a quiet site.

This is an ancient place. A rune stone ("Helleristninger") dating from 1000 is located down by the parking lot. Cross the road and walk uphill toward the Ekeberg Restaurant. Follow the path that starts from the left side of the entrance to the restaurant. After about 15-20 minutes the path will lead up to **Valhallveien**. Follow the street upwards. The small iron sign at the beginning of the street indicates that this is the location Munch used for his famous painting. You can continue to the **Ekebergsletta**, and take the bus back to the center of Oslo.

You can also explore the paths leading farther up the hill toward **Ekeberg Camping**. A sign-posted map indicates the location of Bronze and Iron Age sites nearby. In the fields near the campground, archaeological digs are under way. Along the paths, stop at a lovers' bench for a fine view of the city.

Return to the atmospheric **Ekeberg Restaurant** to sample the specialty single-malt scotches or the excellent lattes, which you can take up to the veranda, or you can splurge and have a meal with your view. A "mod-Munch" painting hangs on the wall of a private room upstairs, an offhand reminder that this was an important place for the painter.

If you want to extend your hike to the sites of ancient Oslo, walk down the old steep-stepped path with an iron railing toward the ruins of King Harald's Viking palace. The **Ruins Café** is at the foot of the long hill if you need a rest. Then take the No. 18 tram (direction Sentrum) back to the center of town.

∧ [top] The Oslofjord as seen from **Ekeberg Heights**—the view that inspired *The Scream*
[bottom] A plaque commemorates the location

2 The Munch Museum, Tøyen

🏠 Tøyengata 53
☎ 47 23 49 35 00 🖳 www.munch.museum.no
○ Jun-Aug Daily 10AM-6PM; Sep-May Tue-Fri 10AM-4PM, Sat-Sun 11AM-5PM ● Mondays

Now that you are acquainted with Munch's old city, head for the suburbs to the Munch Museum in Tøyen for a more in-depth look at the artist and his work. Take the T-bane to Tøyen, two stops from the central train station on the red line. When you exit the station, go up the hill and follow the (half-hidden) signs along the sidewalk to the Munch Museet.

When Munch died in 1944, he left thousands of works to the city of Oslo, which built a museum dedicated to him in 1963. Several high-profile thefts in recent years have led to the installation of a daunting, airport-type security

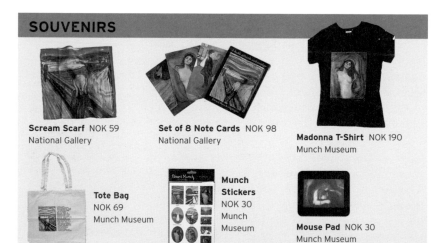

SOUVENIRS

Scream Scarf NOK 59
National Gallery

Set of 8 Note Cards NOK 98
National Gallery

Madonna T-Shirt NOK 190
Munch Museum

Tote Bag
NOK 69
Munch Museum

Munch Stickers
NOK 30
Munch Museum

Mouse Pad NOK 30
Munch Museum

system. Don't be put off by it. Many of Munch's most famous paintings are here, including *The Scream* and *Madonna*, which were both stolen in 2004, then recovered. There's also a version of *The Sick Child* and several exceptionally fine self-portraits. There are pieces here you will see nowhere else: drawings, prints, litho stones, and huge studies for the University of Oslo murals. It is a vast and rich trove. The bookstore offers a comprehensive array of scholarly texts, as well as posters, and plenty of Munch kitsch—including a *The Scream* Rubik's Cube. Films introduce details of the artist's life. An excellent tour in English is scheduled daily at one o'clock in the afternoon during July and August. The welcoming café has great salads and pastries, including apple tart and cake frosted with a design of *The Scream* in chocolate.

The Munch Museum is scheduled to relocate to the Oslofjord, at the Bjørvika inlet, next to the new Oslo Opera House. As part of its massive and continuing Fjord City harbor redevelopment plan, Oslo is building a combined Munch/Stenersen Museum, with an expected completion date of 2014. Works will be on display throughout construction and for more information consult the museum's informative website.

THE MADONNA

The Madonna, sometimes also referred to as "The Loving Woman," is perhaps Munch's second best-known painting. Notorious in its day, The Madonna exploded back into the news when it was stolen from the Munch Museum in 2004 along with The Scream (and recovered with only slight damage two years later). Alluring and provocative, profane and yet true to traditional iconography, Munch's Madonna remains endlessly interesting because of the many questions it raises and the contradictions it contains. Is it a modern woman lost in a moment of ecstasy and conception? The spermatozoa and small bony fetus painted on the border of some of the versions certainly point to that theory. Is it a timeless figure of Mary, her traditional blue veil replaced with bold red, floating in a dream space of tactile brush strokes? Or is it perhaps a bit of both, as many critics have suggested? Art historians have speculated that Dagny Juel-Przybyszewska, a writer famous for her liaisons with artistic men (and who may have briefly been Munch's lover), might have been the model for the series. Munch painted five versions of The Madonna between 1894 and 1895, as well as making numerous drawings and lithographs. Przybyszewska was shot to death by a young lover in 1901 when she was just 34. Munch had painted her portrait in 1893 and may have used her as the inspiration for several other paintings; but he himself repudiates the idea that she is the subject in a letter, a copy of which is now part of the Munch Museum's archives. In that letter, which he wrote to a lawyer in Berlin, Munch says that while the Madonna resembles Przybyszewska, the figure was actually inspired by a model he had used in Berlin in the 1890s. Perhaps he was being a gentleman, or perhaps he used that model precisely because she reminded him of his long-time friend and muse.

THE NATIONAL GALLERY

🏠 Universitetsgata 13
☎ 47 22 20 04 04
💻 www.nationalmuseum.no
○ Feb-Dec Tues, Wed, Fri 10AM-6PM
Thur 10AM-7PM, Sat-Sun 11AM-5PM
● Mondays

The National Gallery (Nasjonalgalleriet) is home to Norway's largest collection of 19th- and 20th-century art. The principal focus of the collection is Norwegian painting, with close to 3,500 works from the 1800s and 1900s. Its star attraction is Norway's most famous painting, *The Scream*. This version (he painted four; this one from 1893) was stolen from the museum in 1994, but was recovered by the police three months later in a hotel 40 miles south of the city. The painting, which was on fragile cardboard was fortunately undamaged. The museum's permanent collection also contains *The Dance of Life*, *Moonlight*, *Ashes*, and several important self-portraits. Its collection of European painters includes works by Van Dyck, Rubens, El Greco, Cézanne, Matisse, and Picasso, among others. It also contains a self-portrait by another pioneer of expressionist painting, Vincent Van Gogh, whose work had a big impact on Munch when he lived and worked in France. Van Gogh's *Self-Portrait* from 1889 has been the subject of extensive debate, with some scholars doubting its authenticity, due to its relatively weak execution and facial expression.

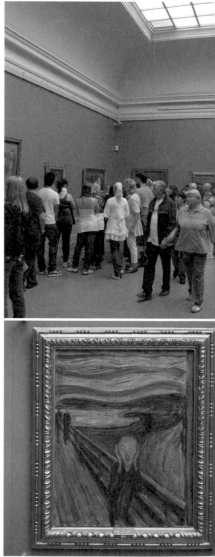

∧ [top] **The Munch Room** at the **National Gallery**. [bottom right] **The Scream** (1893)

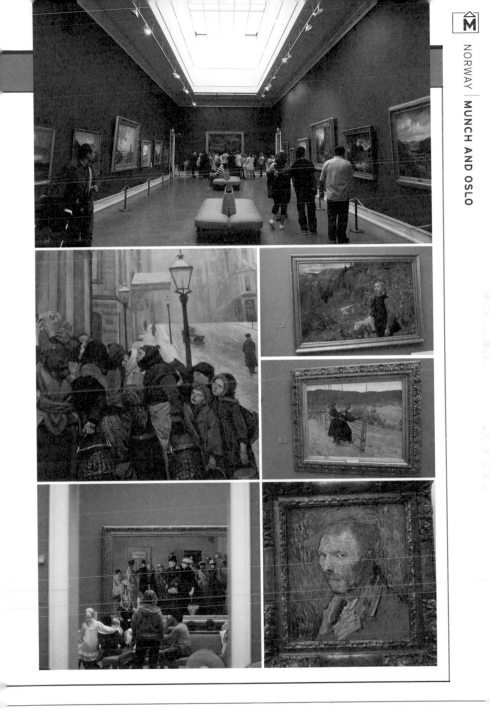

^ The collection at the **National Gallery** [top] includes [clockwise from left] Christian Krohg's ***Struggle for Existence*** (1889), a work by Christian Skredsvig, Erik Werenskiold's ***Telemark Girls*** (1883), Vincent Van Gogh's 1889 ***Self-Portrait***, and Christian Krohg's ***Albertine at the Police Doctor's Waiting Room*** (1887)

WHERE TO SEE...THE WALKING TOUR

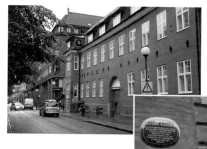

1 **Rådhusgata**

This street in the city center is named for Oslo's Rådhus, or City Hall, and is home to some of the city's oldest buildings. Look for blue signs (in Norwegian) that mark historic buildings dating back to the early 17th century.

3 **Karl Johans Gate 35**

Today it's a T.G.I. Friday's, but this building was once home to Blomqvist Gallery, the influential art gallery where Munch first exhibited the *Frieze of Life*.

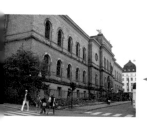

7 **Nasjonalgalleriet**

⌂ Universitetsgata 13
☎ 47 22 20 04 04
🖳 www.nationalmuseum.no
○ Feb-Dec Tue, Wed, Fri 10AM-6PM Thu 10AM-7PM, Sat-Sun 11AM-5PM

A comprehensive collection of Norwegian painting, including two rooms dedicated to Munch.

8 **Pilestredet 30**

The home where a young Munch lived when his mother died in 1868

11 **Telthusbakken**

The narrow street offers stunning views of Oslo, and is home to Old Aker Church, the city's oldest building.

12 **Fossveien 7**

The Munch family home where Sofie died in 1877

2 Christiania Torv

This enclosed square is where King Christian IV decided to rebuild the city of Kristiania after it was destroyed by fire in 1624. Today it is home to a market, a café, and Kunstforening, an art club dating back to the 18th century.

4 Grand Hotel Oslo
🏠 Karl Johans Gate 31
☎ 47 23 21 20 00
💻 www.grand.no

Even if you stay elsewhere, it's worth a trip to the café at Oslo's premier hotel, where Kristiania's bohemians once gathered.

5 Dagligstuen
🏠 Stortingsgaten 24/26
☎ 47 22 82 40 00
💻 www.hotel-continental.no
◯ Mon-Sat 10AM-12AM
Sun 11AM-3PM

The lobby bar of the Hotel Continental features reproductions of famous Munch prints.

6 Theatercafeen
🏠 Stortingsgaten 24/26
☎ 47 22 82 40 00
💻 www.hotel-continental.no
◯ Mon-Sat 11AM-11PM
Sun 1PM-10PM

Across from the National Theatre, this café features portraits of famous faces from theater.

9 National Academy of the Arts
🏠 Ullevålsveien 5
☎ 47 22 99 55 00
💻 www.khio.no

Students still learn technique at the school where Munch spent a year studying drawing.

10 Our Savior's Cemetery
Burial place of Munch and Henrik Ibsen

13 Olaf Ryes Plass
You can see several of Munch's apartments around this square in a vibrant neighborhood with great shopping and nightlfe.

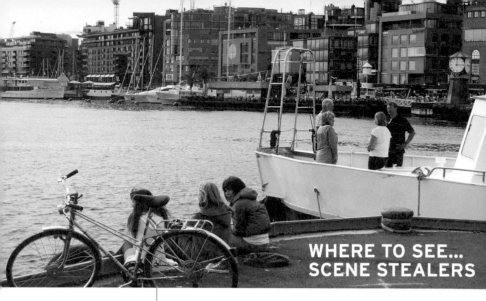

WHERE TO SEE...
SCENE STEALERS

VIGELAND SCULPTURE PARK
⌂ Frognerparken

KUNSTNERNES HUS / THE ARTISTS' HOUSE
⌂ Wergelandsveien 17
☎ 47 22 85 34 10
🖥 www.kunstnerneshus.no
○ Tue-Wed 11AM-4PM
Thu-Fri 11AM-6PM
Sat-Sun 12PM-6PM
● Mondays
💲 NOK 50

1 Vigeland Sculpture Park

Located near the Oslo city center within Frognerparken (Frogner Park) is a collection of over 200 bronze, granite, and iron figures made by Gustav Vigeland. It's known as a local favorite and crowd pleaser and is a beautiful respite from the city noise and construction.

2 Kunstnernes Hus / The Artists' House

If you want to check out the current art scene, this is the place to be. The Artists' House exhibits contemporary art, hosts movie openings, and holds art conversations in English. Every autumn it hosts an art show.

On the weekends, the gallery's bar/restaurant, Arcimboldo, is a hot spot for artists and local celebrities.

3 Oslo Opera House

This visionary building, located in the center of Oslo in Bjørvika, is the headquarters of the Norwegian National Opera and Ballet and the country's national opera theater. It took the culture award at the World Architecture Festival in Barcelona in

⌃ [top] **Oslo Harbor** near the popular waterfront district Aker Brygge

2008 as well as a Mies van der Rohe award, the European Union prize for contemporary architecture, in 2009.

4 Karl Johans Gate

Named after King Karl Johan, Karl Johans Gate is Oslo's main street, leading from the old Oslo train station to the castle. It is lined with some of Oslo's most important monuments including the Cathedral, the National Theatre, and the Palace Park. Much of Karl Johans Gate is a pedestrian zone, and it becomes a parade ground on May 17, Norway's Constitution Day.

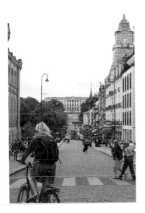

5 Akershus Slott / Akershus Castle

Akershus Fortress, also known as Akershus Castle, was built in the late 13th century by King Håkon V to protect Oslo from attack by rival forces and has been used as a fortress, a castle, and a prison. It was here that Munch's father worked as an army physician starting in 1864. Akershus Fortress is still a military area, but the castle, the Norwegian Armed Forces Museum, and the Norwegian Resistance Museum are open to the public.

6 The Royal Palace

The Royal Palace, which rises up at the end of Karl Johans Gate, is the home of the Norwegian royal family. It is also the place where the monarchy conducts its official business and hosts visiting heads of state. Construction began in 1824 and was completed in 1849, during the reign of Oscar I. The Royal Palace is open to the public during the summer.

KUNSTNERNES HUS

OSLO OPERA HOUSE
⌂ Kirsten Flagstads Plass 1
☎ 47 21 42 21 00
💻 www.operaen.no
○ Mon-Fri 10AM-11PM
Sat 11AM-11PM
Sun 12PM-10PM

**AKERSHUS SLOTT /
AKERSHUS CASTLE**
⌂ Akershus Festning
☎ 47 23 09 35 53
💻 www.akershusfestning.no
○ May-Aug
Mon-Sat 10AM-4PM
Sun 12:30PM-4PM
Sep-Dec by group tour only
Thu 12PM (Norwegian), 1PM
(English), 2PM (Norwegian)
● Jan-April
$ NOK 65

**SLOTTET /
THE ROYAL PALACE**
⌂ Karl Johans Gate
☎ 47 815 33 133
💻 www.kongehuset.no
○ Jun-Aug
Mon-Thur, Sat 11AM-5PM
Fri and Sun 1PM-5PM
$ NOK 95

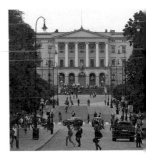

KUNSTFORENING
🏛 Rådhusgt 19
☎ 47 22 42 32 65
🖥 www.
oslokunstforening.no
○ Tue-Fri 12PM-5PM
Sat-Sun 12PM-4PM
● Mondays

**NATIONALTHEATRET /
NATIONAL THEATRE**
🏛 Johanne Dybwads
Plass 1
☎ 47 22 00 14 00
🖥 www.nationaltheatret.no

**MUSEUM OF
DECORATIVE ARTS AND
DESIGN**
🏛 St. Olavs Gate 1
☎ 47 21 98 20 00
🖥 www.nationalmuseum.no
○ Tue, Wed, Fri 11AM-5PM
Thu 11AM-7PM
Sat-Sun 12PM-4PM
● Mondays

7 Kunstforening

Oslo Kunstforening is a contemporary art gallery that was founded as Christiania Kunstforening in 1836 in one of the oldest buildings in the Kvadraturen section of Oslo. The Kunstforening has changing exhibitions of contemporary art.

8 Nationaltheatret/ National Theatre

Many of playwright Henrik Ibsen's plays were first presented here at the Nationaltheatret, which opened in 1899. Ibsen's works are still performed in its lavish rococo hall, and the theater holds an international Ibsen Stage Festival every two years.

9 Museum of Decorative Arts and Design

The Museum of Decorative Arts and Design was founded in 1876 and is one of the oldest museums of decorative arts in Europe. In 1904, it moved to its current location. Its extensive collection ranges from ancient Greek vases and East Asian artifacts to late 19th-century European objects and fashion. Also a contemporary museum,

it has both permanent and changing exhibits of contemporary decorative arts. Since 2003, the museum has been part of The National Museum of Art, Architecture and Design.

10 Aula / Great Hall University of Oslo

The Royal Frederik University (Oslo University) was founded in 1811 and the Assembly Hall (or Aula) was added as part of the University's centenary commemoration in 1911. Munch's mural cycle, which was completed in 1916, is composed of three large panels: *The Sun*, which depicts a golden sun over a sparkling Norwegian fjord; *History*, with allegorical figures of a small boy and an elderly fisherman; and *Alma Mater*, a monumental

tribute to nature and motherhood. The hall, which is used for lectures, ceremonies, and classical concerts, is the former site of the Nobel Prize Award Ceremony.

11 Munch Room Oslo City Hall

Inaugurated in 1950, Oslo's City Hall is the city's administrative body and the current site of the annual Nobel Peace Prize Ceremony. The city of Oslo purchased Munch's large 1910 painting *Life* after it was returned from Germany in 1939 during the Nazi's purge of "degenerate art". The painting, which shows a group of people of all ages beneath the Tree of Life, hangs in a room known as the Munch Room, which until 1994 was used to perform civil marriage ceremonies.

AULA / GREAT HALL UNIVERSITY OF OSLO
🏠 Karl Johans Gate 47
☎ 47 22 85 95 55
🖳 www.uio.no

Aula Hall is currently closed for renovation. Reopening is scheduled for its 200-year anniversary in 2011.

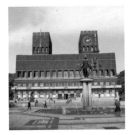

MUNCH ROOM OSLO CITY HALL
🏠 Fridtjof Nansens Plass
☎ 47 0 21 80
🖳 www.visitoslo.com
○ Daily 9-6
$ Free with Oslo Pass

**NOBELS FREDSSENTER /
NOBEL PEACE CENTER**
⌂ Rådhusplassen
☎ 47 48 30 10 00
🖥 www.
nobelpeacecenter.org
○ Jun-Aug Daily 10AM-6PM
Sep-May Tue-Sun 10AM-PM
● May 1, 17, Dec 25, 26
$ NOK 80

STENERSEN MUSEUM
⌂ Munkedamsveien 15
☎ 47 23 49 36 00
🖥 www.
stenersen.museum.no
○ Tue, Thu 11AM-7PM
Wed, Fri-Sun 11AM-5PM
● Mondays, holidays
$ NOK 45
(*Admission is free from
October through March.)

12 Nobels Fredssenter / Nobel Peace Center

King Harald inaugurated the Nobel Peace Center, which is located in a 19th-century train station that overlooks Oslo's harbor, in 2005. The Center, which combines exhibitions and film presentations with digital communication and interactive installations, allows visitors to learn about Peace Prize laureates as well as the life of visionary Alfred Nobel. The center also hosts a variety of cultural and artistic events as well as changing exhibitions.

13 Stenersen Museum

Financier, author, and art collector Rolf E. Stenersen first met Munch in 1921, at the artist's home in Ekely, outside Oslo. Fascinated with the brilliant and eccentric artist, Stenersen befriended him and became a frequent

visitor and collector of his works. By the time Munch died, Stenersen had acquired one of the most important private collections of the artist's work in the world. In 1936, Stenersen donated a large part of his collection to the municipality of Aker, which later merged into the city of Oslo. It included paintings, watercolors, and prints by Munch, as well as an excellent representation of early 20th-century Norwegian art. It wasn't until 50 years later, in 1994, that the collection finally found a home with the opening of the Stenersen Museum, which is part of the City of Oslo

Art Collections. Rolf Stenersen is also known for his intimate biography of *Munch, Close-up of a Genius.*

14 Vikingskiphuset / Viking Ship Museum

This museum on Bygdøy offers the modern traveler a chance to travel through time for a look at Norway's Viking forbearers and their culture. The museum boasts three Viking ships dating from around 1000—reclaimed from the local blue clay (a fine preservative). The ships are among the finest Viking Age artifacts in the world—displayed alongside tapestry fragments and intricate ironwork.

15 Norsk Folkemuseum / Norsk Folk Museum

The Norsk Folkemuseum, which was first established in 1894, is Norway's largest cultural history museum. Located on a 35-acre site on the Bygdøy Peninsula just south of Oslo, this lively indoor and open-air museum strives to re-create what life was like in Norway from 1500 to the present with exhibits and re-creations

from different time periods and regions, as well as different cultural, social, and economic walks of life. Over 150 buildings have been carefully transported from their original sites and reassembled, including medieval structures such as the Gol Stave Church, which dates from 1200. Rural buildings are grouped by region and urban structures are arranged to re-create an old town. Activities include horse-and-buggy rides, folk music and dancing, and artisans demonstrating crafts such as pottery, weaving, silversmithing, and candle making. Indoor exhibits of the over 225,000 artifacts in the collection include folk art, folk costumes, furniture, household utensils, clothing, fabrics, crafts, and agricultural tools.

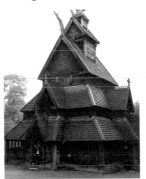

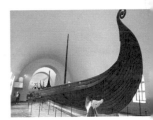

VIKINGSKIPHUSET / VIKING SHIP MUSEUM
⌂ Huk Aveny 35
☎ 47 22 13 5280
🖳 www.khm.uio.no
○ May-Sep Daily 9AM-6PM
Oct-Apr Daily 10AM-4PM
$ NOK 50

NORSK FOLKEMUSEUM / NORSK FOLK MUSEUM
⌂ Museumsv 10
☎ 47 22 12 37 00
🖳 www.norskfolke.museum.no
○ Mon-Fri 11AM-3PM
Sat-Sun 11AM-4PM
$ NOK 100

EKEBERG RESTAURANT
⌂ Kongsveien 15
☎ 47 23 24 23 00
🖳 www.
ekebergrestauranten.com
○ Mon-Sat 11AM-12AM
Sun 12PM-10PM
$ NOK 150-499

RESTAURANT FINSTUA
⌂ Holmenkollveien 200
☎ 47 22 92 40 40
🖳 www.frognerseteren.no
○ Mon-Fri 12PM-10PM
Sat 1PM-10PM
Sun 1PM-9PM
$ NOK 255-375

LORRY
⌂ Parkveien 12
☎ 47 22 69 69 04
🖳 www.lorry.no
○ Mon-Sat 11AM-3:30AM
Sun 12PM-1:30AM
$ NOK 98-225

**LOFOTEN
FISKERESTAURANT**
⌂ Stranden 75
☎ 47 22 83 08 08
🖳 www.lofoten-
fiskerestaurant.no/en
○ Mon-Sat 11AM-11PM
Sun 12PM-10PM
$ NOK 200-425

WHERE TO...EAT AND SLEEP

EAT

A Ekeberg Restaurant

Dubbed "the hottest dining spot in town" by *The New York Times*, this landmark restaurant is just a short cab ride from downtown. Housed in a 1929 structure (which was beautifully renovated in 2005) and perched above the fjord, it offers breathtaking views as well as a menu that incorporates modern and classical Scandinavian cooking.

B Restaurant Finstua

Quintessentially Norwegian, this restaurant is located in Frognerseteren, a century-old mountain lodge on the outskirts of Oslo. The menu of classic Scandinavian specialties includes rich game dishes, as well as a number of variations of Norwegian salmon.

C Lorry

For over 120 years, this traditional café has been serving Oslo's artists, writers, and creative types. The menu of Norwegian classics won't blow you away, but with an outdoor terrace for warm-weather dining, a lively atmosphere, and 130 types of beer to choose from, it remains a perennial favorite.

D Lofoten Fiskerestaurant

Located in the seaside Aker Brygge district and featuring beautiful waterfront views, this seafood restaurant is among Oslo's best. The menu focuses on fresh, seasonal ingredients—be sure to try lutefisk, a Christmastime tradition, in winter and shellfish in summer. Other options include reindeer and mutton.

˄ A dish from **Lorry**

SLEEP

E Grand Hotel Oslo

Located between the Norwegian Parliament building and the Royal Palace on Karl Johans Gate, this hotel has been the city's premier destination since it opened in 1874. An elegant, old-world landmark in the city center, The Grand Hotel is convenient to the city's main shopping and cultural areas. Every year it hosts the Nobel Peace Prize banquet and winners stay in its Nobel suite. The hotel also boasts several excellent restaurants, including the famed Grand Café (where Henrik Ibsen used to eat lunch everyday).

F Hotel Continental

Located across from the National Theatre, this hotel opened in 1900 and has been family-run ever since. On the ground floor, the lively Theatercafeen offers great food in a Vienna-style café (which was included on *The New York Times* list of the world's 10 best cafés), plus famous caricatures of leading theater personalities. Art lovers will want to stop by the lobby bar for a look at reproductions of Munch lithographs.

G Grims Grenka

Decorated in contemporary Nordic style with accents from the East, this design hotel (located by Akershus Castle, near the vibrant Aker Brygge area) is equally popular with business travellers and the chic set. The first boutique hotel to open in Norway, the 66-room Grims Grenka boasts a rooftop terrace, Q Lounge, for guests to relax and unwind, as well as Madu, a fusion restaurant that combines Norwegian and European flavors with an Asian twist.

H Radisson SAS Scandinavia Hotel

Not far from the Royal Palace and several major attractions, The Radisson SAS Scandinavia Hotel offers great views of the city and the Oslofjord, plus convenient access to the entire city. Many of the nearly 500 rooms and suites are newly refurbished. At Summit 21 bar, located on the 21st floor, guests enjoy cocktails and a sweet spot to check out the city panaroma.

MAP OF VENUES AND CITY LANDMARKS

OSLO

Hegdehaugsveien

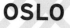

THE ROYAL PALACE

6

Oslofjord

BYGDOY 14 15

KEY

- **ⓘ** Information
- Walking Tour
- Scene Stealers
- Others
- Eat and Sleep

11

10

12 **5** **13** **4**

6

Pilestredet

2 **H**

8 **9** **9**

Hammersborgtunnelen

Hausmanns gate

Frederiks gate

7

10

8

3

5 **6**

F

ⓘ

4 **E**

3 **4**

Nylandsveien

2

2 **11**

7

2

Frognerstranda

G

1

ⓘ

OSLO STATION

Akershusstranda

5

Bispegata

3

A

1

EXTENDED TRAVEL

ÅSGÅRDSTRAND

For the adventurous who want to know the real Munch, a visit to this lovely seaside town, about 60 miles southwest of Oslo, is a must. It is best to rent a car for the hour and a half drive, taking the E18 highway toward Drammen. From the highway, turn left at the sign for Horten. By public transportation, you can take a train to Skoppum, then a taxi to Åsgårdstrand. Or you can take a train to Tønsberg, then a bus (which runs one an hour) into town.

Throughout his life, Munch spent many summers here, until he became too old to make the trip. He said the place made him want to paint, and many of his most beautiful works were done here along the coast in the late summer light. His little house, located at **Munchs Gate 25**, is a museum that is open to the public but closed on Mondays. There are several cafés and hotels in the area, which welcome travelers and vacationing artists.

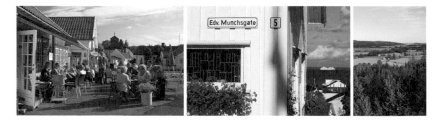

^ Scenes from **Åsgårdstrand**, including [opposite page] the **Munch's House Museum**

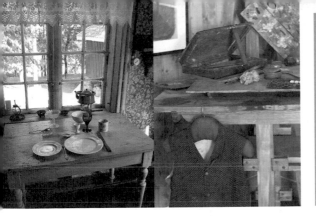

ACCESS:
Åsgårdstrand is located about 90 miles from the Oslo Airport and 60 miles from Oslo Harbour. By train, leave Oslo station and get off at Skoppum (which is just 3 miles from Åsgårdstrand). Or drive along one of two main highways—the E6 or the E18. Travel time is a little over an hour and fifteen minutes.

ÅSGÅRDSTRAND IN ARTWORK

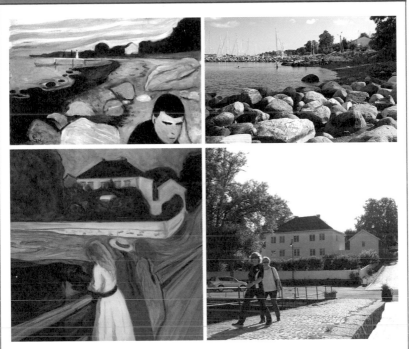

Melancholy, 1891 (Private Collection)
By 1891, Munch was fully immersed in the visual language of the symbolist painters. In this work, the flattened Åsgårdstrand coastline leads the eye from a single gloomy figure in the foreground to a far-off couple as the barren seashore landscape mirrors the solitude of jealousy.

Girls on the Bridge, 1901 (National Gallery, Oslo)
Munch's view of an Åsgårdstrand jetty strays from the Norwegian tradition of epic naturalism in plein-air painting. Instead, Munch uses lyrical line and expressive color—the bold hues of youth and the lingering twilight of Norwegian summer—to suggest a transitional moment in the life of a woman.

ANATOMY OF A MASTERPIECE

The Sick Child, 1885-86
National Gallery, Oslo
Munch found inspiration for his art in the darkest corners of his memory, including the sickness and death that seemed to haunt his family. One of his most famous works, *The Sick Child*, marked a breakthrough in the young artist's career; here we see Munch turning away from salon-style naturalism and painting with the expressive colors and abstracted forms for which he'd become known.

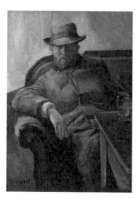

Hans Jaeger, 1889
National Gallery, Oslo
Hans Jaeger, the leader of Kristiania's bohemian intellectual scene, encouraged Munch to paint and write from his own life. Munch painted the provocateur—an outspoken proponent of free love who earned 60 days in prison for his book *From Kristiania-Bohemia*— at a time when his influence was waning. The two spent many an evening at artsy hangout the Grand Café, staring out the window at Oslo's bourgeoisie on the Karl Johan.

Evening on Karl Johan, 1892
Rasmus Meyer Collection, Bergen
At the end of the 19th century, Karl Johans Gate was the center of Kristiania, a boulevard on par with the Champs-Élysées in Paris. The artist knew it well—it was the site of daily promenades of the city's elite and home to the city's hip cafés. By 1892, Munch no longer paints the boulevard naturalistically; instead, he shows a procession of figures with skull-like faces, united by their alienation in the eerie Oslo twilight.

Death in the Sickroom, 1893
Munch Museum, Oslo
"Death and insanity were the black angels on guard at my cradle," wrote Munch, and indeed his childhood was filled with upheaval and illness, themes explored in his work. In *Death in the Sickroom*, Munch re-creates the final moments of his teenage sister Sofie's life, surrounded by family and doctors as she succumbed to tuberculosis some 16 years earlier. Here, the focus is on the isolation of each of the surviving family members, rather than the dying girl seated in the chair. The bold outlines around each figure suggest the influence of artists like Van Gogh and Toulouse-Lautrec, whom Munch would have seen in Paris.

Ashes, 1894
National Gallery, Oslo
The woman in this painting is thought to be Millie Thaulow, the married woman with whom Munch had an affair as a young man. The painting depicts the sense of betrayal felt as a relationship crumbles, with the ashen trees and white stones symbolizing death. Here, as in many of Munch's paintings, the woman is shown as cool and indifferent while the man suffers.

Puberty, 1894-95
National Gallery, Oslo
In *Puberty*, Munch paints a young girl perched on the edge of a bed, awkwardly covering

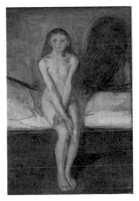

her own nakedness while a phallic shadow falls behind her. Munch may have used the teenage form to explore his own sexual anxieties, aligning himself with the idea of the adolescent—a relatively new concept at the time.

The Day After, 1894-95
National Gallery, Oslo
In this work, Munch depicts a scene from liberated bohemian life—a woman unkempt after a night of drinking—that surely would have shocked Kristiania's more pious citizens, including his own father.

Vampire, 1895
Munch Museum, Oslo

Part of Munch's meditation on life, love, and death—the *Frieze of Life*—this painting was originally shown under the title *Love and Pain*. The controversial canvas shows two figures converged in an abstracted pyramid, their embrace darkened by the painting's deep shadows, as well as its title. Here, Munch shows passion and romantic love as analogous with the vampire's draining kiss of death.

Moonlight, 1895
National Gallery, Oslo
In this painting of a woman—possibly his first lover, the married Millie Thaulow—Munch simplifies the body and shadows into flat, black masses on which a white face seemingly floats like a supernatural presence.

The Kiss, 1897
Munch Museum, Oslo
The relationship between

man and woman was a central theme in Munch's oeuvre, and even in his portrayal of an amorous couple we see hints of darkness. As the two figures come together Munch depicts the death of their individuality, as well as hints of the inevitable separation and despair that is to come.

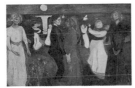

The Dance of Life, 1899-1990
National Gallery, Oslo
At first glance this painting appears to be a celebration on the beach in Åsgårdstrand, but upon closer inspection Munch shows us the three stages in a woman's life—the expectant young innocent, to the mature woman engaged in the dance of life, to the older woman left watching in the wings—with his signature cynical take on life.

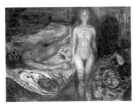

Death of Marat, 1907
Munch Museum, Oslo
Following a failed courtship with Tulla Larsen—which ended with a self-inflicted gunshot wound—Munch paints himself as the slain French revolutionary Jean-Paul Marat, while a woman looms over his bed like the assassin Charlotte Corday (a theme popularized with Jacques-Louis David's 1793 painting of the same name).

INDEX+CREDITS

CONTRIBUTORS

Lea Feinstein is a San Francisco Bay Area artist and writer who has written about art for a variety of publications including *ARTnews* and *SF Weekly*, where she was the chief art critic. She has taught studio art at Rhode Island School of Design and Georgetown University, among others.
⌨ www.leafeinstein.com

Kristin Hohenadel is an American arts and culture correspondent who has been based in Paris since 1995. Her articles and essays have appeared in such publications as *The New York Times*, *The Los Angeles Times*, *Vogue*, *Travel + Leisure*, *The Times of London* and *Der Spiegel*.

Barbie Latza Nadeau is an American journalist and travel writer who has been based in Rome since 1996. She reports for *Newsweek*, *The Daily Beast*, *CNN Traveller*, *Budget Travel* and *Frommer's*.

⌨ www.barbielatzanadeau.com

Sandra Smallenburg studied art history at Leiden University and works as an art editor and critic for Dutch newspaper *NRC Handelsblad*. She is also a contributor to *ARTnews* magazine. Sandra resides in Leiden, The Netherlands.

George Stolz is an independent critic and curator based in Madrid, where he is a correspondent for *ARTnews*.

ABOUT THE ILLUSTRATORS

Max Porter and Ru Kuwahata began collaborating after realizing that they had mutual affection for chubby animals, forensic science, and handmade miniatures. Since 2008, Tiny Inventions has directed music videos, developed original television content, headed design on a large-scale toy brand, and created independent works. Combined, Max and Ru's animations have shown in over 70 film festivals.

ACKNOWLEDGEMENTS

Museyon Guides would like to thank the following individuals and organizations for their guidance and assistance in creating *Art + Travel Europe.*

Van Gogh and Arles

Arles Tourism

Atout France – France Tourism Development Agency

Reattu Museum

Recontres d'Arles

Suds à Arles

Cilantro Restaurant

Grand Hotel Nord-Pinus

Hotel Jules Cesar

L'Hôtel Particulier

La Chassagnette Restaurant

Le Calendal Hotel

St-Rémy Tourist Information

Van Gogh Museum (Amsterdam)

Art Institute of Chicago Museum

Yale University Art Gallery (New Haven)

Kröller-Müller Museum (Otterlo)

Vermeer and Delft

Netherlands Board of Tourism & Conventions

Tourist Information Point Delft

Vermeer Center

Museum Het Prinsenhof

Museum Lambert van Meerten

Nieuwe Kerk

Oude Kerk

Delft Ceramica

Delft Chamber Music Festival

Taptoe Delft

The Mauritshuis (Den Haag)

Rijksmuseum (Amsterdam)

Goya and Madrid

Madrid Tourism Center

Prado Museum

Royal Academy of Fine Arts of San Fernando

Basilica de San Francisco el Grande

Royal Tapestry Factory

Museos de Madrid

Zaragoza Turismo

Turismo de Aragón

The Museum of Zaragoza

Basílica de Nuestra Señora del Pilar

Iglesia de la Santa Cruz

Caravaggio and Rome

Professor David M. Stone

Azienda di Promozione Turistaca di Roma

Provincia di Milano

Vatican Museums

Borghese Galleries

Palazzo Barberini

Galleria Doria Pamphilj

San Luigi del Francesi

Pieux Etablissements de la France et à Rome et à Lorette

Malta Tourism Authority

St. John's Co-Cathedral Foundation (Malta)

Munch and Oslo

Visit Oslo

The National Museum of Art, Architecture and Design

The Munch Museum

Ekeberg Restaurant

Frognerseteren

Munchs hus (Åsgårdstrand)

PHOTO CREDITS

5/10